POLAROID

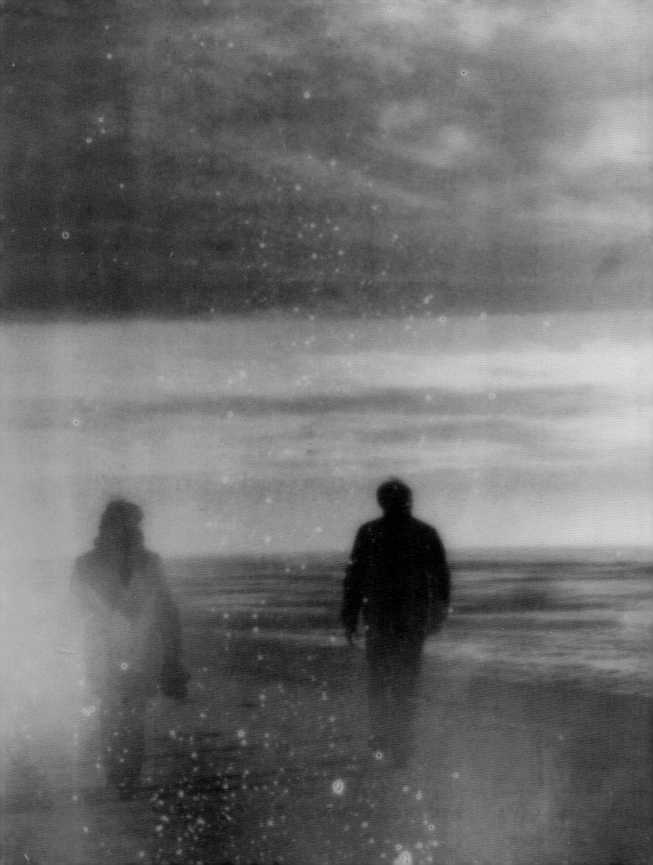

POLAROID

THE COMPLETE GUIDE TO EXPERIMENTAL INSTANT PHOTOGRAPHY

RHIANNON ADAM

840 illustrations

Thames & Hudson

To Melinda, for everything, always. Without all you have done
I could never have written this book.

And to Nan, from whom I inherited the "collecting gene," and
who fed my obsessions but sadly never got to see this happen.

Of course, also to Edwin Land and Florian Kaps, who made
dreams a reality and kept the flame burning.

*Polaroid: The Complete Guide to Experimental
Instant Photography* © 2017
Thames & Hudson Ltd, London
Text © 2017 Rhiannon Adam
Designed by Kate Slotover
For illustration credits see page 231

First published in 2017 in the United States
of America by Thames & Hudson Inc., 500
Fifth Avenue, New York, New York 10110

www.thamesandhudsonusa.com

Library of Congress Control Number:
2017934761

ISBN 978-0-500-54460-0

Printed and bound in China by C&C Offset
Printing Co. Ltd

Be Safe
Whenever you work with chemicals
you need to be aware of the hazards and
safety measures associated with them.
The safety information provided in
this book is only a starting point and
does not supersede the manufacturer's
safety instructions, which you should
always consult in all circumstances
before beginning work. It is always
recommended that you wear protective
gloves, goggles and a lab coat (or similar
form of protective clothing) as basic
precautions. Additional protective
measures may be necessary depending
on the chemicals involved.

Reasonable effort has been made to
review and verify the information in
this book. Neither the Author, Thames
& Hudson nor its publishing partners
assume responsibility for completeness
and accuracy of the information, or
for its interpretation. The reader is
responsible for making appropriate
decisions and taking appropriate
care with respect to the safe use of
specific materials, work practices,
equipment and regulatory obligations.

The techniques suggested in this book
should not be used by anyone under
18 years of age. To the extent permitted
by law, no liability is accepted by the
Author or Thames & Hudson for any loss,
damage or injury arising as a consequence
of attempting the processes described
in this book.

Contents

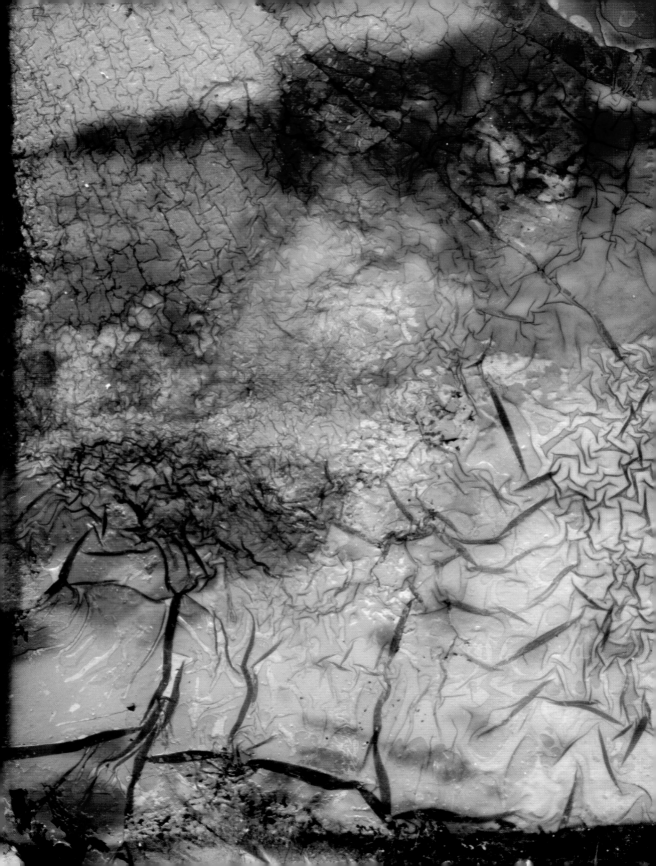

Author's Note

I began shooting Polaroids obsessively in my early teens. I can still remember the first time I held the camera in my hands, hearing the clunk and whir after releasing the shutter, then watching the magic appear from the grey gloom. I was transfixed. What strange alchemy was taking place within that tiny square of plastic? Even now, the answer remains enigmatic.

Every image is a collaboration between the photographer, film and the external environment. The film's self-contained chemistry gives each Polaroid its individual signature. Colours shift in the heat or cold and the image becomes ours: forever altered as we nurture it through development, becoming a part of the place where it was 'born'. 'Reading' a Polaroid is like embarking on an archaeological dig. Surface fissures, tones, textures and imperfections all reveal far more than the picture itself. These allow us to see beyond the frame, becoming a keyhole to the past.

Analogue is now undergoing a revival. Perhaps in this digital age, where so much of our time is spent in front of a screen, we all crave a little bit of reality, something to anchor us in three-dimensional space. This is what a Polaroid does. It is a unique object, a tiny 'sculpture', an intersection between photography and fine art: not ephemeral but real and tangible. In contrast to the thousands of digital pictures taken each minute, a Polaroid remains special, each one exuding an innate sense of trust and intimacy.

To use a cliché, Polaroids bring people together. Everyone – from toddlers to nonagenarians – fall captive to their spell. After all, everyone loves a spot of magic.

Throughout their history, Polaroids have been used in every application imaginable, from casting to continuity, insurance to identity cards, and from pornography to policing. Films including *Desperately Seeking Susan* (1985) and *Memento* (2000) have cemented the place of Polaroids within pop culture. Songs have been written about them, album covers have featured them and music videos have been made from them. Even the old Instagram logo was based on the Polaroid 1000 camera. The humble

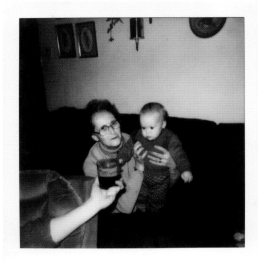

Polaroid is the rock star of the photography world: rebellious and a little bit subversive.

Polaroid is more than just a film format. The invention itself is a testament to the power of dreaming big, and that is the spirit that lies at the heart of this book. Experiment, always enjoy the journey and don't be afraid to push boundaries. In the words of Edwin Land, Polaroid's founder, never attempt anything unless it is 'manifestly important and nearly impossible'.

Oh, and one piece of advice: never, ever shake a Polaroid...

That's me in the red bib, being held by my Nan. It's my first Polaroid and was taken on an SX-70.

How to Use This Book

Instant-film photography can seem a bit of a minefield at first. Many formats have been discontinued while others are still produced; some expired film formats are still worth buying, while others are useless. Many old cameras can now be used with modern film stock, while more 'modern' instant cameras are completely defunct. The sheer number of available cameras can be overwhelming, with prices ranging from a few pounds to hundreds, often for models looking remarkably similar. On top of this, certain creative techniques can only be realized with particular film emulsions, regardless of their format. So, where to start? The answer is largely up to you.

This book is split into two halves. 'Part 1: Camera and Film Format Guide' deals with the technology and history of instant film, told through chapters dedicated to the different camera and films. These chapters also detail hardware that is recommended for use, whereas the Polaroid Relics sections introduce models that, though key to the development of instant technology, are now probably better collected than used. 'Part 2: Creative Techniques' details the incredible range of creative interventions that are possible with instant photography, including examples produced by some of the most innovative photographers working with the medium today. There is also an extensive resources section at the end, including a useful Instant Film Compatibility Guide, Stockists and Safety Information.

Before you begin, see the Quick Start Guide (see pages 10–11) for help with navigating this book.

Quick Start Guide
Instant Cameras/Equipment for Creative Techniques

If you already own an instant camera and are familiar with its functions you may wish to skip to 'Part 2: Creative Techniques', using the table opposite to check the film that can be used for each method and the guide below for the compatible camera.

Where film is listed as 'Polaroid original' in the table opposite, this refers to all formats made by the Polaroid company. Of the models listed below only instant printers, Fuji Instax and Impossible cameras are currently being produced.

Peel-apart Film Cameras Of all expired films, peel-apart (see pages 22–23) fares the best with age. Peel-apart film cameras come in a number of forms, and there are many types of compatible film. See the table on pages 224–29 for a full film list. The best peel-apart film cameras are detailed in the buying guide on pages 38–39. Key pack film formats include types 669, ID-UV, 665 and Fuji FP-100C. **See pages 26–39.**

SX-70 Cameras These were the first integral film (see pages 42–43) cameras and had a long tenure. The most sought after of these models is the folding SX-70 SLR series. Today, MiNT produces a refurbished version, the most flexible SX-70 compatible camera available. You can use either original Polaroid SX-70 film in this camera, or new Impossible SX-70 film. **See pages 44–56.**

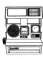

600 Cameras This group of integral cameras were the next to be developed after the SX-70 series. There are many different models, including non-folding and folding ones. They are compatible with 600-speed integral films, including expired Polaroid (the results of which are unreliable) and Impossible Project 600 film. See the buying guide on pages 62–63 for the best models. 600s are an inexpensive way into instant photography. **See pages 58–63.**

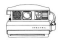

Spectra Cameras This model is also known and marketed as the Image camera and the Minolta Instant Pro, which is the same as a Spectra Pro. All accept expired Polaroid Spectra, Image or 1200 films, but the film is very unreliable. The Impossible Project produces compatible film for this camera too. **See pages 66–71.**

Instant Printers These copy images onto instant film. Some are compatible with smartphones, such as Impossible's Instant Lab, while others use a copy-stand model or 35mm slides. Impossible's Instant Lab allows you to transfer photos from your phone onto Impossible film. Printers are useful for practising creative techniques without risking film wastage. **See pages 72–75.**

Fuji Instax Cameras Fuji Instax film is less flexible than Impossible and pack film because of its chemistry and structure but it does contain chemical pods, making some creative techniques still possible. There is a wide range of camera hardware to choose from. Some cameras include dedicated creative modes that make the operative hacks detailed in the creative techniques unnecessary. **See pages 78–81.**

Impossible I-1 Cameras This is a highly flexible camera designed exclusively for use with Impossible's I-Type film. Though the first release has had a few teething problems, the app-compatibility unleashes a range of features never before seen on a consumer Polaroid camera. **See pages 82–89.**

Creative Techniques
Film Compatibility Guide

Creative Techniques	Integral Film (see pages 42–43)			Peel-apart Film (see pages 22–23)		
	Polaroid original	Impossible Project	Fuji Instax	Fuji FP-100C	Polaroid original (not all films)	New 55 (and Polaroid 55, 665)
Transparency/Dry Lift (pp. 96–99)	X	X	–	–	–	–
Expired Polaroid Film (pp. 100–3)	X	–	–	–	X	–
Long Exposures (pp. 104–7)	X	X	X	X	X	X
Multiple Exposures (pp. 108–13)	X	X	X	X**	X**	X**
Cartridge Manipulations (pp. 114–23)	X	X	X	X	X	X
Controlled Burn (pp. 124–25)	–	X	–	–	–	–
Light Painting (pp. 126–29)	X	X	X	X	X	X
Mosaics (pp. 130–33)	X	X	X	X	X	X
Image Transfers (pp. 134–39)	–	–	–	X	X	–
Emulsion Lifting (pp. 140–49)	–	X	–	X	X	–
Emulsion Manipulation (pp. 150–55)	X*	X	–	–	–	–
Finger Painting (pp. 156–59)	–	–	–	X	X	–
Scratching and Scoring (pp. 160–61)	X	X	–	X	X	X
Polaroid Decay (pp. 162–65)	X	X	–	–	–	–
Microwaved Polaroids (pp. 166–69)	X	X	X	X***	X***	–
Polaroid Destruction (pp. 170–73)	–	–	–	X	X	X
Fuji Negative Reclamation (pp. 174–77)	–	–	–	X	–	–
Impossible Negative Reclamation (pp. 178–81)	–	X	–	–	–	–
Negative Clearing (pp. 182–85)	–	–	–	–	–	X
Polagrams (pp. 186–89)	X	X	X	X	X	X
Cyanotypes (pp. 190–95)	–	–	–	X	–	X
Experimental Painting (pp. 196–99)	X	X	X	–	–	–
Hand Development (pp. 200–1)	X	X	X	–	–	–
Roller Manipulation (pp. 202–5)	X	X	X	X	X	X
Interrupted Processing (pp. 206–9)	–	–	–	X	X	X
Colour Injection (pp. 210–13)	X	X	X	–	–	X
Projection Printing (pp. 214–17)	X	X	X	X	X	X
Collage and Mixed Media (pp. 218–23)	X	X	X	X	X	X

X* Some types only, check materials lists for specifics
X** Not detailed in 'Creative Techniques', as possible without manipulation
X*** Not detailed in 'Creative Techniques', but is possible with some adjustments

Introduction

Polaroid is a brand much like Hoover, Sellotape or even Google – a name so powerful that it enters the dictionary and becomes synonymous with an action, a thing or, in Polaroid's case, even a medium. The word is almost bigger than the Polaroid Corporation ever was and has become shorthand for 'snapshot'.

It's not without some hint of irony that, when Polaroid declared bankruptcy in 2001, one of its most important assets was the trademark itself, worth more than all of the years of research and chemical innovation put together. Most of what the company had built was sold off, piecemeal, and much of the factory machinery was dismantled and sold as scrap metal. Today the 'new' Polaroid company (run by owners Gordon Brothers and Hilco Consumer Capital and operating as a lifestyle brand rather than as a producer of cameras or film) bears little resemblance to its namesake.

Before its extraordinary dismemberment, Polaroid was a multi-billion dollar company and at its peak employed more than 20,000 workers. It embodied the essence of the American dream.

The company was essentially the creation of one man, Edwin H. Land, who through his own hard work and iron-will, imagined a future and then made it happen. Land was a visionary. He actively oversaw all decision-making and development, and steadfastly sought out problems and solved them so elegantly that one might ponder 'why has no one ever done this before?'

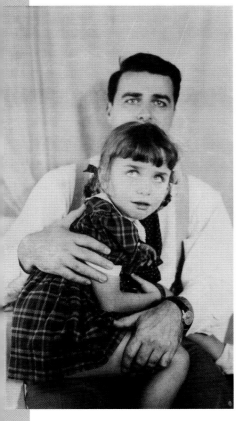

Above: Edwin Land in his office, c. 1943. **Below:** Land and his daughter, Jennifer, c. 1945.

In 1926, a young Land – displaying a keen interest in optics – dropped out of his studies in chemistry at Harvard University after just one year to travel to New York. (Although in later life Land became reverentially known as Dr Land he never completed an undergraduate course, let alone a PhD, though he was awarded numerous honorary degrees from institutions the world over, including Harvard.) It was in New York that he would develop his first invention, producing in 1934 the first polarizer (polarization being a process that involves restricting the direction of light waves) in sheet form. These could be applied to any product where the control of light was key. Variations of this invention are now used in almost every pair of polarized sunglasses, photographic lenses, on LCD screens and car headlights (for which Land's sheet polarizer was initially intended).

It was also from this invention that the name of his company emerged. In trying to come up with a catchy title for his new product Land decided, with the help of his friend, Clarence Kennedy, a fine art photographer and art historian at Smith College, to combine the suffix 'oid' (from 'celluloid', the product's base) with the word 'polarizer'. The result was 'Polaroid', the heading under which all his inventions would be developed and sold.

Over the next few years Land went from strength to strength. In 1938 he effectively made 3D film a reality, by developing 3D viewing glasses that employed his polarization system, which made their debut at the New York World Fair. During the years 1941–44 he was heavily

involved in the war effort, and developed a range of products for that cause, including polarized goggles. Land even advised Eisenhower on military surveillance during the Cold War, his expertise leading in the development of the U-2 spy plane.

The Polaroid laboratory began to expand, Land employing several key figures who would go on to shape company history. One of them, fellow college dropout Howard Rogers, invented the 'magic molecule': the secret ingredient to Polaroid's colour film (see pages 42–43).

It wasn't until the early 1940s that Land even thought of inventing instant photography. In 1943, he and his family were on holiday near Santa Fe in Mexico. One day, Land went for a walk with his three-year-old daughter, Jennifer, with his trusty Rolleiflex camera in hand. Jennifer, with childlike innocence, posed a question that was to set the course of the rest of his lengthy career: 'Why can't I see the picture now?'

The idea was sketched out in a few short hours after Land returned. Back in the lab, the project was assigned a codename, SX-70 (during the Second World War, Land had worked on various projects that were named with the suffix 'SX', for 'special experiment').

Just four years later, Land introduced the first instant photography system (the roll film camera; see pages 26–27) to the Optical Society of America. This product demonstration would change the landscape of photography forever. The cameras were a huge hit, and though Land was the reluctant hero of the piece, his name appeared somewhere on the body or in the literature of every Polaroid camera until the release of the Spectra (see pages 66–71) in 1986.

It was only in 1972 and after twenty-nine years of development – in which time other groundbreaking models, including the Automatic 100 (see page 26), which used the new peel-apart film (see pages 22–23), and the gigantic 20"×24" camera (see page 41), were introduced – that Land delivered the product he had envisaged in Santa Fe: that of 'one step' photography, where a single shutter press could lead to a finished image. Using his newly invented integral film (see pages 42–43) this project, he felt, was finally deserving of the SX-70 name (see pages 44–56).

After the release of the SX-70 Polaroid went on to develop other equally lucrative products, including the 600 camera (see pages 58–63), the Spectra system and the 500 format (see page 76), as well as others less long-lasting, including Polavision (see page 57) and the i-Zone (see page 77). Irrespective of the fortunes of each of these models, and right up until its demise in 2008, Polaroid had established itself as a household name, and one that was synonymous with innovative and cutting-edge technology.

Demonstration of Polaroid's polarizing lenses.

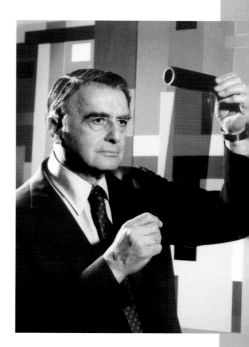

Land examines colour negative material, *c.* 1960.

Kodak's Instant

In the photographic world, Polaroid was second only to one other great American superpower: Eastman Kodak. For a time the two companies had a reciprocal relationship. In 1934 Kodak gave Land's company its first substantial contract (for the supply of sheet polarizer). When Polaroid launched the first instant film in 1948, it was Kodak that helped to manufacture it, churning out for the next twenty years the negative component of Polaroid film. Kodak even assisted in the production development of the first Polacolor film.

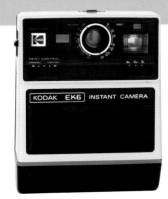

When Polaroid launched the integral SX-70 system in 1972, Kodak were, unbeknownst to Polaroid, working on a pack film system like Land's Automatic 100. Called the Lanyard, it involved pulling the film through the rollers by a cord. Land's product was far superior to Kodak's: the company scrapped the Lanyard and went back to the drawing board, examining the intricacies of Polaroid's output in microscopic detail.

On 21 April 1976 Kodak finally launched their own integral cameras, the EK4 and EK6, and also the film, PR-10. Just six days later Polaroid filed a patent infringement case, citing twelve patents relating to both film and camera. Ten would see their day in court. The trial began in 1981 and lasted seventy-five days. Land barely left the courtroom: once the trial was over, his job was done and, in August 1982, he resigned from the company.

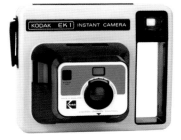

It wasn't until September 1985 that a ruling was made. In the meantime, Polaroid's resources were being ploughed into legal fees while Kodak forged on, selling approximately 16.5 million cameras along with their compatible film packs. Polaroid's petition was upheld in seven of the ten patent judgments, and Land was exalted. The judge issued a request that Kodak cease manufacture, sale and promotion of its instant photography products within three months. Kodak refused, pending appeal. This and a subsequent appeal were thrown out, and the clean-up operation began, not least for Kodak's corporate image.

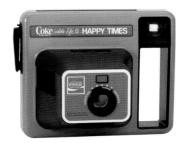

In October 1990, Polaroid was awarded a $909 million settlement, the largest patent infringement award that had ever been granted. By July 1991, a few month's after Land's death, Kodak had settled their final bill, paying Polaroid $925 million, including interest. All the while Kodak's stock rose, and Polaroid's declined.

It could be claimed that the patent case was responsible for Polaroid's eventual demise in the 2000s, since as it went on the company took its eye off the ball, focusing entirely on instant film in an evolving industry. The award from Kodak was not big enough to insulate against the company's ailing fortunes.

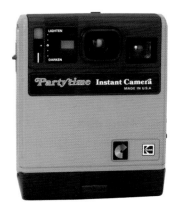

From top: Kodak's EK6 and EK1; the Coca Cola Happy Times model and the Partytime integral camera.

Fuji and Polaroid

Over the years there were multiple other attempts to close in on Polaroid's territory. In 1952 the Soviet company GOMZ (later Lomo) made a version of the Model 95 and, in 1972, Berkey's Keystone pack film-compatible cameras emerged in the US. A later SX-70 compatible Keystone camera, the Wizard XF1000 (also known as the Porst Magic 500 or Revue) and its sister camera, the XF1500, were pushed from the market by another patent complaint by Polaroid.

In 1981, another giant entered the ring, Japan's leading film manufacturer, Fujifilm. Fuji's Fotorama instant cameras and integral 'F series' films were largely based on Kodak's and the two films were cross compatible. Polaroid took out a patent case against Fuji, only this time the two companies successfully negotiated a truce. Polaroid granted Fuji the freedom to continue marketing their own cameras and films in exchange for retaining exclusivity in the US and having access to a range of Fuji's technologies, including digital.

The Fuji agreement gave Polaroid a few years' head start in various areas of development and manufacturing. Fuji's influence would be seen in a long list of Polaroid product releases, including Polaroid-branded video tape, conventional 35mm films and floppy discs for storing computer data. By the mid-1990s Polaroid was the world's biggest-selling digital camera brand.

Fuji and Polaroid would collaborate on a number of other products, with the former company even releasing the first ever films compatible with Polaroid cameras, among them FP-100C, 100B, 3000B and 4"×5". Meanwhile, Fuji's integral film evolved into the Fuji Instax system. By this time, Polaroid's patents had expired and Fuji products started to slowly appear in American stores.

In 2001, Polaroid filed for bankruptcy and all assets were sold. Under new ownership, an inevitable restructure took place. It was decided to slowly withdraw instant film from the market in line with projected demand. Camera production ceased in 2006, as did chemical sourcing. Should film demand have continued at the imagined rate, there would have been enough stockpiled raw material to last a decade. However, stocks had already sold out by the time the company's bankruptcy was made public, and it was too late to backtrack. Fuji would, until Impossible's first film release, become the last manufacturer of Polaroid-compatible instant films.

From top right: GOMZ 'Moment' camera; Keystone Wizard; Fuji Fotorama F-10 camera; Polaroid VHS tapes and floppy discs using Fuji components; Fuji FI-10 film.

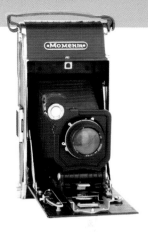

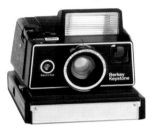

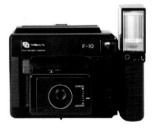

From Polaroid to Impossible

When Polaroid started to wind down its operations, a company called Unsaleable stepped in, proposing a marketing plan focused on social media on which they wanted to collaborate. Unsaleable was an online store largely focused on analogue products (including instant film) run by the makers of Polanoid.net, an online community and sharing platform for instant photography. Its founders were three members of the Austrian Lomographic community (a society that emerged after the discovery by students of a Lomo LC-A camera relic in the early 1990s, which they persuaded the manufacturer to bring back into production), one of whom was Florian Kaps.

In 2005, Polaroid granted Kaps the rights to become a distributor, resulting in the release of several special-edition pack films (blue, sepia and chocolate) and Fade2Black integral film. The Polanoid team also began investigating the possibility of making their own instant film.

Kaps attended the closing-down party of the Polaroid factory in Enschede in the Netherlands and there met factory manager André Bosman, a Polaroid veteran who had worked for the company for thirty years. Together they formed a plan, and after some hard work, managed to secure enough investment to lease the building. Kaps scraped together €180,000 and bought the plant's machinery. For an additional €1,000,000, he purchased the last of the plant's Polaroid film, which he began selling through Unsaleable to raise funds for the project.

The Enschede factory contained machinery for manufacturing integral films only, and this is where the company concentrated its efforts. However, the team had their work cut out. By 2008, there was a broken supply chain in production, and almost all of Polaroid's constituent chemistry had been discontinued or banned due to environmental regulations. Of those that were still attainable, production could not start without huge bulk orders, which could not be sustained. The only option was to develop or 'reverse engineer' them from scratch.

Due to funding constraints, Unsaleable had just two years to take a product to market, so research began in earnest. A rather apt name for the venture was then settled on, 'The Impossible Project', referring to the memorable words of Land: 'Don't undertake a project unless it's manifestly important and nearly impossible.'

Impossible's first films were black-and-white, with test editions codenamed Type 40 and Type 42. Both were very problematic, and would fade completely over just a couple of days. Improvements were made, but problems persisted, including a recurring flaw nicknamed the 'killer crystal', which plagued the earliest production runs of Impossible's commercial 'PX' film. This was caused by moisture being trapped between the layers, causing a type of fungus to spread that turned the pictures blotchy and orange. Like Land before them, Impossible released stop-gap solutions including dry-age kits containing foil bags and silica gel, and issued disclaimers and warnings about the experimental nature of the film. In 2012 only 10 per cent of customers became repeat purchasers, many having been put off by the high price and inconsistency in the product.

In the meantime, Oskar Smołokowski, son of energy tycoon Wiaczesław 'Slava' Smołokowski, had paid a visit to Impossible's New York project space and bought some film. After meeting Kaps and hearing Impossible's story, the young Smołokowski persuaded his wealthy father to invest €2,000,000 in the company, in exchange for a 20 per cent stake in the business, making him the company's largest shareholder. Smołokowski soon began working at Impossible, eventually heading up the team responsible for the development of the company's first camera, the I-1 (see pages 82–87).

By early 2013 Kaps took the decision to retire from the company, leaving the CEO role to Creed O'Hanlon, who went on to centralize operations and shut down many of Impossible's Project Spaces.

New recruits appeared within Impossible's ranks, not just across marketing, but in research too, including Stephen Herchen, a former Polaroid scientist who had spent thirty years working on instant films at Polaroid's headquarters in Cambridge. Herchen is now Impossible's chief operating and technology officer, and his influence has changed Impossible's film product significantly, making colours brighter, chemicals more stable and reducing development time. By December 2014, Smołokowski took over as CEO.

Kaps now runs Supersense, a company based in Vienna that develops and sells analogue products, including Impossible's range. Kaps has made short-run editions of Impossible compatible cameras exclusively for Supersense, which make use of the Impossible CPU unit – including the Supersense Pinhole. He has also marketed a custom-built attachment to transform your Instant Lab into a usable camera (LAB2CAM), and has even built a new 20"×24" camera that uses Impossible integral film and is available to hire in Vienna. In 2016 he released a book on instant photography called *The Magic Material*.

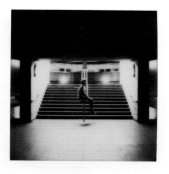

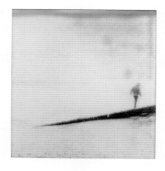

Opposite from top: Impossible employee holding custom printed film borders at the Enschede factory; Impossible's colour tests. **Above:** A selection of test images taken by the author for Impossible using their very earliest test films.

Polaroid packaging before Giambarba's redesign; a classic Polaroid advert by DDB, 1960; Polaroid black-and-white 87 film packaging.

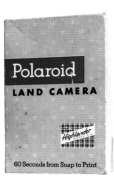

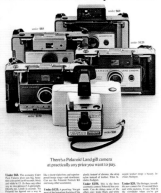

Polaroid Branding

In the early 1950s, when Polaroid was fast becoming a juggernaut, one thing seemed to have been forgotten: the corporate image, which up until that point had largely been Land. It was his face that was featured on the front pages of newspapers, and his name that graced the cameras and the advertorial copy.

In 1954 Polaroid's marketing team, led by Stan Calderwood (later Polaroid's vice president), decided to break from the past, appointing forward-thinking DDB to work on their advertising. Polaroid needed to start thinking like a company that wanted to sell products, not just ideas. DDB's approach was to place the products front and centre, selling on aesthetics and innovation, and topping them off with clever one-liners.

It was also during this period that a young designer named Paul Giambarba entered Polaroid's echelons. Giambarba would become a seminal graphic designer through his work with the company. From 1957–77 he was Polaroid's in-house art director, ultimately responsible for every piece of graphic communication that left the building. It was no small task.

Giambarba became indispensable in revolutionizing Polaroid's public face. His first task was typographic, and he adopted a new sans serif font called News Gothic, which he set in uppercase (Polaroid had often been misspelled as 'Poloroid' due to an indistinguishable lowercase 'o' and 'a').

Polaroid was also struggling for attention on shop shelves, jostling with Kodak's eye-catching yellow packaging. Giambarba created a new modern look with black end panels, where the type was set in white, with brightly coloured accents to differentiate between products. It was a bold departure, and for the first time Polaroid's in-store presence was defined by its superior graphic design as well as the elegance of its technology. The rebranding was a success and, by 1957, Polaroid's gross sales were more than $48,000,000, a significant increase from the previous year's $34,000,000.

The Polaroid rainbow, another much-copied Giambarba invention (think of Apple's and Instagram's original logos), did not emerge until 1968, but swiftly became the company's signature. The black-and-white packaging was also given a facelift at this time, resulting in a seven-tone gradient of greys and blacks.

Over time, Polaroid's own rainbow shrank and became less prominent, but even today, those colours still define the 'new' Polaroid company and remain a key part of their brand.

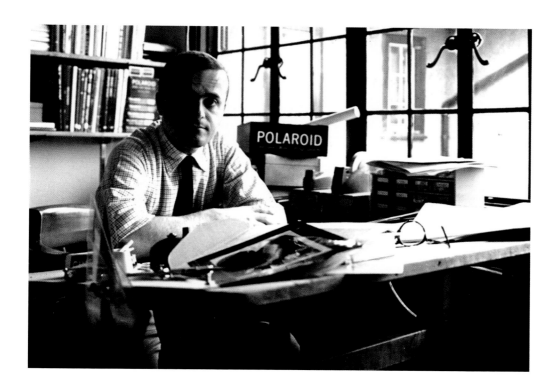

Above: Giambarba at work in his Everett Street studio, 1960.
Right: Polaroid's first colour film, the 108 Colorpack. **Far right:** The tessellated and colourful packaging of the Squareshooter camera, 1971. **Below right:** pack film Model 210.

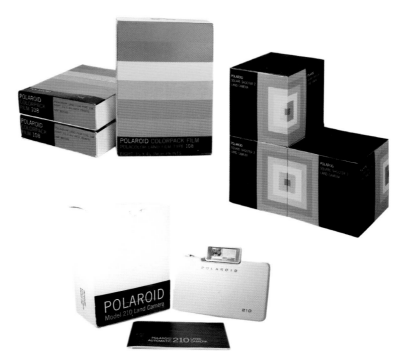

'Polaroid Instant Film and Impossible Instant Film are the world's most chemically complex man-made thing…. When a picture is developing and you have the simple joy of watching it develop, there are literally hundreds of chemical reactions happening.

 Analogue instant photography really is an entire science and an entire artform in itself.'

— *Stephen Herchen, The Impossible Project*

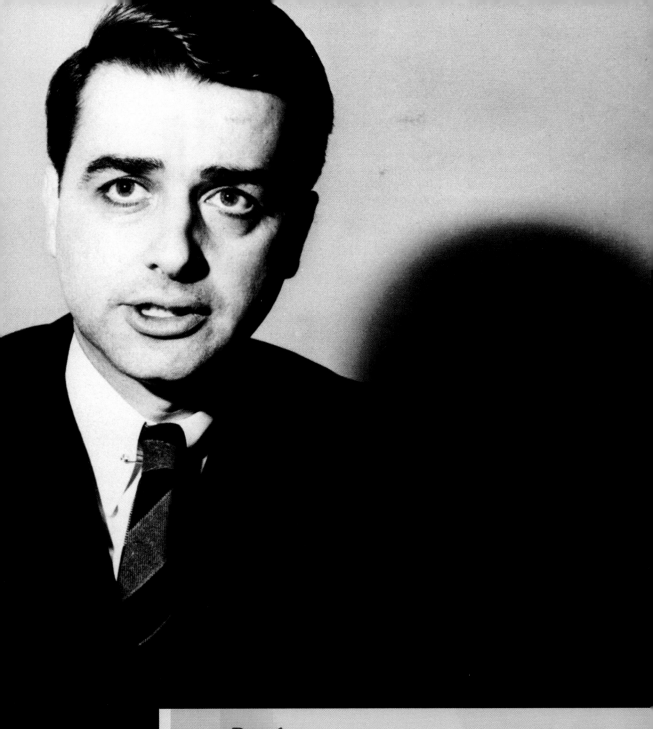

Part 1
Camera and Film Format Guide

Film Primer
Peel-apart Film

Peel-apart film involves peeling a positive away from a negative after development to reveal the finished print. The peel-apart family consists of roll films, pack films and sheet films. The only peel-apart film currently in production is the 5"×4" sheet variety, a black-and-white positive/negative film made by film manufacturer New 55.

Roll Films
The first Polaroid films came in roll format (see pages 24–25) and were available first in sepia, then in black and white. Roll films have two intersecting spools – one of negative material and one of positive – and a chemical-filled Polaroid pod. On most models, these spools sit on either side of the camera and meet at the centre, where the picture is developed and removed via a hatch. Roll films work in the same way as all peel-apart films, through a combination of silver halide and dye diffusion.

Sheet Films
Sheet films first appeared in 1958, came in two large-format varieties and were aimed at the professional photographer. The smallest of the two measures 5"×4" and is held and processed in a dedicated light-tight film envelope. Each sheet contains a positive and negative layer and a chemical pod. Before exposure, the photographer slides a film envelope into a sheet-film holder, then inserts this into the camera. The end of the film envelope

The subtractive process as used in almost all Polaroid colour films. Secondary colours are mixed to form the colour primaries of red, blue and green. When all three mix equally, black is formed.

(containing the positive) is then partially pulled back out, while the negative sheet is held in place behind the lens, ready for exposure.

After the shot has been taken, the positive has to be pushed back into the holder by hand. The rollers must then be tightened using a switch, and the whole film assembly withdrawn from the holder in one swift movement, crushing the chemical pod on its way out.

The second of the professional formats is 1973's 8"×10" film, which works largely in the same way as 5"×4", although rather than being held together in a sleeve, the negative, positive and pod are separate. The negative is loaded into a film holder, exposed, then mated with the positive sheet/pod in a secondary external processor.

Original Polaroid 8"×10" films used paper positives, and were peeled apart, but Impossible have produced an integral version: where a plastic sheet forms the 'positive' and both layers are permanently sealed together.

Pack Films
In 1963 Polaroid launched the first pack film format, Type 100. Pack films came in numerous guises: the 'original' Type 100 series (sometimes known as type 660), Type 80 and Type 550.

Pack films comprise ten shots (early versions had eight). When loaded, the film has a long dark slide that wraps around a concertina arrangement of negatives and positives. These are threaded by a sequence of tabs and conjoined with a waxed paper. When the pack is slotted into the camera and the dark slide removed, the first negative sits facing towards the lens, ready for exposure.

All the negatives sit atop one another, separated from the positives by a flat metal spring. The negatives and positives have an opaque backing to prevent light leaks. The two layers are brought together, and the pod assembly is burst after a set of tabs are pulled in sequence.

Processing takes place within the film assembly as the pod's viscous chemical reagent is spread evenly between the film layers. This chemical also serves the purpose of sticking the layers together, making a temporary 'darkroom' in which the film can develop.

When the first narrow white tab is pulled from the camera, inside the negative moves from the front of the pack to the back. When the second tab is pulled, the two parts of the picture become perfectly

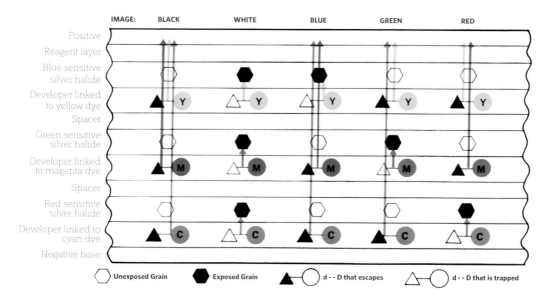

aligned, and the leading edge (containing the pod) meets the rollers and is squashed, allowing the chemicals to spread, after which the film ejects.

Colour Film: The Subtractive Process

Every Polaroid colour-print film employs the subtractive process. Colours develop from dyes, which diffuse through the layers of the film during development.

Peel-apart negatives are made up of nine layers: an opaque-backed negative base, three light-sensitive silver halide layers paired with three complementary dye layers, and two spacer layers. The positive comprises four layers: a resin-coated paper layer, an acid layer (to neutralize alkali in the developer), a spacer (preventing the acid from coming into contact with the image) and a mordant (dye-fixing) layer that forms the positive image. Howard Rogers's (Polaroid's director of research) 'magic' molecule (represented by the triangles in the diagram above) ties the dyes to developers via an atomic 'leash'.

Each of the silver halide layers is paired to a single colour of dye that is able to block, or 'subtract'. The appearance of each dye in the finished print is carefully controlled by this stacked system, since the exposure level of the silver halide determines the amount of the dye transfer.

When a picture is taken, the silver halide layers are exposed as light passes through them. As the light meets its matching sensitized silver halide, a reaction is triggered: the silver halide exposes more, or less, depending on the intensity of the reflected light. The moist alkali of the reagent spreads through the layers of the negative in seconds. When it reaches a 'magic' developer and dye molecule, it sets the molecule in motion, allowing it to diffuse through all of the films layers.

The carrier alkalis keep moving up and reach the acid coating on the positive sheet, when the process is neutralized and the image is fixed. A self-washing system was developed that flushed out leftover alkali in the image layer via the production of salt and water through the spacer and acid layers of the positive. This removed the need for post-process coating, a triumph for Land.

Polaroid Relics

The Roll Film Format

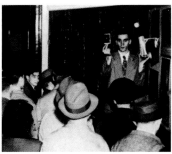

On 21 February 1947, Edwin Land revealed the first instant photographic system to an enthralled public at a meeting of the Optical Society of America. Land and his team had modified an 8"×10" view camera to accommodate a supersize version of Polaroid's top-secret instant roll film (see pages 22–23), which was still being developed. Land took a self-portrait for the demonstration. It was a spectacle to behold: Land, holding up a life-size rendition of himself, which had been shot just a minute earlier, developed and processed in situ, all without the need for external chemistry.

In November 1948 a first run of fifty-six Model 95 roll film cameras and their compatible sepia film (Type 40) made their way to Jordan Marsh (now Macy's), a big department store in Boston. The cameras used the new instant roll film and were heavy, weighing almost 2 kilos, and cost $89.75. This didn't deter the customers: every camera and pack of film in stock, including the demonstration model, sold out on the first day of sales.

In 1950 Type 41, an unstable black-and-white film stock, replaced the first sepia roll films. The film was problematic and suffered from discolouration and fading. As a solution Polaroid began selling the film with a film coater to effectively fix the print after development. The coater was slightly gelatinous and left the Polaroid prints wet. To dry these and stop dust from settling on the surface, people would shake their prints, an action that has since been synonymous with the Polaroid, much to the detriment of the millions of modern-day integral film shots (see pages 42–43) that are damaged by so doing.

A total of eighteen different roll films were sold between 1948 and 1992 across three series: Type 40, Type 30 and Type 20. Twenty-one cameras were also produced across the range, the biggest seller being

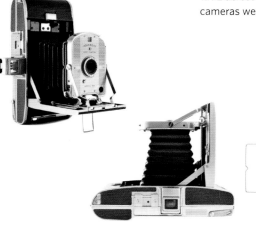

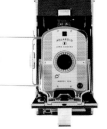

From top left: Land's Polaroid 'selfie' from 1947; the launch of Polaroid cameras at the Jordan Marsh store in 1948; the 95a, a variant of the 95.

the Swinger, which made its debut in 1965 and was aimed at the youth market. It was such a huge success that Polaroid would cash in on the name for years to come. Roll films are now more than twenty-five years out of date.

If you are determined to use a vintage roll film camera, Polaroid's own film is not your only option. With a little ingenuity, roll film cameras can be resurrected to accept a full range of films, including Fuji Instax (see pages 78–81), peel-apart film (see pages 22–23), Impossible Project stock (see pages 82–90), sheet-film (see pages 22–23), 120 film and beyond. A good place to start is Option8's website, Instant Options (see Stockists, pages 234–35).

The models 110a and 110b have extremely high-quality lenses in general, the best being those made by Rodenstock, and are considered to be the most superior roll film cameras for conversion. The 110b has a slight edge, due to its single-window rangefinder (through which, unlike the 110a: you can both focus and frame). The 95a (an upgrade on the original 95) also provides good value for money and offers various conversion possibilities.

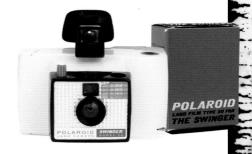

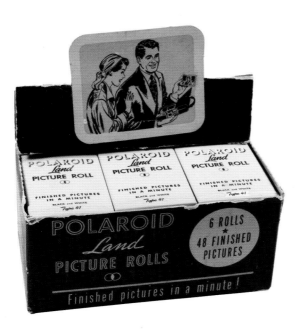

From top: The Swinger instruction booklet; the Swinger and Type 20 film; roll film to pack film conversion by Option8. **Left:** Polaroid roll film.

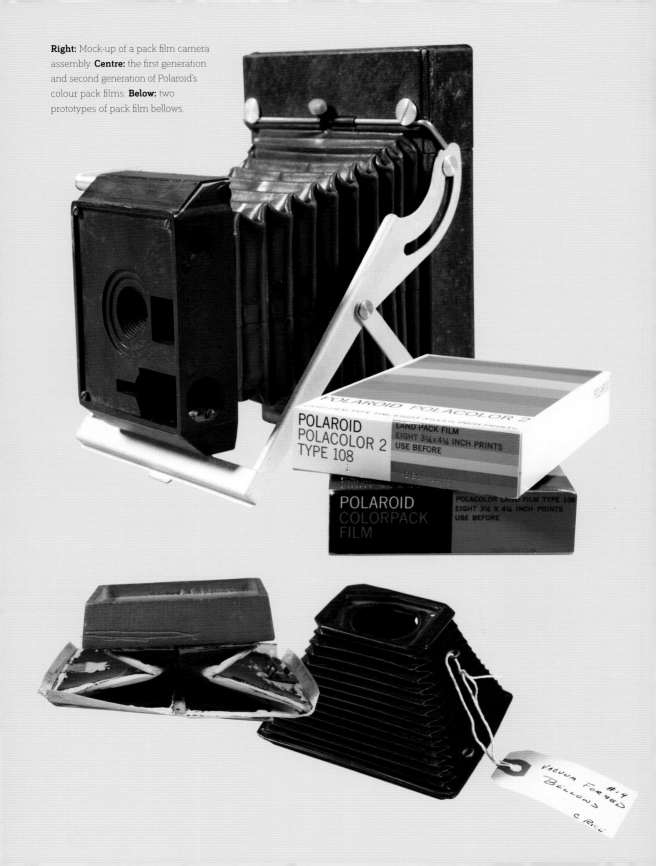

Right: Mock-up of a pack film camera assembly. **Centre:** the first generation and second generation of Polaroid's colour pack films. **Below:** two prototypes of pack film bellows.

Peel-apart Film Cameras

In 1963, and after nearly twenty-five years of research, Polaroid introduced their first colour film to the market, Polacolor. Development had been complicated, with more than 5,000 different dye compounds having been tested before arriving at the final formula.

Polacolor also brought about the launch of an entirely new product line: a new 'pack' film cartridge and camera series as well as colour roll and sheet films (see pages 22–23). The new 100 system, as the folding pack film cameras and films became known, was the first in which a consumer-grade instant image could develop outside of the camera. This meant that a photographer could shoot consecutive images in quick succession and never miss a moment again. The first pack film camera, the Automatic 100, was lighter than Polaroid's roll film predecessors, had folding bellows (so the camera could be folded up when not in use), 'electric eye' aperture (for auto exposure), aperture priority (whereby the user can set the aperture) and required batteries. The first type of pack film cameras that followed (of which there were more than thirty variants) all adopted a similar design and are known as 'old-style' models. All cameras within this range accept 100 film and are known as 100 series irrespective of their model numbers (e.g. the 250, a superior 'old-style' model, is from the '100 series').

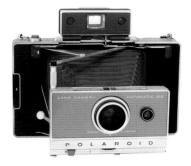

Different pack film formats became available too (Type 80 and '550' series pack film), in both black and white and colour. Available film speeds varied widely, making pack film Polaroid's most adaptable photographic system. The only film still compatible with these cameras – Fuji's FP-100C – ceased production in 2016, though it is still attainable online.

Rigid-bodied Cameras

Rigid-bodied, or 'box-type', pack film cameras are fixed-lens, auto exposure and relatively cheap. While most look similar, only a few accept the smaller-format Type 80 film, which has the same emulsions as the 100 series, but which is far more expensive due to its recent discontinuation (the last batches made expired in 2006).

Type 80 cameras also usually have poor-quality (plastic) lenses and produce images with distorted edges. You can convert Type 80s to accept 100-size films, including Fuji FP-100C, but results will never be full frame. Type 100 cameras within this range have a larger loading area than Type 80s, though they usually only accept one of the two film speeds produced by Polaroid – 75 and 3000 – rarely ever both.

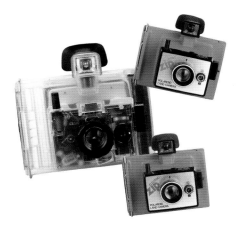

One of the most iconic models within the rigid-bodied range is the Big Shot. Andy Warhol was particularly fond of this model, and many of his celebrity paintings were made using Big Shot photos for reference.

Though lightweight, this model is extremely long. It has a fixed focal lens of 220mm and was designed for taking portraits (at a fixed aperture

From top: Badge in protest of the ID-2 camera, with its 'boost' button for illuminating darker skin that was adapted by the South African government for passbook photography; the Automatic 100; Electric Zip cameras, which accept Type 80 only.

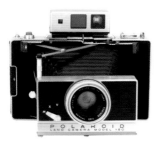

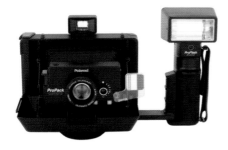

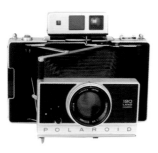

of f.29). The camera has a large flash diffuser, to make more flattering portraits, and uses large, disposable MagiCube flashes. It uses spreader bars rather than rollers to burst the film's chemical pod, but can be upgraded to accept rollers. The Big Shot's shutter timing was calibrated to 75 ASA film only, so 100 ISO speed pack film like Fuji FP-100C is compatible. One of the best things about this camera is that it does not require batteries.

Folding Bellows Cameras

The pack film camera favoured by most photographers is the folding type produced by Polaroid from 1969 to 1977. These all, irrespective of their individual model numbers, accept 100 series films.

The numerous variations all look very similar. The more expensive models usually include a glass lens, metal body and a Zeiss viewfinder (see picture 1, opposite). They also have folding viewfinders that slot inside the camera at the front (in contrast to the lower-end models, where the viewfinder is positioned outside the casing, even when closed).

In the late 1970s, Polaroid released the 'new style' folding pack film range, which included the Reporter and EE100 and, in the 1990s, the ProPack. These all accept AA batteries. The ProPack has the advantage of being compatible with the ProPack flash accessory, but like all cameras in this group, it has a plastic lens and is much bulkier than the earlier models.

There are also three professional manual models that were made in the period 1965–76: the 180, the 190 and the 195. These cameras are the *crème de la crème* when it comes to Polaroid's folding pack film range and are best-suited to the experienced photographer more accustomed to using manual settings. All feature large 114mm lenses, flash sync (where the flash fires at the same time as the shutter opening) and self-timer options. The 180 also features a helpful EV (Exposure Valuation) dial (for exposure compensation) and, with its single-window Zeiss finder, has an advantage over the 190 and 195. The 190 and 195 both open up to an aperture of f.3.8, while the 180 opens to f.4.5. The 195 and 190 also have print development timers on their back panel but, as with the mid-range models, these aren't very useful, particularly when using Fuji film (whose development is self-terminating) and other Polaroid expired film (whose development times will vary due to age).

From top left: The Big Shot; the ProPack; the 180 and 190

Accessories

Close-up and portrait kits for professional folding models are expensive and rare. The items pictured here are workarounds that you can use instead. For a more exhaustive list of pack film accessories and compatibility, see the table on pages 30–31.

1.

2.

3.

4.

5.

1. Zeiss finders allow you to focus and frame through one window. You can modify your camera to accept these, but only if it has a folding finder.

2. If you prefer single-window shooting at wide apertures use a 195, buy a broken 250, 350, 360 or 450 and swap the finder. If you have a 195 compatible close-up/portrait kit **(5)**, or portrait kit **(4)**, this modification will make them almost redundant. If you own a 195 compatible close-up/portrait kit, you can substitute the viewfinder 'goggles' from a more common and cheaper lens kit. Add-on lenses are non-interchangeable between professional models and their automatic counterparts but the goggles are cross-compatible within the viewfinder group and magnification is the same. Close-up kits enable focusing at 9in. and portrait kits, 19in. The goggles contained within kits made for the automatic Zeiss finder models (250, 350, 360 and 450) are differentiated from non-Zeiss finders by an 'a' in their name (close-up kit numbers 583a/473 and portrait kit 581a/471 were made for Zeiss finders only). You can make your own hybrid lens kits for any of the professional-level cameras by using the appropriate 'goggles' from any close-up or portrait kit designed for one of the automatic bellows cameras (check the table on pages 30–31 to find a match for your camera).

3. 45–46mm step ring. Professional models share the same 45mm thread, for which there are fewer compatible lenses made by other manufacturers. To overcome this you can use an inexpensive 45mm 'male to female' step ring, which you can screw into the front of your lens to make a standard 46mm thread. This will allow you to fit almost any filter or close-up lens you wish.

4. Goggles 1 from 473 close-up kit.

5. 1951 close-up kit designed for a 195.

Accessories and Compatibility Guide

Camera	Glass Lens	Metal Body	Tripod Socket	Scene Selector	Print timer	Finder type	Battery*
100	×	×	×	×		2 window folding	531 (4.5V)
101	×	×	×			2 window folding	531 (4.5V)
102	×	×	×			2 window folding	531 (4.5V)
103	×					2 window folding	532 (3V)
104						1 window rigid	532 (3V)
125						1 window rigid	532 (3V)
135	×					2 window folding	532 (3V)
210						1 window rigid	532 (3V)
215						1 window rigid	532 (3V)
220				×		2 window rigid	532 (3V)
225				×		2 window rigid	531 (4.5V)
230	×			×		2 window folding	531 (4.5V)
240	×	×	×	×		2 window folding	531 (4.5V)
250	×	×	×	×		Zeiss	531 (4.5V)
315						1 window rigid	532 (3V)
320						2 window rigid	532 (3V)
330	×				×	2 window rigid	532 (3V)
335	×				×	2 window rigid	532 (×2, 3V each)
340	×			×	×	2 window folding	531 (4.5V)
350	×	×	×	×	×	Zeiss	532 (×2, 3V each)
355	×	×	×	×	×	2 window folding	532 (3V)
360	×	×	×	×	×	Zeiss	532 (×2, 3V each)
420						2 window rigid	532 (3V)
430					×	2 window rigid	532 (3V)
440	×			×	×	2 window folding	532 (3V)
450	×	×	×	×	×	Zeiss	532 (×2, 3V each)
455	×	×	×	×	×	2 window folding	532
Countdown M60					×	1 window rigid	532 (3V)
Countdown M80	×				×	2 window rigid	532 (×2, 3V each)
Countdown 70					×	2 window rigid	532 (3V)
Countdown 90	×				×	2 window folding	532 (×2, 3V each)
The Reporter			×			1 window rigid	AA
EE100/EE100 Special			×			1 window rigid	AA
Pro Pack			×		×	1 window rigid	AA
180	×	×	×	Fully manual		Zeiss	N/A
190	×	×	×	Fully manual	×	Zeiss	N/A
195	×	×	×	Fully manual	×	2 window folding	N/A

*Where it is stated that two batteries are needed, one is for the print timer, which is not necessary for camera function.

Battery Modification	Flash	Close-up	Portrait Kit	Cable Release	Filters	Self-timer	Cloud Filter
3 × AAA	268	583/543	581/541	191	585 (UV)	192	516
3 × AAA	268	583/543	581/541	191	585 (UV)	192	516
3 × AAA	268	583/543	581/541	191	585 (UV)	192	516
2 × AAA or lithium 3V	268	583/543	581/541	191	585 (UV)	192	516
2 × AAA or lithium 3V	268	N/A	N/A	191		192	
2 × AAA or lithium 3V	268	N/A	N/A	191		192	
2 × AAA or lithium 3V	268	583/543	581/541	191	585 (UV)	192	516
2 × AAA or lithium 3V	268	N/A	N/A	191		192	
2 × AAA or lithium 3V	268	N/A	N/A	191		192	
3 × AAA	268	N/A	N/A	191		192	
3 × AAA	268	N/A	N/A	191		192	
3 × AAA	268	583/543	581/541	191	585 (UV)	192	516
3 × AAA	268	583/543	581/541	191	585 (UV)	192	516
3 × AAA	268	573/563/583A	471/561/581A	191	585 (UV)	192	516
2 × AAA or lithium 3V	268	N/A	N/A	191		192	
2 × AAA or lithium 3V	268	N/A	N/A	191		192	
2 × AAA or lithium 3V	268	N/A	N/A	191	585 (UV)	192	516
2 × lithium	268	N/A	N/A	191	585 (UV)	192	516
3 × AAA	268	583/543	581 / 541	191	585 (UV)	192	516
2 × lithium	268	573/563/583A	471/561/581A	191	585 (UV)	192	516
2 × AAA or lithium 3V	268	583/543	581 / 541	191	585 (UV)	192	516
2 × lithium	365	573/563/583A	471/561/581A	191	585 (UV)	192	516
2 × AAA or lithium 3V	490	N/A	N/A	191		192	
2 × AAA or lithium 3V	490	N/A	N/A	191		192	516
2 × AAA or lithium 3V	490	583/543	581/541	191	585 (UV)	192	516
2 × lithium	490	573/563/583A	471/561/581A	191	585 (UV)	192	516
2 × AAA or lithium 3V	490	583/543	581/541	191	585 (UV)	192	516
2 × AAA or lithium 3V		N/A	N/A	191		192	
2 × lithium		N/A	N/A	191	585 (UV)	192	516
2 × AAA or lithium 3V	490	N/A	N/A	191		192	
2 × lithium	490	583/543	581/541	191	585 (UV)	192	516
N/A	4025	N/A	N/A	Standard fit			
N/A	4025	N/A	N/A	Standard fit			
N/A	ProFlash	N/A	N/A	Standard fit			
No battery	280	593	591	191	595 kit	Built-in	inc. in 595
No battery	280	593	591	191	595 kit	Built-in	inc. in 595
No battery	280	1953	1952	191	595 kit	Built-in	inc. in 595

If you swap your finder to a Zeiss finder, you need a Zeiss viewfinder cover for close-up/portrait kits.

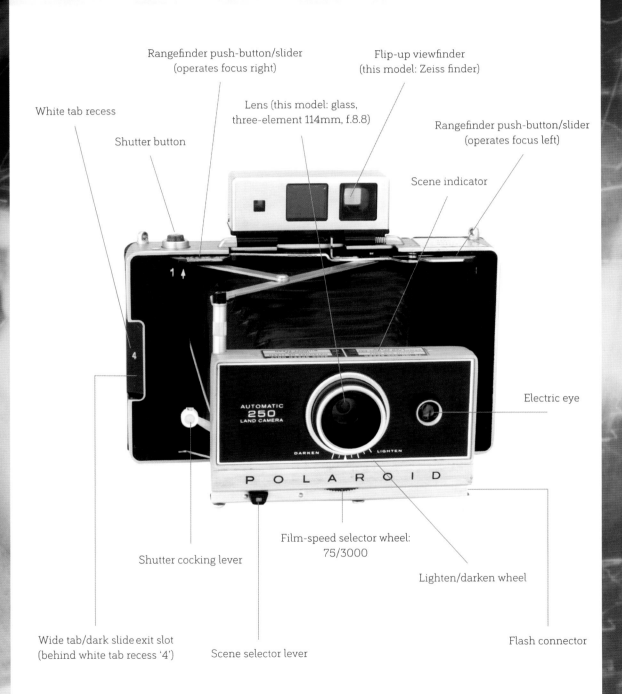

Rangefinder push-button/slider
(operates focus right)

Flip-up viewfinder
(this model: Zeiss finder)

Lens (this model: glass,
three-element 114mm, f.8.8)

Rangefinder push-button/slider
(operates focus left)

White tab recess

Shutter button

Scene indicator

Electric eye

AUTOMATIC
250
LAND CAMERA

DARKEN LIGHTEN

P O L A R O I D

Shutter cocking lever

Film-speed selector wheel:
75/3000

Lighten/darken wheel

Wide tab/dark slide exit slot
(behind white tab recess '4')

Scene selector lever

Flash connector

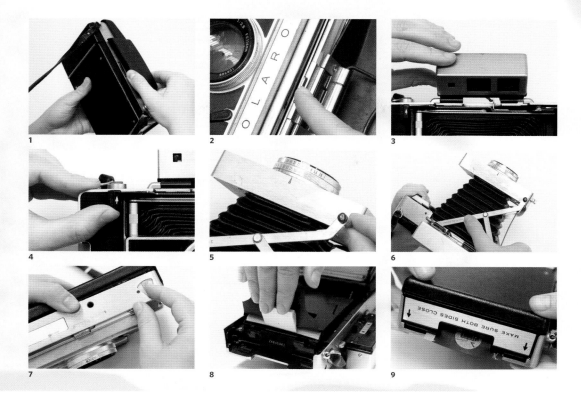

User Guide

Folding Peel-apart Cameras

Opening/Closing

Most folding cameras open and close and load/eject film in the same way. On rigid-finder models, the plastic front casing hooks under the fixed plastic finder and, with a combination of downward pressure and outward movement, it will unhook.

On folding viewfinder models, the outer casing is attached by a magnet. To release, lift the back edge of the casing at the top of the camera until it swings open **(1)**. You can also remove the fascia entirely by pressing down on the latch **(2)**. If you have a folding viewfinder, flip it up **(3)**.

Extend the bellows. Find the plastic lever on the front of the camera with an upward-pointing arrow and numbered #1 at top **(4)**. Push this up gently with one hand as you extend the bellows with the other. Pull the lens panel forward using the upright metal bar at top right of the lens housing **(5)** until it locks into position. To close the camera, follow this process in reverse. Retract the bellows

by first pushing down on the locking bar **(6)**. Next, push the lens housing back until it locks into the body. Remember to flip your viewfinder back down, and lift the front cover up and over the top until the magnet holds it securely in place. On non-folding versions, depress the top of the cover slightly to hook it under the finder.

Loading Film

Turn the camera upside down and push the small recessed lever **(7)** to release the film compartment door. Insert the film pack into the camera – the dark slide should face the bellows and white tabs should be on the right, exiting the camera – until it locks into position. The white paper tabs positioned at right should be in a concertina arrangement **(8)** rather than crumpled.

Close the back and locate the black tab (dark slide), which should be sticking out of the camera's recessed slot **(9)**. If you can't see it, open the camera and guide it into place. Now close the camera.

Pull the black tab out in one motion, being careful not to let it rip. Once it pulls free, a white tab will appear. Do not pull this yet.

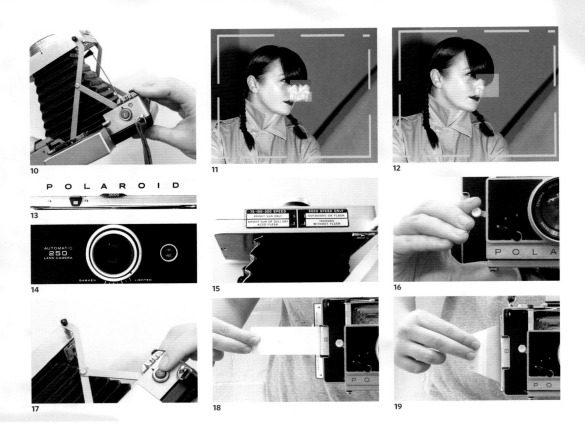

10 11 12

13

14 15 16

17 18 19

Viewing/Focusing

This step focuses on the Zeiss finder (see page 29) though the focus mechanism is nearly the same for all folding pack film cameras. (For non-Zeiss finders, you will need to frame in one window and adjust focus in the other.) Place your index fingers on the #1 buttons either side of the camera and slide the bellows in and out to adjust focus **(10)**. Look into the rangefinder, and you will see a yellow outline indicating the crop area. Adjust focus until the split images **(11)** become one **(12)**. The minimum distance at which this viewfinder can focus is around 91cm (3 ft). If you wish to shoot a subject in closer range, use a portrait or close-up kit attachment (see pages 30–31).

Exposure Settings

If there is one, ensure that the film speed wheel **(13)** is set correctly. Compensate if necessary by using the lighten/darken ring **(14)**. Set the scene selector **(15)** if present. If you are using a professional camera, set the camera to 'M' mode and adjust the aperture and shutter speed rings (or EV numbering) as desired.

Shooting

'Old-style' and professional models require you to cock the shutter before shooting. To do this push the white lever to the right of the lens **(16)** all the way down, then let go. Now press the red shutter button to take your shot **(17)**.

Developing the Print

Pull the single white tab **(18)** extending from the camera's tab slot out in one go. The film will now unfurl inside the camera and a black-and-white tab will push out through the film exit **(19)**. Pull on this until the film sheet exits the camera completely.

While the image is developing hold it carefully at the edges. If chemical leaks on to your hands remove immediately with a wet wipe.

Use the film pack instructions as a rough guide only: development times vary greatly with expired film. Note that expired Polaroid films become very blue if peeled too late and that Fuji is self-terminating. If you peel too early, your print may be pale, if you leave it for too long it will turn dark blue.

Pack film is folded and glued together. If you pull the tabs out in the wrong order or with too

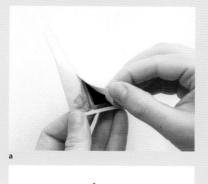
a

b

d

c

Tip

You can peel your image apart in two ways. In the first **(a)**, you find the edge of the print and peel away from the negative. This leaves a clean white border around the image **(b)**.

The second method is known as 'backwards peel' **(c)**. Separate the two layers of waxed paper at the tab end, tearing them where they join and peeling apart. This results in a chemically saturated paper border **(d)**, adding to the overall 'Polaroid' look.

much force the feed of the film will not be aligned correctly and your shots will be ruined. Never pull at an angle. If you do the film will misalign on exit and developer chemical will spread on the rollers, making the pull tabs inside the camera wet. This will result in tearing and stop the film from feeding through.

Always pull the exposed film carefully from the camera, so that it tears where it should. If your print emerges with white spots on it you have pulled it out too fast, if it is banded, too slowly.

Camera Maintenance

Check your camera regularly to avoid image errors. You can also follow the tips in this section to assess second-hand equipment before buying.

First examine the condition of the camera lens. Can you see fungus or does it have smears/ scratches? If necessary, clean with a soft, lint-free lens cloth, taking care not to scratch the coating.

Does the camera close flush? If it has suffered a knock, the back door can become loose and cause light leaks. This is often best remedied with electrical tape.

Most importantly, check/clean your rollers regularly. Rusty, pitted or dirty rollers are a disaster for final prints. Luckily they can be replaced (all folding pack film cameras accept the same size).

Check the bellows frequently. Over time the inner lining can come away from the exterior, causing sagging and resulting in black shadows on the edges of your images. Check that the bellows fold together neatly from the inside. If they appear irregular and crumpled, they have separated.

Aged bellows can also develop pinholes. These are easily spotted by shining a torch inside the camera (in darkness) and checking the exterior for any light escaping out. Pinholes can usually be fixed with liquid black electrical tape. If necessary, you can replace the bellows. To do this unscrew the shutter cable and remove the screws (or shear off the rivets) that hold the bellows to the lens block. At the film end, bend up the metal tabs (using needle-nose pliers if necessary) that hold the bellows in place until they come loose. Follow this process in reverse to attach your replacement bellows, and recreate the light seal around the metal tabs with liquid electrical tape.

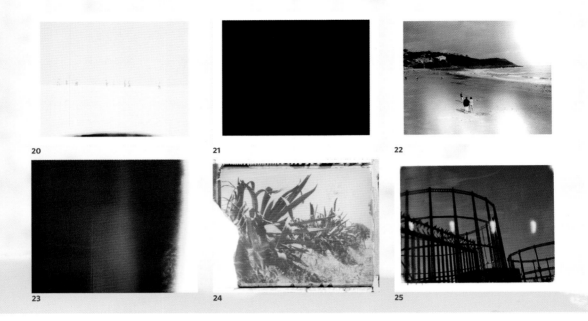

20

21

22

23

24

25

Troubleshooting

Overexposure

Are your pictures blown out, pale and have little
detail or contrast **(20)**? This can be the result of
too wide an aperture or too long an exposure, or
both. Check that the lighten/darken dial has been
set to lighten and that the scene selector and film
speed settings are correct. With auto exposure
cameras, the position of the subject may also
be a factor: the camera might be metering a
background darker than your subject. If this is
the case, move in closer.

Underexposure

If using a professional model, check the aperture
and shutter speed settings to rectify underexposed
images **(21)**. If using an auto exposure model,
check that the lighten/darken dial is not set to
darken. If it is in the middle, but your shots are still
underexposed, move towards lighten. If you are using
colour film check the camera is not on the '3000'
or 'black and white' setting. If using an auto exposure
model, your battery may be low on charge, stopping
the exposure meter from functioning correctly.

Fogging and Light Leaks

If your image is hazy or light and patchy in areas, this
is most likely the result of light leaks **(22, 23)**. Leaks
can occur when loading film in bright conditions,
through incorrect film handling or when the camera
back is slightly loose. If you are using fast film that
has been exposed to an X-ray machine you may also
see these effects. Try a new film pack. If the problem
persists, check the bellows and repair if necessary.

Image Incomplete

If your image hasn't spread to all corners of the
print **(24)** or appears to be misaligned, it's possible
that you pulled it from the camera at an angle,
preventing the chemicals from spreading evenly.
If the image seems straight, but shows brownish
marks around the missing areas, it may be that the
film has long expired and the chemical pods have
started to dry out. If spots **(25)** are appearing on
your film (these can be white or yellow) it is likely
that the camera's rollers are dirty.

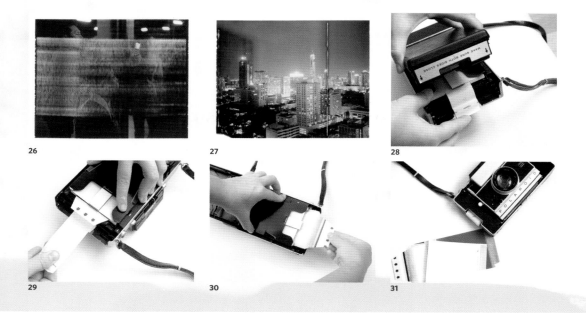

26

27

28

29

30

31

Camera Jams

You will almost certainly experience film jams while shooting Polaroid. This can be incredibly frustrating, especially bearing in mind the cost of instant film.

Regular Jams

If you experience frequent camera jams and tab shapes imprinted on your images **(26, 27)**, it may be because you are using Fuji film in a print-timer equipped camera. The timer can press against the back of the film pack, squashing it slightly and making it difficult to pull the shot out of the camera and causing the tabs to rip. A temporary fix is to remove the back plate off the Fuji film pack and replace with a metal Polaroid plate.

If you shoot Fuji film regularly, you may want a more permanent solution. With some ingenuity, you can remove the timer completely. Removing the flat metal spring inside the film compartment can also help to create space. You can do this by bending it back and forth until it snaps off.

Infrequent Jams

If you have the tab issue described above, you may have pulled on it too hard, causing it to rip. If the tab is still protruding from the camera you can use pliers to pull it out. If this doesn't work, unlatch the camera's rear door and open very slightly: with less pressure on the pack, the tabs should pull out easily.

If they don't the only option is to fully open the camera and remove the troublesome shot. Do this in subdued light to avoid the risk of light leaks. Unlatch the back of the camera and hold the pack down with your finger **(28)**. While still holding the film pack, pull the uppermost film and negative sheet from the camera by holding on to the narrow white tab **(29)**. Next, pull the wide tab in the direction of the arrows **(30)** until the film sheet comes free from the pack and discard. Close the camera back up **(31)** and check that the next slim white tab is protruding as it should.

Buying Advice

Consult the Accessories and Compatibility guide on pages 30–31 and the Instant Film Compatibility Guide on pages 224–29 for full information.

Rigid-bodied Models

Most box-type 100 cameras share the same features, though some have better focusing capabilities than others and include a coated glass lens. If you are in search of one of these, try the Colorpack III. This accepts both 75 and 3000 ASA films and has a focusing aid viewfinder. Glass-lensed versions are relatively common.

Other models include the Super Shooter **(1)**, Super Shooter Plus and Colorpack V (or CP5), all of which have plastic lenses, rollers and accept 75 and 3000 100-sized film. For high-quality portraits, opt for the Big Shot **(2)**.

Avoid Type 80 cameras. These only accept Type 80 film, making them the least flexible option within this group.

Folding Bellows Models

The best all-rounder is the 250 **(3)**. This model features a folding Zeiss viewfinder (see page 29), glass lens, robust metal body, tripod socket and scene selector (to help you accurately match the scene you want to shoot). The original 100, 350, 360 and 450 are also all good options. Avoid models with a print timer, as these are often inaccurate and can compress the film inside the camera, causing jams. Also steer clear of models that are plastic-bodied and plastic-lensed, particularly those with single-window fixed finders, as these are not compatible with close-up or portrait kits (see page 29).

Automatic pack film cameras require batteries that can be difficult to source. Consult the table on pages 30–31 to find the battery compatible with your camera (for suppliers see pages 234–35). You can also convert automatic cameras to accept batteries that are currently being manufactured (see the battery modification column on page 31).

For manual photography choose a professional folding camera. The 195 **(4)** lens has one extra aperture setting, but includes a two-window viewfinder (slowing down shooting) and annoying print timer. The 180 has a single-window Zeiss finder and useful EV exposure system, but is missing the extra aperture stop. The 190 is the best of the three, having both the extra f3.8 aperture stop and the Zeiss finder, though can be difficult to find. The 195 and 190 have the slightly annoying and defunct print development timer. NPC also manufactured the NPC195, which has superior focusing to the original 195, but is not compatible with many of its accessories.

In addition to the professional folding models there is a group of metal-bodied cameras, referred to as 600s. There are two Polaroid models within this range, the 600 and the 600SE **(5)**. Both are rangefinders. The 600 model has a swappable film back, but the 600SE has the edge, with its swappable back and interchangeable lenses (75mm, 127mm, 150mm) and viewfinder add-on for accurate framing once swapped, making it the most flexible pack film compatible camera on the market.

There is also the Konica Instant Press **(6)**, which takes images comparable to the 600SE and has flexible apertures but is incompatible with Polaroid accessories.

Collector's Notes

Keep an eye out for the very rare 185. Only between 50 and 200 of these were made and given to Land's closest associates. These have an in-built exposure meter and command extremely high prices.

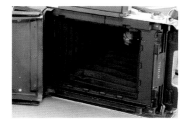

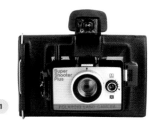

1

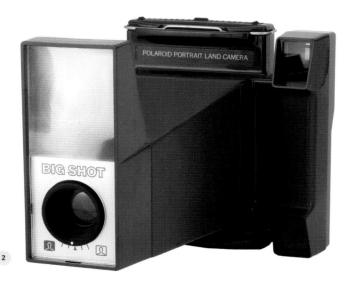

2

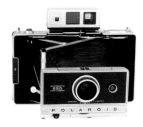

3

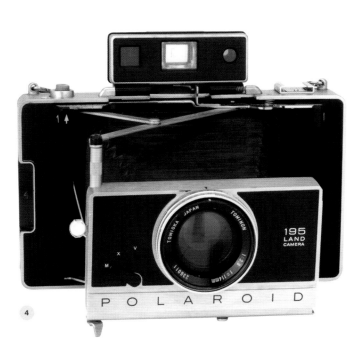

4

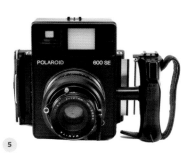

5

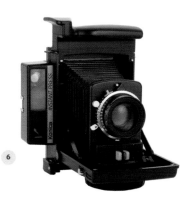

6

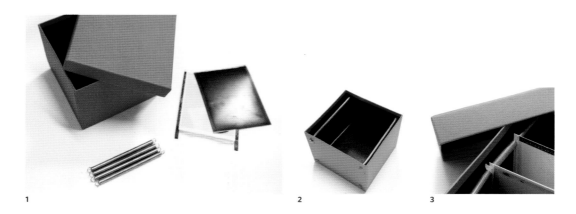

1 2 3

Print Drying

Once peeled apart after processing, the positive prints from any peel-apart format take a long time to dry (this is especially true of colour film). The prints are prone to sticking to one other, leading to emulsion rips or dust settling onto the surface.

To avoid this make a booklet of greaseproof paper cut to size, interspersing the prints between the leaves. The leaves can cause faint marks on the dry prints, but these marks will not be visible when scanning (see pages 90–91) or emulsion lifting (see pages 146–49).

To keep your negatives safe before clearing (see pages 182–85), remove the paper surrounds, along with most of the chemical residue, and place in a ziploc bag with a few millilitres of water to keep them moist and scratch free.

For more long-term storage you can keep your Polaroid prints in acid-free archival boxes with some silica gel pouches. Lay the pictures flat and use acid-free archival paper in-between.

You could also make your own drying and storage box. All you need to do is find a box large enough to house the film when standing on its edges and some springs to fit **(1)** that are slightly shorter than the length of the box.

Cut four holes at either end of the box. These should be positioned so that, once you insert the springs **(2)**, they overlap with the border of the print only **(3)**, leaving the image area untouched. Insert the springs into the holes and 'knot' the end of each one by bending it over itself a few times. You can now slide your prints in-between the spring's coils to dry.

If you don't fancy the DIY approach, then there are a number pre-made alternatives, including the 3D printed box from Step5 or Holgamods (see Stockists, pages 234–35).

Polaroid Relics

20"×24" Cameras

The largest commercially available instant film is the 20"×24" format. The monolithic compatible camera has been used by a diverse range of artists, including Andy Warhol, Chuck Close, Mary Ellen Mark, Ellen Carey, Robert Rauchenberg and William Wegman.

The first 20"×24" was created by Polaroid engineers in order to take a portrait of Howie Rogers, Polaroid's director of research. It was assembled from parts found lying around the lab and made use of the supersize raw film material as it came off the production line on rolls (as a negative 60in. wide and a positive 44in. wide).

In 1976 Edwin Land, ever the showman, decided to replicate the system in preparation for a shareholders' meeting. The intention was to photograph a subject live from the stage, a challenge taken on by none other than Andy Warhol. The camera proved an immediate hit.

Five more models were designed and made by Polaroid from 1977–78. One of these belonged to John Reuter's studio in New York, while another has resided with portrait photographer Elsa Dorfman (left), who retired, age seventy-eight, in 2016.

Since Polaroid's demise, film production has been handled by Reuter and his small team in a workshop outside Boston. Reuter purchased leftover chemical from Polaroid's factory when it closed, mixing and filling the pods with it only when needed. However, with the chemicals becoming increasingly unstable and demand for the format diminishing, in 2016, Reuter announced plans to wind down operations.

Over the years, various companies have made their own versions of the model. One such camera lives in Supersense, the Vienna-based store run by Florian Kaps (co-founder of the Impossible Project, see pages 16–17). There, you can even transfer your digital picture to the 20"×24" format via the 'Superlab: a process whereby a 20"×24" camera is coupled with an iPad to become a giant Instant Lab (see page 72).

Me and my camera. May 28. 2003

Elsa Dorfman, self-portrait with her
20"×24", 2003.

Film Primer
Integral Film

In 1972, after many years of development and around $600 million of investment, Polaroid released its first 'integral' film format: SX-70. The development of integral film was said to have been partially spurred on by Claudia Alta 'Lady Bird' Johnson (America's first lady from 1963–69), who as part of her 'Beautification' campaign to clean up the nation's cities, asked Land to produce a system that did not create as much waste.

The film itself processes in a single 'sheet' in complete daylight, stopping automatically when full development has been achieved. All Impossible (see pages 82–90), Fuji Instax (see pages 78–81), SX-70, Spectra (see pages 66–71), 600 (see pages 58–63) and vintage film formats, including 500 (see page 76) and i-Zone (see page 77), work in this way.

Integral film results in the 'classic' Polaroid, with its wide-bordered bottom and square/rectangular central image. The wide border contains a concealed chemical pod. Many integral films also include a battery that powers the camera.

The chemical process of integral film development is widely thought to be one of science's most complex man-made chemical reactions, with hundreds of reactions taking place in perfectly choreographed sequence. Though chemically similar to colour peel-apart film (see pages 22–23) and using a similar tethered dye-developer molecule, SX-70 was also the first format to make use of Land's ingenious system of chemical opacifiers (light blockers), which, when activated by the chemical reagent contained within the chemical pod, created a shield between the light-sensitive emulsions and the clear outer layer.

The 'opacification layer' is achieved by very high pH value alkali dye indicators. These are dyes that change colour as they detect alkali and acid. The indicators migrate through the film layers, eventually hitting a thin acid layer, which, in turn, reduces their pH level and renders them colourless. As the solid coloured alkalis are neutralized, the latent image that has been developing underneath 'appears'.

If you peel apart an integral shot, you will also notice white chemical between the layers. This is the titanium dioxide layer that forms the 'background' to the picture. The diffused dye image layer is transparent and the picture's backing black: without this white pigment it would be impossible to discern the picture without peeling the image apart and holding it up to the light. This layering creates luminosity and depth in the instant picture.

Stability is achieved through neutralizing reactions that produce water, much as in peel-apart film. The moisture, if left, becomes extremely destructive. To prevent this, on the reverse of instant films, you will find air vents that allow the moisture to evaporate.

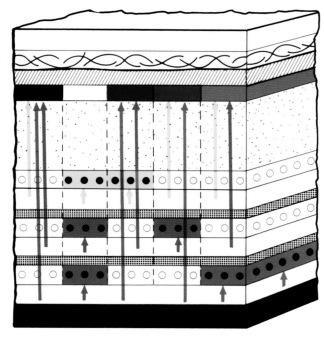

Clear plastic layer

Acid polymer layer

Timing layer

Positive image in image-receiving layer, visible from above

White pigment component of reagent

Negative imagine in blue-sensitive layer

Metallized yellow dye developer layer

Spacer

Negative image in green-sensitive layer

Metallized magenta dye developer layer

Spacer

Negative image in red-sensitive layer

Metallized cyan dye developer layer

Negative base

● **Developed silver**

Above: Diagram showing the different layers of integral film. **Right:** Integral film ejecting from an SX-70.

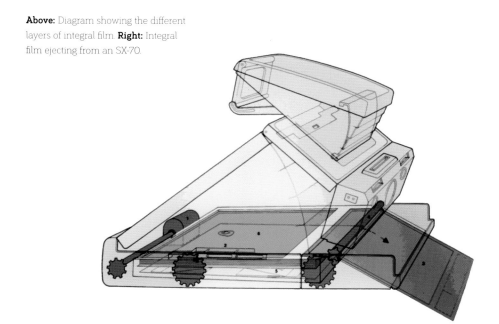

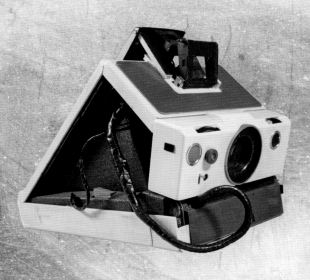

It's here.
Polaroid's new SX-70.
The most advanced photographic system in the world.

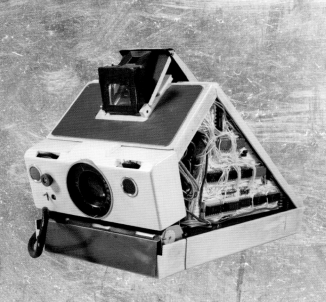

SX-70 Series Cameras

Folding SX-70s

Unlike Polaroid's previous camera models, the first SX-70 cameras were truly portable, and small enough to fit into a large jacket pocket when folded flat. All folding SX-70s (excluding the Model 3) were SLR cameras (single-lens reflex), making them the first folding SLRs ever marketed.

As with automatic pack film cameras, SX-70s use an 'electric eye' for auto exposure. They accept SX-70, Time Zero and some Impossible film. Folding SX-70s are compact, elegant and functional. They allow for manual focus and have good-quality glass lenses with great depth of field (from f.8 to f.90). They make use of a flash bar system, which means they are compatible with detachable reusable flashes, like those made by MiNT. Close-up focusing is in-built, with sharp focus achievable from just 10½in. (26.5cm). 1:1 close-ups and telephoto can be achieved with add-on accessories.

One of the best cameras within the folding range is 1977's Alpha 1. At first glance early SX-70s and the Alpha 1 are almost indistinguishable, however, there are several key differences. The Alpha 1 has a built-in tripod socket, a guaranteed split-focus viewfinder, neck strap lugs (making it easier to carry) and fill flash capability (meaning the flash can be fired at any time, not just in low light conditions).

Alpha 1s are the most desirable SX-70 model, though all folding versions (excluding the Model 3) are good choices (any missing features can be supplemented with add-on accessories). Always seek out an authentic leather-covered version (such as the tan and chrome), as many are covered in a vinyl material called Porvair, which disintegrates over time and causes unwanted dust in your camera, as well as a mouldy exterior. The white- or black-bodied versions often have this type of cover. You can also buy laser cut 'skins' to recover your SX-70 (see stockists, page 234). You can purchase a refurbished version from the Impossible Project with a three-year extendable warranty.

Variations

In 1978, Polaroid introduced an autofocus SX-70. Based on the Alpha 1 body it uses a sonar pulse to focus, making it longer and more fragile. Although you can switch the autofocus on and off, certain accessories (including the 1:1 close-up kit) will not fit. The autofocus feature allows live preview through the viewfinder when the shutter button is depressed halfway.

MiNT has also recently released three variations of the classic Alpha 1. The first, the SLR 670-S, looks just like an SX-70, however, it is also compatible with 600 film, allowing for a 6x faster shutter, which is great for taking pictures indoors. All existing SX-70 accessories are compatible.

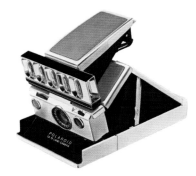

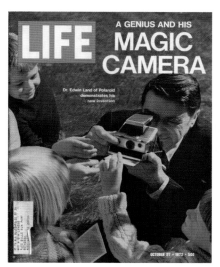

Opposite: SX-70 prototypes. **From top:** The tan leather SX-70 camera, with disposable 10 flash unit; Edwin Land launching the SX-70, as shown in *Time Life*, October 1972; the SX-70 atop a section of its electronic layout.

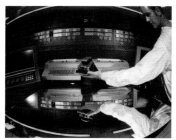

Top and above: Still from Charles and Ray Eames's promotional SX-70 film; the Polaroid SX-70, 1972. This image illustrates the level of technology compressed into the electronics of the model.

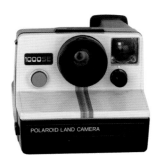

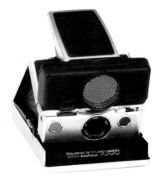

The second, the SLR 670-M, is equipped with MiNT's 'Time Machine' unit, allowing you to switch between auto exposure and manually control the shutter speed. It is the only SX-70 camera to do this, enabling programmable shutter speeds from 1/2000s to 1 second, with a bulb mode for long exposures. Though intended solely for SX-70 film, this model has manual controls that allow you to compensate for exposure with 600-speed film.

In mid-2016, MiNT released the SX-70-S, a hybrid of the SX-70-M and SX-70-A. This is also fitted with a time machine, but auto exposure can be used with both SX-70 and 600 film. This is the most flexible folding SX-70 camera in existence. On both time-machine equipped models there is a handy feature that enables the shutter button to be locked.

Box-type SX-70s

It is easy to confuse an SX-70 camera with a 600 camera (see pages 58–63). You can check which film your camera will accept by opening the film compartment and checking for a sticker identifying the compatible film. Although both films will fit inside, the film speed (ISO) is matched to the camera's internal electronic light metering system and all automatic shutter speeds are calibrated accordingly.

Starting with the Pronto! in 1976, Polaroid began releasing cheaper, mass-produced, more accessible box-type integral cameras in quick succession in order to drive film sales. The Pronto! model soon morphed into the Model 1000 OneStep and was in 1977 the biggest-selling camera (of any type). Most cameras in this category are incredibly commonplace. These are great starter integral cameras, offering more flexibility than the later 600 models, and can be found cheaply on auction sites.

The sonar models all make good purchases. You will recognize these by a metallic circular grille on the front of the camera. Like the folding models, box-type SX-70s have a slot at the top where disposable flash bars can be inserted. Some cameras also have dedicated electronic detachable flash units. If you are buying one without a flash, you can also use external units such as those made by MiNT. Look out for the Pronto Sonar OneStep, TimeZero OneStep or TimeZero Pronto AF (all of which include tripod socket, cable release socket, autofocus and manual focus).

Left: Polaroid model 1000SE; SX-70 Sonar autofocus.

Accessories

Folding SX-70 Cameras

The accessories pictured here are suitable for almost all folding SX-70 cameras (many fit the Sonar Autofocus and MiNT cameras). Some can also be used with the folding 600 cameras (SLR680 and 690).

Compatible with folding integral cameras (including the 600-speed SLR 680/690)

1. #111: tripod mount (not required for the Alpha range or 600 folding cameras).

2. #112: remote shutter button.

3. #119 and #119A: telephoto lens.

4. #2350: polatronic (not compatible with SLR 680/690, as these have built-in flash).

5. #132: mechanical self-timer.

Compatible with compact folding integral cameras (excluding Sonar folding models, SLR 680/690 and SX-70s using MiNT's time machine unit):

6. Mint Bar 2: lightweight rechargeable flash bar with two power settings: low and high. Compatible with all SX-70 cameras (excluding SLR 680/690), including Sonar and box-types.

7. #113: accessory holder that enables the use of the close-up lens, and allows you to insert filters. The holder slots into the flash bar socket, and won't fit the Sonar or SLR680/690 models.

8. #121: close-up kit. Allows for life-size close-ups and copying. Requires #113. Includes a flash diffuser.

9. #137: microscope adaptor.

10. Ikelite's underwater housing for nonsonar folding SX-70 models. While a fun accessory, it is rather difficult to focus the camera and submerge it fully in the water without the housing floating to the surface.

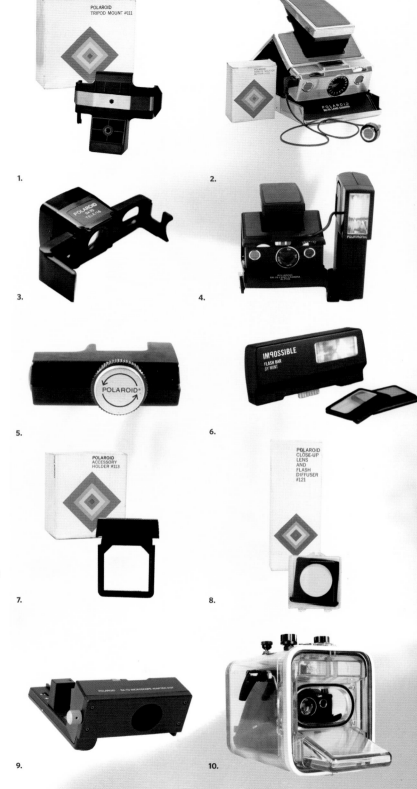

1.

2.

3.

4.

5.

6.

7.

8.

9.

10.

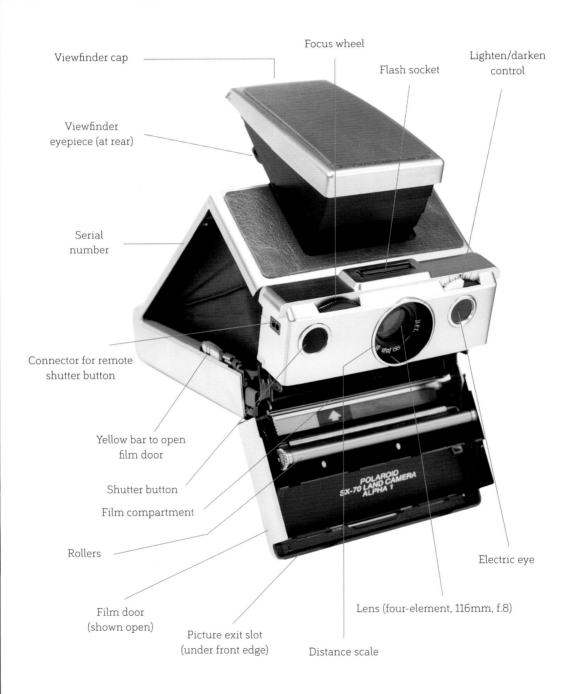

Viewfinder cap

Focus wheel

Lighten/darken
control

Flash socket

Viewfinder
eyepiece (at rear)

Serial
number

Connector for remote
shutter button

Yellow bar to open
film door

Shutter button

Film compartment

Rollers

Electric eye

Film door
(shown open)

Lens (four-element, 116mm, f.8)

Picture exit slot
(under front edge)

Distance scale

POLAROID
SX-70 LAND CAMERA
ALPHA 1

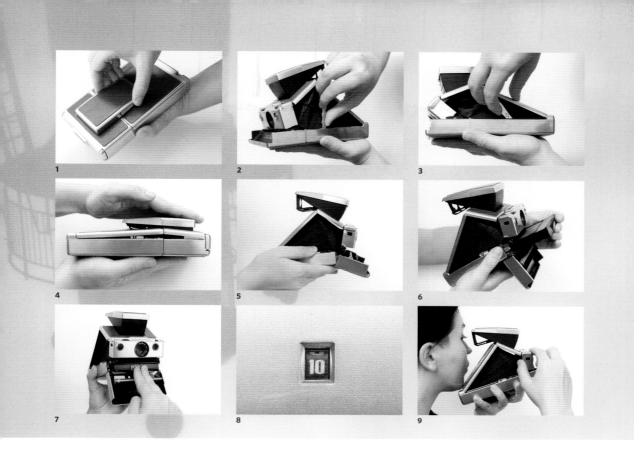

User Guide

Folding SX-70 Models

Opening/Closing

To open, grip the ribbed area of the viewfinder cap firmly **(1)** and pull straight up. Push the locking bar towards the front of the camera to hold it open **(2)**. To close, release the locking bar by pushing in the direction of the arrow **(3)** until it goes slack. Push the viewfinder cap downward until both sides of the camera latch **(4)**.

Loading Film

Once the camera is open, push the small yellow button (on the right-hand side of the camera next to the bellows) **(5)** down to release the film door. Open your film pack and insert it thin end first, with the dark slide facing up **(6)**. Push all the way in until the thin plastic strip along the front of the pack snaps **(7)**. Never squeeze the film pack: this can cause the pods to burst and ruin images.

Close the film door. The dark slide will now eject and the film counter will show the number 10 **(8)**. (Impossible film packs contain eight shots, so subtract two from the film counter in order to accurately count the number of shots in your camera.) To unload the empty film cartridge, pull on the film pack's coloured plastic tab.

Viewing/Focusing

Angle the camera slightly upwards, and hold the viewfinder about 3cm (1¼in.) away from your eye **(9)**. If you can't see all four corners of the composition area, reposition. If you can still only see a portion of the image after doing this, see Troubleshooting (see pages 52–53). (Note that, unlike the Alpha 1 shown here, not all cameras have a split focus.)

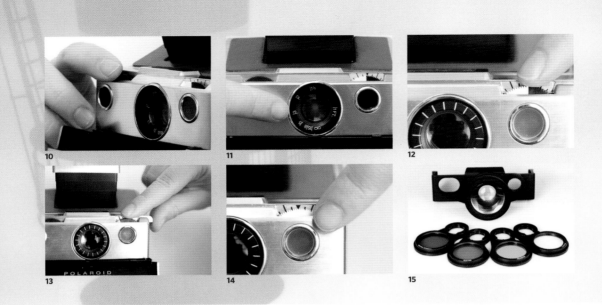

10 11 12

13 14 15

To focus, simply turn the focus wheel **(10)** until the image becomes clear and sharp in the viewfinder. The split focus is most useful in low light. In bright conditions set the distance scale on your camera to 4.5m (15ft) **(11)**: everything from 2.4m (8ft) onwards will be in focus.

Exposure Settings

SX-70 cameras are auto exposure but you can assert some control via the lighten/darken wheel **(12)**. If your picture comes out too light, turn the wheel towards black to make it darker **(13)** and vice versa. If shooting Impossible film turn the wheel one-third of the way towards darken to get the best colours. The wheel will reset every time you close the camera, and you will have to readjust the exposure setting manually each time this happens.

The SX-70 has an 'electric eye' **(14)** that corrects the shutter speed in relation to the light conditions. Exposure can be inaccurate if you are, for example, shooting a subject against a bright background in sunny conditions. The camera will meter exposure for the dominant area of your composition – the background – and underexpose your subject. You can counteract this by moving in closer until the subject becomes more prominent within the frame.

SX-70 cameras are intended only for use with SX-70 film so you will need to use a neutral density filter (a piece of ND-4 two-stop lighting gel if you are shooting with the faster 600 films (640 ISO). Simply cover the lens with the filter or tape it to the

top of your film pack. You can also buy pre-made lens versions from MiNT **(15)** or pre-cut film pack filters from Impossible. You could also source online a 28mm threaded ND-4 filter (two stops) and attach this to the front of the SX-70 lens.

Folding SX-70s were designed to be used with disposable flash bars and a flash diffuser **(16)**, though a range of electronic flash accessories are available, including one made by MiNT. Flash can be used in daylight since the electric eye reads light from both flash and natural light in combination. For best results, your subject should be positioned between 1.2m (4ft) and 3.5m (12ft) in front of the camera. If you are using the MiNT flash bar **(17)** in ND compensation mode, you can use 600 film without an ND filter. Remember to keep the L/D wheel in the central position and focus accurately: the flash's output correlates with the focus distance.

Shooting

The SX-70 has a maximum aperture of f.8, so bear this in mind when shooting. Impossible's 'Color Film' (for SX-70) is rated at ISO 160, so is slightly faster than Polaroid's film, but in low light even a 160 ISO and f.8 aperture can result in a longer exposure and higher risk of camera shake.

When you press the shutter button on your SX-70, there will be a slight time-lapse between the click of the shutter and the whir of the rollers: this is the point at which the shutter is open. Don't move until you can hear the rollers starting up (and warn

16

17

18

19

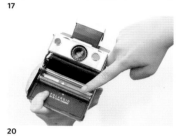

20

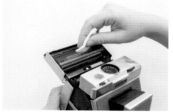

21

your subject of this delay). The same goes for when shooting images with flash, which fires a split second after the initial shutter click.

Don't press on/block the film's exit slot as the image ejects from the camera. If you do, the film may crumple or jams might occur.

If shooting in low light, use a tripod (any standard tripod will work with the Alpha 1). Tripod attachments are available for cameras without a tripod socket. SX-70 cameras are capable of exposing for up to 14 seconds automatically, which is great for capturing light trails from passing cars, or sunsets. You can use a remote shutter cable (see page 47) to reduce camera shake **(18)**.

Press the remote shutter button gently and hold for at least a second before releasing. The camera will now continue to expose until adequate exposure has been made. For long exposures, see pages 104–7, or use a MiNT camera with time machine. Another trick is to cover the electric eye while pressing the shutter **(19)**, as this will enable exposures up to the camera's maximum limit.

Once the picture emerges, hold it by its white border only. If you put pressure on or shake the image while developing, the chemicals will not spread evenly.

Camera Maintenance

Taking good care of your camera is the secret to successful images. SX-70 cameras seem to suffer the most when left unattended for years on end. Keep them in a dust-free environment and in a moderate climate.

Cleaning Rollers

Always check your rollers before you load and unload film. To reveal the rollers fully for cleaning, open the film door and depress the light-shield door **(20)**. Rotate the rollers and remove any dust or dried developer with a slightly damp lint-free cloth **(21)**. Let them dry before shooting. It's best to do any cleaning while there is an empty film pack still in the camera so that unwanted dust and detritus does not enter inside and obscure the mirror.

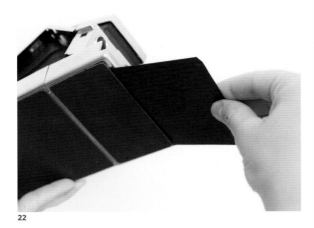

22

Troubleshooting

Incorrect Exposure

If you are using a flash, do not obstruct it while shooting. Also take care not to block the electric eye. If shooting Impossible film, don't forget that it requires shielding as it exits the camera and is slightly faster than original SX-70, and turn the lighten/darken wheel a little towards darken. If your pictures emerge with the top half fogged or are completely white, you may have pressed on the bellows during shooting. Again, check the lighten/darken wheel is set correctly.

Image Distortion

Sometimes the film exit slot can be obstructed by developer chemical that has leaked out from the film and dried. Push a dark slide under the front edge of the exit slot until it opens and then pull it back and forth and side to side to loosen any dried developer **(22)**. Never force the slot open, since this could cause damage and permanent light leaks.

If it is windy, remove the picture promptly from the camera to ensure that there is no damage from vibrating **(23)**. If brown, undeveloped patches **(24)** appear on your film, the pod chemistry has dried out. If the exit slot was blocked you will see vertical bars or repeated smudges/spots **(25)** in your images.

Film Not Ejecting

Jams are unavoidable so it's best to be prepared. To diagnose mechanical issues on the go, carry an empty film pack with good charge and a spare dark slide. If your camera has started to behave irregularly

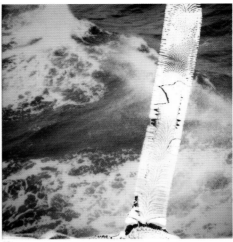

23

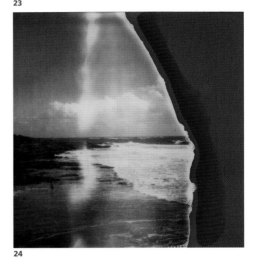

24

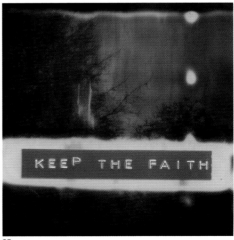

25

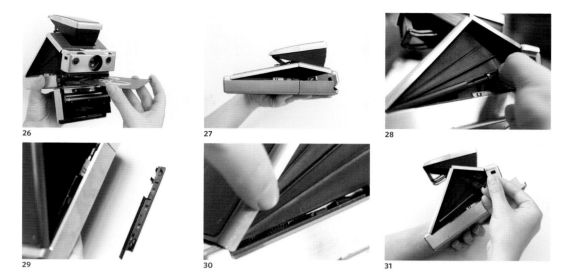

26

27

28

29

30

31

or sounds odd, open the film door slightly, push a dark slide into the pack to protect the film, then remove the pack to diagnose the issue **(26)**.

You could also carry out an empty film pack test by removing your film pack in a dark bag and inserting an empty one. Press the shutter and listen to the mechanics. You should hear the sound of the picking arm (a snap), the mirror slapping (a clunk), then the motor and gears (a whir). The dark slide should eject, after which you can fire a few shots to reset the camera. You may need to repeat this test a few times before your camera functions normally.

Issues such as this are often caused by a flat film-pack battery. To fix this, remove the unused film frames from the faulty film pack and swap them into a fully functioning one (see pages 64–65).

If the dark slide hasn't ejected at the end of the cycle or there is a continuous whirring sound the pick-arm – which is located at the back of the camera and pushes the film out – can straighten out over time and no longer reach the film sheet. Remove the film pack and push the pick arm down with a long thin implement, taking care not to damage the mirror.

Jams

If your picture jams while ejecting from the camera you may have blocked the film exit slot. In subdued light open the film door slightly and rotate the rollers backward to move the film through.

If your mirror is stuck the viewfinder will be obscured and your camera won't shut flat. (Never try to force it to closed if this is the case.) Stuck mirrors can sometimes be fixed by completing the film-pack test just described.

However, if your mirror is still blocking the viewfinder but the mechanics sound normal, there is another solution. On the right-hand side of the camera **(27)**, there is a long strip of black plastic faring that runs along its length **(28)**. This conceals the drive gears for film ejection, pick-arm and mirror operation. Gently remove it, starting at the front and working your way along **(29)**.

Underneath, you will find a series of cogs **(30)**. Roll the nearmost cog you can reach with your thumb in the direction of least resistance. If it won't move or gets progressively stiffer, roll it in the opposite direction. Stop winding when you hear the 'snap' of the pick arm. Now check the viewfinder to see if it has cleared. If it has and the camera now closes completely, you have fixed the problem.

Reattach the plastic faring **(31)**, aligning it with the film chamber release button. Insert the empty film pack and press the shutter a couple of times, each time checking you can see through the viewfinder.

Other Issues?

If the viewfinder is black for as long as you hold your finger on the shutter button, there is not enough power. Change the pack. If you are using a disposable vintage flash bar and the camera fails to take a picture, all five flashes on one side of the bar have been used up. You will need to flip the bar over.

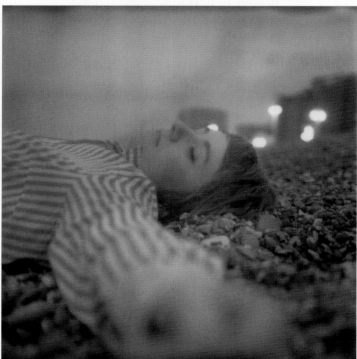

This page and opposite:
Photographs taken with a SX-70 using a variety of film types (including expired Polaroid SX-70 and Impossible's colour and black-and-white stock).

 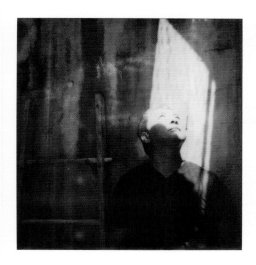

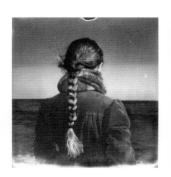 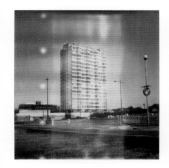 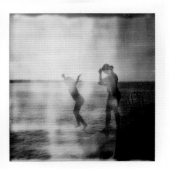

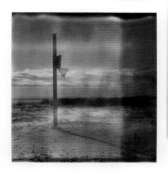 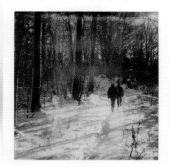

Buying Advice

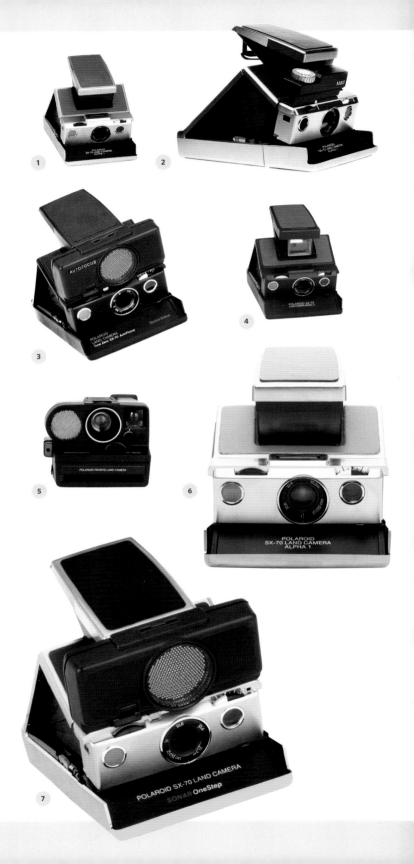

Folding Models

The best folding SX-70 cameras have a tripod socket, split-focus viewfinder and are leather-covered (avoid those finished with Porvair, a material that can disintegrate over time). These include the Alpha 1 **(1)**, which can be purchased from Impossible.

For a model with more manual control try MiNT's SLR 670-M **(2)** or SLR 670-S. Both of these are reconditioned Alpha 1s and include a detachable shutter speed override feature for long-exposures and varied film compatibility.

With their powerful focusing capabilities, Sonar autofocus models **(3)** are useful in low light conditions (though they are incompatible with some accessories, including the close-up kit).

Avoid cheaper models, such as the SX-70 Model 3 **(4)** (the only non-SLR model, it has a transparent foldable viewfinder and uses a measuring scale to focus).

Box-type Models

The best options are models that can be manually or automatically focused. This includes the Pronto Sonar OneStep, TimeZero OneStep **(5)** and TimeZero Pronto AF (all have a tripod socket, cable release socket, autofocus, manual focus and compatible electronic flash).

Collector's Notes

The gold-plated Alpha 1 camera is the most sought after and a highly expensive SX-70 model. Another rare model is the Mildred Scheel gold Alpha 1, named after the renowned physician and bearing her signature on the body **(6)**. These were produced in an edition of 1,000, and were released in February 1978 for public auction to raise money for Scheel's charity, the German Cancer Aid. There is also an extremely rare gold Sonar model **(7)**.

Polaroid Relics

Polavision

Launched in 1977, Polavision was intended as Land's great hallelujah post SX-70 (see pages 44–56). However, this 'movie film' system could not compare to Kodak's inexpensive Super 8mm, the existence of Betamax and the predicted rise of videotape.

The film quality was not brilliant and it was slow (around 40 ISO). The tapes lasted just two and half minutes, had no sound and could not be edited. Home-movie making was also a relatively specialist market by the mid-1970s and Polavision arrived a decade too late.

Polavision was a bulky setup (the viewer was the size of a portable television). Without the mains-powered viewer to hand, the film could not be processed.

Few would have taken a Polavision camera on holiday when they could just as easily shoot with Super 8 and return the cartridge for processing.

The nature of the system seemed somehow to contradict the merits of Polaroid's other inventions: being simple to use and portable. Without a Polavision viewer (and unless you were willing to dismantle the cartridges and rethread them onto 8mm reels) the films were unwatchable. The price was also eye-wateringly expensive: starting at around $675 it was enough to put off even Polaroid's most dedicated followers.

To Land's dismay, the cameras and viewer sold poorly and became a source of derision at Polaroid. For the first time his vision had been wholly wrong. The exact cost of Polavision's development and marketing is hard to fathom and reports vary, but estimates hover between $450–550 million. Sales amounted to fewer than 65,000 units. It was, by all accounts, an unprecedented flop. The system was discontinued in 1979 and the existing stock sold off in a job lot for losses in the region of $70 million.

Luckily, Polaroid's fortunes had changed in the intervening years and the SX-70 system had become the resounding success Land has always believed it would be, turning consistent profits. The sales of pack film also continued to be lucrative. Many had made millions in the meantime on undersold Polaroid stock. Polavision was not enough to throw Polaroid off course but the cracks had started to show and Land was no longer untouchable or always ahead of the game.

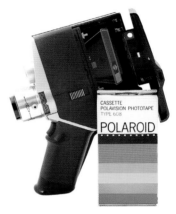

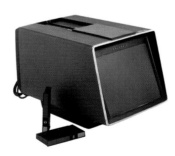

From top: Paul Giambarba's sketch for Polavision packaging; Polavision camera and Type 608 cassette; Polavision viewer.

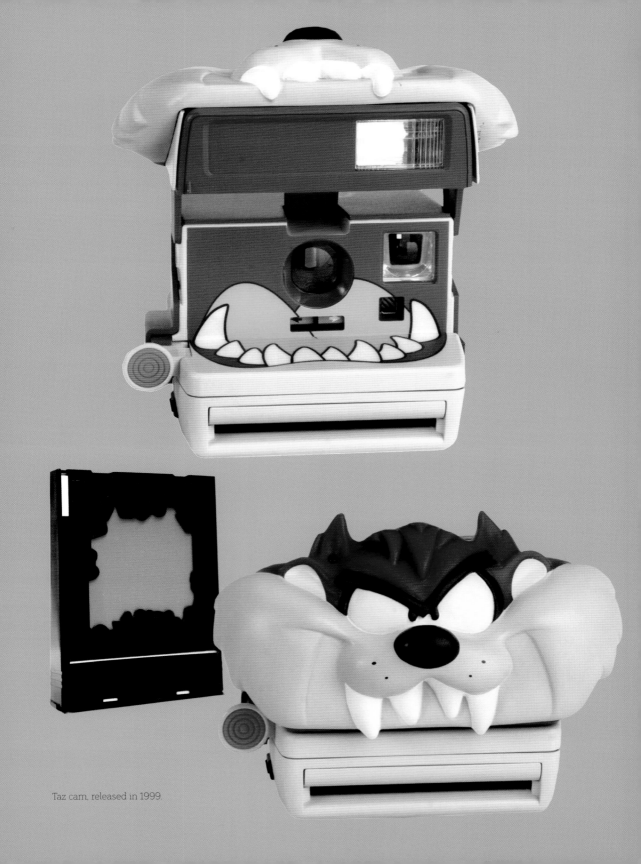

Taz cam, released in 1999.

Box-type (Plastic-bodied) 600s

In 1981, the first camera in the 600 series was launched, the OneStep 600. It was a repurposed, low-cost 'box-type' model for use with integral film. With its flip-open plastic box, single lighten/darken slider and shutter button, the OneStep was foolproof. It also featured a slot at the top for flash bars.

The OneStep design and feature list evolved little across models, of which there were around thirty 'official' variants. The camera essentially went through five stages of development: resulting in the OneStep 600 (right); the OneStep Flash; the OneStep with 'close-up' lens slider; the bubble-like generation IV and the One Classic (all pictured on page 61). There was also one anomalous body-type shift within the 600 group, the Impulse (see pages 62–63).

In the 1990s Polaroid made the model relevant to a younger audience. A new slogan, 'Live for the Moment', appeared and was attached to both the 'Expressions' line of 600 cameras (aimed at nine- to twelve-year-olds), which centred on the release of a pink-and-black CoolCam, or 'Spice' cam, endorsed and promoted by the girl group the Spice Girls at the height of their fame, and the 'Wave' line (targeted at teenagers), which was focused on the new i-Zone system (see page 77).

This era saw some of the most collectable Polaroid cameras being produced. These included 'special editions', like the Looney Tunes Taz cam (opposite) or the very rare Street Photo Night Cam, equipped with a remote shutter button and flash override with ten timer settings, allowing for exposures of up to 8 seconds.

Folding 600s

In 1982, Polaroid released a 'professional' 600 system, the SLR 680, followed by the SLR 690 in 1996. Both models are almost exactly the same, taking their lead from the folding SX-70 Sonar system (see pages 44–56), but also featuring an improved exposure meter and a built-in sonar-driven electronic flash that can be switched on and off. Unique to the folding model is a flash reflector that automatically tilts in relation to the focus distance. Like the SX-70 Sonar models, they can switch between autofocus and manual focus and have a tripod socket. With the flash switched off and the camera mounted on a tripod you can make automatic timed exposures of up to 13 seconds.

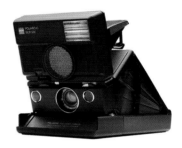

The SLR 690 and 680 also share an accurate, through-the-lens image preview (including depth of field), an autofocus system, a four-element coated glass lens and, as with the folding SX-70 range, they can focus on subjects up to roughly 25cm (10in.) away.

All cameras in the 600 series accept 600 film. This is a 640 ISO-speed general-purpose film, and shares the same properties as SX-70

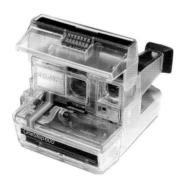

From top: The OneStep 600; the SLR 680; the OneStep 600 transparent model.

and Time Zero films, with the exception of the plastic 'nubs' on the underside of the film pack, preventing it from being mistakenly inserted into an SX-70 camera and resulting in vastly overexposed pictures. (When SX-70 film was discontinued in 2006, many SX-70 camera owners would slice the nubs off and use filters to compensate for the faster film speeds.)

More specialist films were also released, including the 600 Copy and Fax for photocopy and fax reproduction, where a halftone screen was incorporated into the film pack, and the unreliable 600 Black and White. There was also a 600 'Party' film, produced from 1996 onwards. This was a short-lived special edition, with some films in the range featuring a border that developed alongside the picture. Other films included a printed border promoting one product or another. Today, 600 film is available from the Impossible Project in black and white, colour and duochrome.

Folding 600 Camera Accessories

For a full accessories list, refer to 'Accessories: Folding SX-70 cameras' (see page 47). In addition to the items listed there, you could use a dedicated close-up lens (below right), though an easier-to-use option is the MiNT lens kit (see also page 47). Cases for these models are often difficult to find. You can make one yourself from a two-tiered zippered CD storage book by removing the internal CD folder. Your camera and a couple of film packs will fit comfortably inside.

User Guide/Troubleshooting

When it comes to opening/closing, loading film, exposure compensation and manual focus, folding 600s operate in exactly the same way as SX-70 folding models. Overall, these are an excellent general-purpose camera with the best image-taking capabilities of all of the native Polaroid 600 cameras. The box-type models are so simple to use that a guide has not been included here.

Left: Grant Hamilton's graphic images, made with later generations of 600 film. **Right:** The rare dedicated 680/690 close-up lens with flash diffuser.

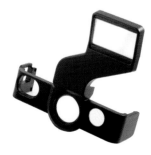

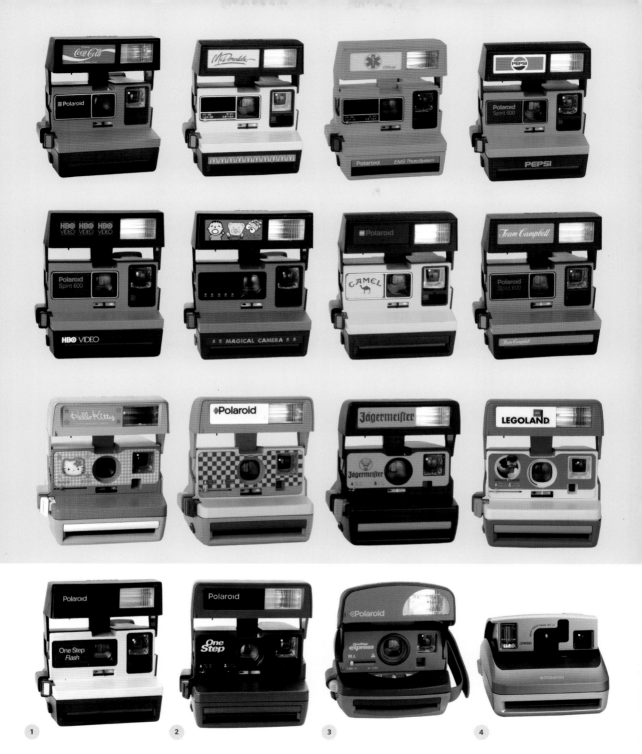

Top (rows 1–3): Just a few examples of collectable special edition and promotional 600 cameras.

Above (left to right): OneStep, generations II–V (see page 59, top, for generation I): 1. OneStep Flash; 2. generation III, with 'close-up' lens slider; 3. the bubble-like generation IV; 4. generation V, the One Classic.

Buying Advice

Box-type Models

Basic and cheap, box-type models are literally the definition of 'point and shoot'. These are great cameras to experiment with if you are new to Polaroid photography.

Check the features carefully before buying. Don't be fooled by the name of the camera, particularly when it comes to focus options: 'close-up' or 'portrait' often doesn't mean very much. Many low-end 600 cameras are fixed focus from 1.2m (3ft) to infinity, while others have a sliding close-up lens that allows 'portraits' or 'close-ups' for anything closer than 1.2m (3ft). Both of these systems are imprecise and often result in blurry pictures.

Models with 'pro' in the title usually have the most features and are a better option. These include the One600 Pro **(1)** and One600 JobPro **(2)**, which have a useful flash on/flash off function, self-timer, red-eye reduction, a status LCD, lighten/darken switch, a 12.9f maximum aperture and infrared autofocus as near as 45cm (18in.). The JobPro also has a tripod socket. The One600 Ultra is also a good buy, though it lacks a lighten/darken control and tripod socket. It's closest-focus is set at 60cm (24in.).

The next best options are sonar autofocus variants of the Impulse range. These churn out consistently sharp results and there is a compatible filter kit available. One that is sonar-enabled – which includes the 'AF' (Autofocus) editions – is a good place to start **(3)**.

The Sun 660 **(4)** also has a broad feature range, including the sonar autofocus system, allowing focus as close as 60cm (2ft). It has a 106mm front lens which, though fixed, has an internal rotating disk with four lenses. Apertures range from f.14.6 to f.45 and shutter speeds from 1/3 to 1/200 of a second. It also has a tripod socket, autofocus override button (underneath the flash), and a flash override button.

Avoid early versions of the 600 camera (with exception of the Sun 660), and early international models, including the Amigo 610/620, Quick 610 and Pronto 600, which have no built-in flash.

Also steer clear of models without a close-up lens, or the CoolCam, which offer little manual control.

If you are in any doubt as to the features of your prospective camera, refer to The Land List (see page 237 for details). Also ask the seller of the camera for as much information as possible.

Collector's Notes

Two collectable versions of the Sun 660 exist, a gold model **(5)**, released in 1987 to celebrate Polaroid's fiftieth anniversary, and a completely transparent variation **(6)**, used as a demonstration model.

Folding 600s

Both folding 600s – the SLR 680 (see page 59) and the SLR 690 – make great purchases but they come at a price and are highly sought after by Polaroid fans and resellers.

The SLR 680/690 does almost everything without the need for add-ons. The SLR 690 is the newest and most attractive to buyers (and commands a higher price).

If you are wishing to benefit from the advantages of the SLR 680/690 system without paying the hefty price tag you could purchase a folding Sonar SX-70.

The SX-70 Time Zero Model II **(7)** will give you the best of both worlds because it features a newer exposure meter than the other SX-70 Sonar cameras, the same one as in the SLR 680. Over time, some SX-70 cameras experience light-metering issues: this one fares the best.

To compensate for the difference in film speed between SX-70 and 600, all you need to do is attach an ND-4 filter (two stops) over your lens or use ND-4 lighting gel as an over-pack filter. You can also adapt the lens semi-permanently by removing the glass from a 28mm ND-4 filter and using hot glue to stick it into place.

To add a flash option, you can buy a reusable lightweight MiNT flashbar. In fact, you can even use the MiNT flashbar to shoot 600 film in an SX-70 without using an ND by using flash on all pictures and using the decrease power switch to compensate.

If cost is not an option, you could opt for one of MiNT's adapted, fully serviced, manual SX-70 cameras (see page 56). With this you can set your shutter speed manually and meter your light **(8)**.

There are a few extremely rare accessories for Generation I–V box-type 600 cameras. Most are not worth purchasing. Generation II cameras had, for example, the P6467 close-up attachment (allowing for focus 2–4in. away). As an alternative to these, you can buy an adapted Impulse camera, like the relatively common Dental Pro, with three close-up lenses and tiltable reflected flash **(9)**.

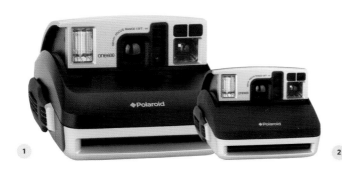

1

2

3

4

5

6

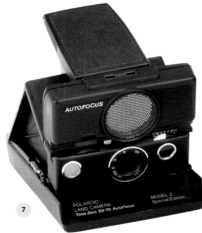

7

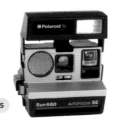

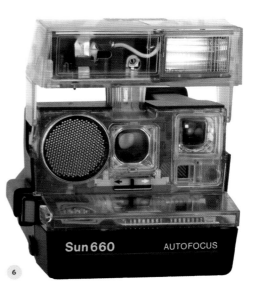

9

8

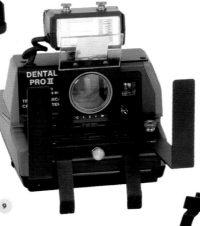

How To
Swapping Film in Integral Film Packs

Swapping film has many practical applications, including fixing low-battery pack issues and can be useful for a variety of creative techniques, including multiple exposures (see pages 108–13) and pack-filters (see pages 114–23). You can even use this method to transfer single sheets of Spectra film into roll film cameras like Polaroid's 95a; see page 15).

Method

1 Find an empty film pack that matches the one you want to swap film from **(a)**. (Note that Impossible's SX-70 and 600 empty packs are interchangeable.) One battery is usually enough for twenty shots.

If you are in any doubt as to the charge, test the contacts on the bottom of the film pack: they should read at around 6V, but anywhere between 3V and 6V will be perfectly fine for a reuse.

2 This tutorial will focus on swapping film from a full (or partially full) integral film pack. To avoid exposing the film to light you will need to follow the steps in complete darkness.

3 Remove the dark slide from your film pack and set it to one side. Feel for the small, thin plastic flap at top left (this corresponds with the slot at the top left of the film pack). Place this on your work area in the same orientation as your pack. Gently slide your film sheets out of the pack **(b)**. You can

place your stack of unexposed film face-up on top of your dark slide to make it easier to reinsert later. If you are unsure of which side is which, feel for the film's wide chemical pod area: the padded papery side is the back and the flat plastic side the front.

4 Insert your film into the new pack. Press down on the central spring as far as you can while inserting your first picture, to prevent it from slipping underneath the metal **(c)**. Push the thin end of the film past the light-shield flap and into the pack **(d)**.

The chemical pods should enter the film pack last and be next to the soft plastic light seal. This seal can get caught between the film sheets: it this occurs, pull it out **(e)**.

Sometimes the last few millimetres of the sheet can be difficult to insert. Aim to position the sheet in-between the spring and the pack's plastic frame. You may need to gently depress the film sheet with your finger to push the spring

down as you slide the film sheet beneath the frame **(f)**.

Repeat this process for every sheet of film from the pack from which you are swapping. If you are using Impossible film remember that no more than eight shots will fit comfortably into the pack.

5 Position the dark slide on top of your unexposed film sheets: the tab at top left of the dark slide has to align with the corresponding slot on your film pack **(g)**. Make sure that all the film sheets and the dark slide are fully inside and not protruding from beneath the light seal.

6 Now turn on the lights. Load your camera and the dark slide should eject as normal.

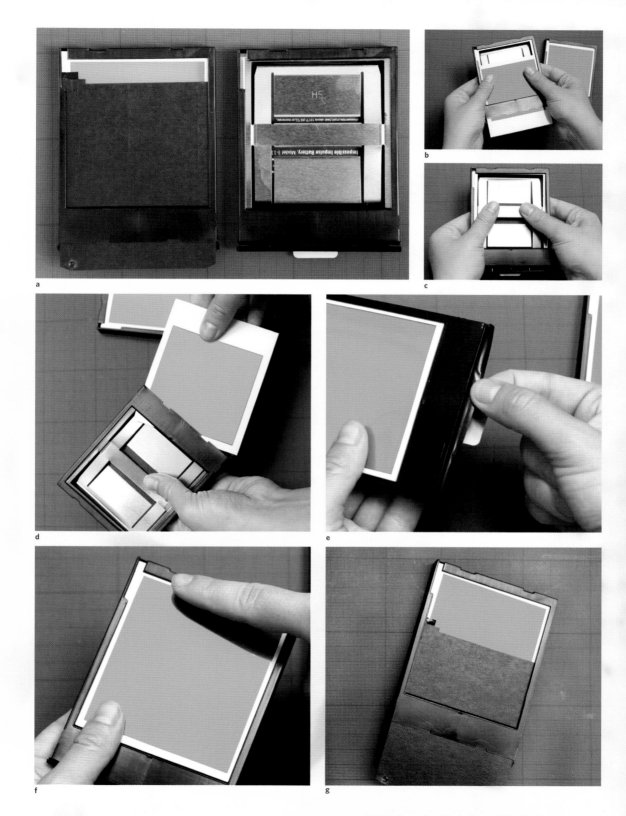

a

b

c

d

e

f

g

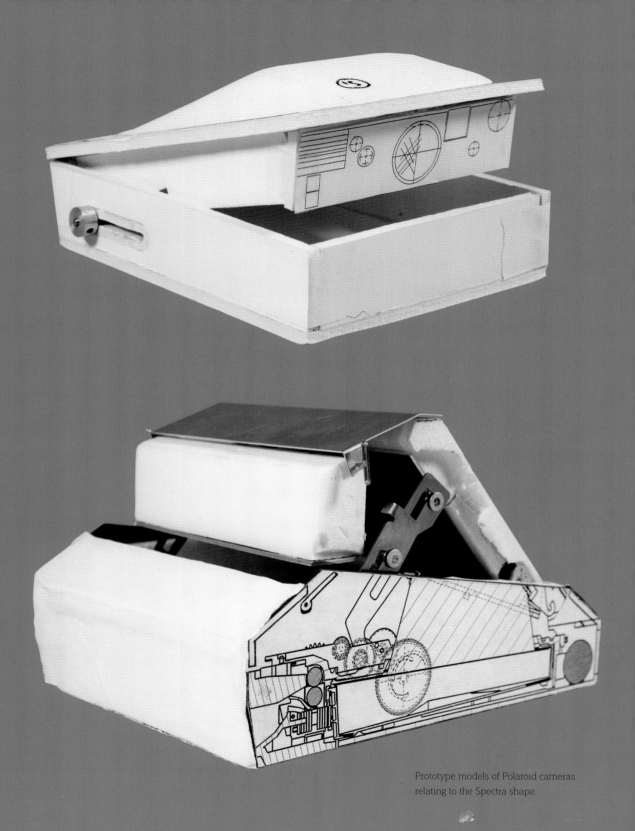

Prototype models of Polaroid cameras
relating to the Spectra shape.

Spectra Cameras

Spectras (marketed as Image cameras outside of the US) feature more powerful lenses than most of the plastic-bodied 600s (see pages 58–63) and have an improved focusing system. Spectra film is characteristically the same as Polaroid's 600, but exists in a wide format, with an image area of 9.2 × 7.3cm (3½ × 2¾in.). Spectra film is sometimes referred to as 700 film but a wide range of types were produced, including 990 and 1200. A later edition of Spectra film, called Softtone, was released by Impossible. Early Spectra film packs had ten shots; later editions, twelve. All of the cameras in this series are compatible with Impossible's eight-shot Spectra film, rated at 640 ISO and available in black and white and colour. One noteworthy feature of Impossible's Spectra film is that it fits (as individual sheets) in old roll film cameras like the 95a (see pages 24–25).

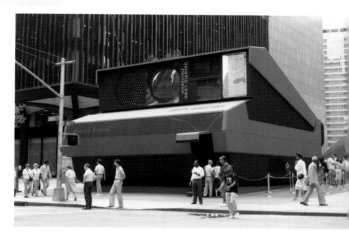

'Original Style' Spectras

These models all feature a 125mm f.10 three-element 'Quintic' lens. They have a built-in flash and are auto exposure (though high-end models allow override) with shutter speeds ranging from 1/250–2.8 seconds. Autofocus is achieved using the sonar system. Some cameras within this group have a remote-control socket, tripod socket and self-timer capability. They also have a spring-loaded folding top so that the lens is protected when folded down. They are capable of multiple exposures (see pages 108–13).

Common models include the Spectra, Spectra SE, Spectra AF, Spectra 2, Spectra Pro, Spectra 1200I, Spectra 1200SI and Spectra Onyx. Common Polaroid Image cameras, which run in parallel to the Spectra series, include the Image (same as the Spectra), Image 2 (equivalent to the Spectra 2), Image Elite, Image Elite Pro (another Spectra Pro) and Image Pro.

Spectra Exceptions

In 1996 Polaroid introduced the ProCam, a Spectra model with an entirely new body design. Also a spring-loaded folding model, it is hinged only on one side. It has a 90mm lens – the widest of any Spectra model – allowing for a wider field of view. It was sold with a close-up attachment, though many of these have been separated from the cameras since they were released (without them, the camera has no close-up capability). Accessories made for the 'original' models are

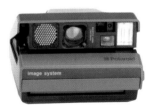

From top: Enrique Valdivia, a Spectra outside the World Trade Center, 1986; Impossible's Spectra packaging; Polaroid Image System Camera; rear view of a typical Spectra.

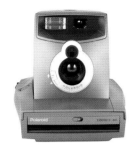

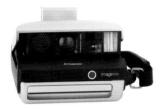

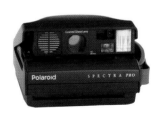

From top: The Image 1200FF; Image
1200 Professional with LCD screen;
Macro 5 camera; the Spectra Pro.

not compatible. The ProCam has a time/date imprint capability, a self-timer, infinity lock, and lighten/darken control but lacks autofocus and flash override and multiple-exposure capability.

In 2001, Polaroid updated the range with the release of the Spectra 1200FF. This was another fold-up camera, and sported a neat, pleated metal folding mechanism on one side. Its slim profile makes it the smallest of the Spectra range. The lens panel sits on the top of the camera when folded down and has a metal cover that slides opens automatically when the camera is extended. It has a wider 100mm f.11.5 lens and a counter that caters for twelve shots. It has a fixed focus with a selector for close-up (under 60cm/2ft). It lacks a tripod socket, lighten/darken control and flash override.

In 2004 the last Spectra incarnation was released, the Image 1200. This model had one notable difference to its predecessors: a flip-up LCD screen for composing.

SLR Models

The Macro 3 and 5 are the only SLR models in the Spectra range. These non-folding cameras were designed for use within two of Polaroid's key industrial areas: forensics and medicine. To coincide with the Macro range, Polaroid also released a special film, where a printed grid appeared on the finished image, effectively recording measurements for scientific applications. The Spectra Macro cameras are extremely useful tools for anyone wishing to take on close-up work or large-scale mosaics.

The Macro 5 has a fixed shutter speed of 1/50 seconds and five magnification presets: 0.2x (f.20), 0.4x (f.34), 1x (f.47), 2x (f.67) and 3x (f.100). This allows a focusing range from 7.5–132cm (3–52in.). The Macro 3 has only three magnification settings: 1x, 2x and 3x. Two supplementary lenses were available – the 0.67x and 5.0x – though these are hard to come by. Both cameras can be fixed onto a tripod or copy stand and are designed for indoor use. They also have excellent flash capabilities. Focusing is precise and easy: on the Macro 5 there is even an alignment grid in the viewfinder. Focus is achieved by two intersecting beams of light that overlap on the subject.

'Pro' Models

These cameras all fold down and are compatible with the full range of Polaroid/Spectra accessories. They are also the most expensive of the range. A version by Minolta, the Instant Pro, was released in 1990, ahead of Polaroid's own.

The 'Pro' models have a three-element 125mm coated glass lens, and the automatic shutter system speeds range from to 6 seconds, with apertures ranging from f.10 to f.45, and timed exposure override for exposures longer than 6 seconds. The camera has a ten-zone focusing system, from 60cm (2ft) to infinity. Spectra cameras have the widest range of features of any integral camera.

Spectra/Image Close-up Copy Stand

For Spectra cameras, there is a copy stand accessory that you can use to photograph flat source material at a 1:1 scale. This is very useful for creating mosaics, as can be seen in Maurizio Galimberti's work (above).

Note that this accessory is only compatible with folding Image/Spectra cameras (including the Image, Image 2, Image Elite, Spectra, Spectra 2, and so on) but will not fit models like the Spectra 1200FF and ProCam.

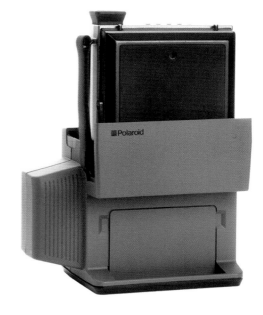

Above: Maurizio Galimberti's elaborate mosaic made using a Spectra copy stand. **Right:** Spectra camera inserted into the copy stand attachment.

Accessories

Most accessories are only compatible with 'Original Style'/Image cameras, since these share a common body shape and lens arrangement.

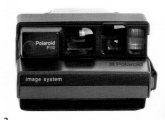

1.

2.

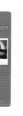

3.

4.

5.

6a.

6b. **6c.** **6d.** **6e.** **6f.** **6g.** **6h.**

1. Light-lock close-up lens (shown fixed to an Image System camera). This fits all Polaroid Spectra cameras of this body type and allows you to take pictures from 25cm (10in.) away at 50 per cent magnification. It features either a measuring string or light-lock focusing system and distance is set manually. The light lock is generally inaccurate and the F112 is usually a cheaper and more sufficient option.

2. F112 – Close-up lens, with the same capabilities as **(1)** but without the light-lock option.

3. Creative Effects Filter Kit, which includes a filter holder and five filters; the F101 (horizontal blur), the F102 (red centre spot); F103 (starburst); F104 (a

three-image prism); and the F105 (a five-image prism).

4. Remote Control. This functions only with cameras that have a remote-control socket. The receiver plugs into the socket and the wireless transmitter can be located anywhere from within 12m (40ft) of the receiver.

5. The F106 filter holder. Required to hold any of the individual filters in **(6)**

6. Individual filters include: F101 Motion Filter **(6a)**; F102 red centre spot filter **(6b)**; F103 Starburst Filter **(6c)**; F104 Multi-image (triple) filter **(6d)**; F107 Orange spot filter **(6e)**; F108 Diffusing Surround filter **(6f)**; F110 Polarizing filter **(6g)**; and F111 double-image filter **(6h)**.

Buying Advice

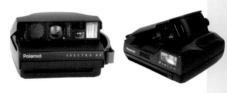

There are a large number of Spectra cameras available second hand, most of which are relatively inexpensive. Almost all are good options for those looking for a good quality/cost balance.

Impossible film is slightly faster than original Polaroid films, so look for models with an exposure compensation option to rectify this (this rules out the 1200FF, see page 67; and Image 1200, see page 68).

If on a modest budget, seek out an original Spectra or Image camera **(1)** or Spectra AF **(2)**, as these have many manual overrides.

For a newer model with the same feature list, the Spectra 1200SI, which is based on the original Spectra but with a smoother shape and an upwards counting counter, is a good option. Avoid the Spectra 2, Image 2 and 1200I editions: these lack manual override, and their only advantage over the 1200FF is that they have a lighten/darken switch at the rear. If you are not concerned about close-up kits or lens accessories, the odd-looking ProCam may appeal **(3)**.

If budget permits, a good buy is any one of the professional/'pro' models **(4)** (see page 68). These have the best range of features and accessory compatibility including manual or autofocusing, long-exposure capability and user-programmed timed exposures, multiple exposure facility, a tripod socket and self-timer. If you want to take close-ups of exceptional quality, aim for the Macro 5 **(5)**.

As with all Polaroid cameras, film-test before you buy and check that the camera opens and closes correctly.

Collector's Notes

Spectra cameras are not very collectable. One official 'limited edition' Spectra camera was sold; the Onyx, made from transparent brown plastic **(6)** and the gold 'First Edition' **(7)**. There is also a rare version of the 'Spectra System' that is made from transparent plastic **(8)**.

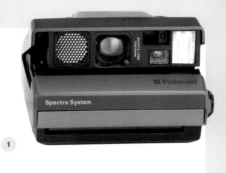

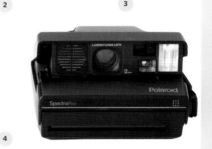

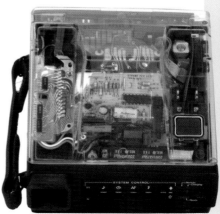

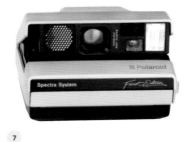

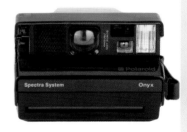

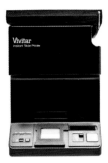

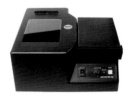

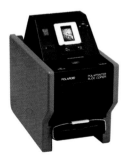

Instant Printers

Many Polaroid photographers make use of a Daylab Copysystem Pro, Polaprinter or Vivitar Instant Slide Printer in their work. Easy to use, these photograph source material and turn it into instant photographs at the touch of a button.

If using a Daylab Copysystem Pro, your source material could be printed matter, photographs or even 3D objects. Daylab also produces a series of slide printers, some of which can 'print' onto various formats: from normal pack film to 5"×4", 8"×10" and integral SX-70 (including Impossible Project stock).

The Vivitar Instant Slide Printer and Polaprinter use 35mm slides only and are compatible with 100 series pack film. If you want to use one of these make sure you that have a stock of 35mm slides at the ready or be prepared to have your digital imagery turned into slides. With E-6 slide film becoming harder to come by, this may soon be your best option. The Vivitar benefits from being lightweight and portable and having a slide slot that matches the width of lighting gel sample booklets, like those made by Rosco and Lee filters, perfectly. By layering these filters over your slides you can colour correct or produce special effects in your images.

Instant printers make it easier to produce large, perfectly matching composites. On standard film cameras it is possible to make use of a wide range of lenses to shoot your source imagery, while instant printers allow you to transfer this imagery to instant film. Polaroid cameras can be limiting as they do not have a zoom. By using a 35mm multi-lens camera with E6 slide film you have a telephoto option, enabling you to make images from distant subjects and transfer them to pack film with ease. Instant printers can be used with numerous creative techniques and won't involve the risk of ruining original images.

From top left: Vivitar Instant Slide Printer; lighting gel swatch booklet; Daylab Copy System Pro; Polaprinter.

Impossible's Instant Lab

This ingenious piece of equipment works with smartphone technology (iOS and Android) via an app that can transform your digital images onto Impossible's 600 and SX-70 films (not Spectra, yet).

You can transfer images shot on other cameras back to your phone for transfer to instant film or plan big composites in Photoshop, and crop/tile these perfectly before exposing: a great way not to waste film. The Instant Lab is excellent for testing out ideas over which you can exert some control.

Can you tell that an image has been 'Instant Labbed'? The answer is yes. Instant Lab images always appear slightly vignetted at the edges. When you clear the negatives (see pages 182–85) you will also be able to see the pixels of your phone screen.

The Instant Lab is a great tool for experimentation, allowing you to make striking, unique images, often featuring scenes that could never be photographed, all without the need for dark bags or to dismantle film packs (for those difficult integral double exposures)!

Above: The Instant Lab Universal is a small and compact unit that becomes operational when fully extended.
Below: Instant Lab in use with an iPhone 6.

Above and right: Ina Echternach,
Don't Panic and *I Did Not Know that
the Wind Could be Tender*, all images
made using an Instant Lab.

Left: *The Waters of the Night.* **Above:** *West of the Moon, East of the Sun.* **Below:** *Summer #1.*

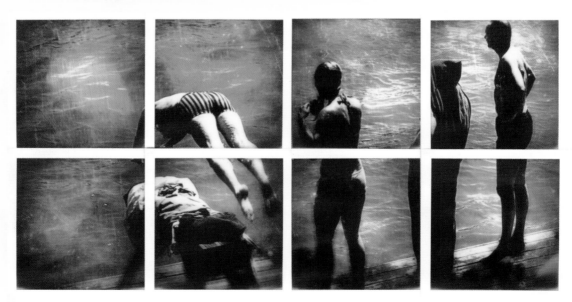

Polaroid Relics

The Captiva/JoyCam

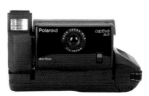

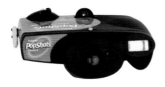

Released in 1993 the Captiva camera was Polaroid's final true camera innovation and its last SLR model. It was subjected to more consumer testing than any other product in Polaroid history.

The camera had a triangular collapsible body with in-built lens cover and a handy compartment into which each shot was ejected. Captiva cameras also had a good autofocus capability, flash and self-timer. However, these advancements were not enough to disguise the fact that the camera produced tiny prints, with an image area of just 7.3 × 5.4cm ($2\frac{7}{8}$ × $2\frac{1}{8}$in.)

In 1999, the JoyCam was released: a cheap, ugly and lightweight 95-film compatible camera aimed at the Japanese market. It was also the first integral camera that required the user to pull the film from the camera manually. It achieved moderate success. The 95 format did make a few other appearances, including Polaroid's PopShots, the world's first disposable instant camera. These cameras looked and felt more sturdy than the JoyCam.

This was later followed by the P-500 printer; a bulky piece of plastic equipment that allowed the user to print from CompactFlash and SmartMedia cards, so that multiple copies of the same image could be 'printed'. Though a neat idea, it served no useful purpose. It was not small enough to be portable and provided no viable alternative to a conventional printer. The film it used was expensive and it produced small prints unsuited to commercial applications or creative techniques.

Impossible now make their own digital hybrid 'printer', the Instant Lab (see page 73), doing what the P-500 did many years before, the only difference being that Impossible's films are well suited to creative manipulations. Fuji's digital printer (the 'Instax Share' that uses Instax Mini film) and the 'new' Polaroid company's Bluetooth 'Zinc' printers (called the 'Zip', formerly Pogo) that transfer digital images to thermal paper both use media remarkably similar in size to the 95 film.

From top: Polaroid's 500 film; JoyCam, Captiva and PopShots cameras; portrait taken with a Captiva.

Polaroid Relics

The Polaroid i-Zone

Above: Steven Monteau's i-Zone photo joiner. **Below:** Boxed Backstreet Boys i-Zone camera, 2001.

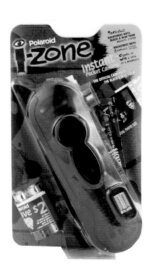

The i-Zone was a short-lived, low-cost integral system released in 1999, and Polaroid's last gasp before bankruptcy. For a time it was the world's biggest-selling camera, turning Polaroid's first annual profit in five years and making up most of the 9.7 million Polaroid cameras sold that year.

The i-Zone had appeared in Asia as the Tomy 'Xiao' almost six months before the system's US release. Seeing the popularity of the Instax Mini system (introduced 1998, see pages 78–81), Polaroid partnered with the Japanese toy manufacturer Tomy to produce this model. Xiao cameras were cheap, lightweight and, like the i-Zone, required the user to manually pull the film from the camera like pack film. The film was based on 600 film emulsion, and the pictures were tiny – measuring just 3.8 × 2.5cm (1½ × 1in.) – inspired by the 'Puri Kura' (print club) sticker booths popular with Japanese teenagers. Unsurprisingly, some special Xiao/i-Zone films incorporated a sticky back, and colourful patterned printed borders. One special film release even displayed a fortune tale that vanished after full development.

The Tomy Xiao was an almost immediate hit, and within a few months Polaroid launched the i-Zone worldwide. The new format took its name from the phrase the 'Internet generation'. Polaroid's marketing team came up with a dedicated handheld i-Zone scanner leading to a tie-in website, which featured forums, a chat module, profiles and the possibility of sharing your digitized i-Zone pictures. In 2001, a hybrid i-Zone combo camera came onto the market that used both film and a digital sensor, making extremely low-resolution digital pictures too (only 0.3MP).

Over the years, and until i-Zone was discontinued along with all other Polaroid formats in 2006, a stream of bright, cheerful cameras and limited editions were sold and various body styles emerged, including features such as interchangeable clip-on fascias and even a radio with a headphone socket. The i-Zone is one of the most collectable Polaroid formats but its features are limited: it has only three aperture settings, requires additional batteries and the images are tiny. Though the original cameras are largely resigned to the shelf, a new version of the Tomy Xiao using ZINK (thermal) paper has been released, and the 'new' Polaroid company have dusted off the i-Zone name with their 18MP digital micro-size camera, released in 2016.

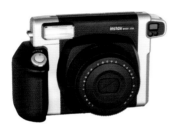

Fuji Instax/Other Instant Cameras

For a short-lived period between the last expiry dates of Polaroid film (2009) and Impossible's launch, Fuji would become the only manufacturer of instant films in the world across any format. After several years of cutting back on analogue product inventory, in 2016 Fuji cut pack film production altogether, deciding to concentrate wholly on the popular Instax range.

Film

Fuji's Instax film is the only integral alternative to Impossible's but is not cross-compatible with 'original' Polaroid cameras: SX-70 (see pages 44–56), 600 (see pages 58–63) and Spectra formats (see pages 66–71). It is the most ubiquitous of all instant photography products and the most economical route into analogue instant photography. Fuji Instax film was initially only compatible with Fuji cameras but now companies including Lomo, Leica and MiNT make compatible models (see page 80). Fuji also make mobile printers that use the film, bridging the gap between analogue and digital. You can even buy a dedicated attachment (a back) to use with the popular Diana+, Lomo'LC-A+, and Belair cameras (all available from Lomo).

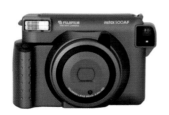

Instax film comes in three sizes: Instax Mini (54 × 86mm; image area of 46 × 62 mm), Wide (86 × 108mm; image area of 99 × 62 mm) and Square (86 × 72 mm; image area of 62 × 62 mm). Instax Wide is available in colour only, while the Mini and Square films are available in colour and monochrome. All are rated at 800 ISO.

Instax film and the compatible cameras are very intuitive to use. However, there is a catch. The structure of the film sheet means that many manipulation techniques are impossible.

Fuji's Instax Wide Cameras

The first Fuji Instax Wide format, the Instax 100, was introduced in 1999. The most recent model in this format is the Instax Wide 300. The cameras in this range are cheap and easy to use. They include a tripod socket, exposure compensation and flash. This format has much slower shutter speeds than other Instax cameras, ranging from 1/8 to 1/125. Its drawbacks include an off-centre viewfinder (making accurate framing difficult) and a macro mode (0.9-3m), which is automatically selected every time the camera is switched on. If you forget to change this you will make blurry pictures.

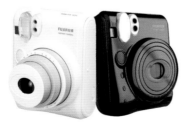

There has only ever been one autofocus Instax Wide: the Instax 500AF, released in 1999. This is quite possibly the most economical Fuji Instax Wide camera, since you are less likely to waste film on out-of-focus pictures.

Fuji's Instax Mini Cameras

The first Instax Mini was introduced in 1998. Mini-compatible cameras make up the biggest proportion of Fuji instant hardware. For the most part, pre-2008 models share the same features and are very basic. They possess a similar lens, ranging from 60mm f.12 to 60mm f.12.7 (current generation). Until 2013, when the Mini 90 was introduced, all Instax models had shutter speeds of either 1/30–1/400 or 1/60–1/400. Some of the more superior older models include the Instax Mini 7S (low end), Instax Mini 25 (mid range) and the Instax Mini 50S (high end). The 50S has three added functions: tripod socket self-timer and the ability to take two self-timer pictures in quick succession (perfect for group selfies when more than one copy is needed). The 25 and 50S both come with a close-up lens attachment, allowing focus up to 30cm (11¾in.) away. Fuji has three variants on the Instax Mini in production, the Mini 8, 70 and 90 NeoClassic.

The Mini 8 is the cheapest model and, with an additional exposure setting ('Hi-Key' for overall brightening), is an improvement on earlier models. The Mini 70 is an upgraded 50S and combines the features of the Mini 25 and the 50S with the Mini 8. It has a dedicated selfie mode button and selfie mirror. This mode optimizes all settings for closer pictures and adjusts flash accordingly (including fill flash to avoid dark backgrounds).

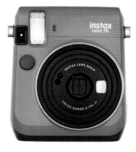

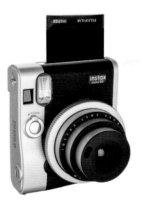

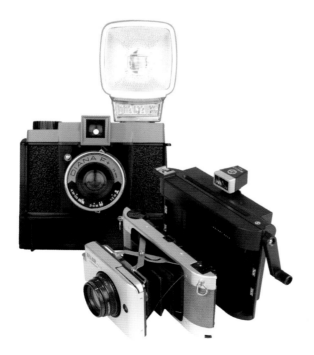

Opposite, from top: Fuji film packaging; the Instax Wide 300, Instax 500AF; and Instax Mini 50s. **Above:** the Instax Mini 8; Instax Mini 70; and Instax Mini 90 (NeoClassic). **Left:** the Diana F+ camera with Instant Back+ and the Belair camera equipped with an Instax wide back.

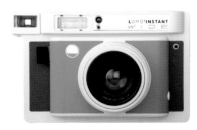

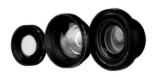

It also has a macro mode, allowing focus from 30cm (1ft) away. The Mini 9 NeoClassic is the most flexible of the Mini range and is the most well suited to creative photography. It has an in-built bulb mode, allowing exposures of up to 10 seconds, with normal auto exposure shutter speeds ranging from 1.8s to 1/400s. It also has a double-exposure mode and rechargeable lithium battery (with which you can take roughly one hundred shots before having to recharge).

Leica

Leica entered the world of instant photography with their 'Sofort' camera in 2016. It is the most expensive of the point-and-shoot-style Instax cameras. It comes with selfie mode, timer, full auto, exposure compensation, bulb/long exposure mode, double exposure, macro from 30cm away, sport mode, party mode, flash on/off, red-eye reduction, and a rechargeable lithium battery. It has few manual controls.

Lomo

Lomo make two Instax Mini compatible cameras: the Lomo'Instant and the retro-style Lomo'Instant Automat. Both require the user to select a focus zone (as with earlier Fuji Instax models, there are three zones from which to choose) and include a selfie mirror to check framing.

The Lomo'Instant has a wide-angle 27mm lens as standard and a fixed shutter speed of 1/125. It has both a bulb setting and unlimited multiple exposure (MX) capability. Apertures are selected automatically (f.8 to f.32). You can use the EV+/- dial to have some control over exposure.

The model's automatic equivalent, the Instax Automat, comes with a 60mm lens as standard and has all of the creative modes above, but has a vastly improved automatic exposure system even when flash is off, and a range of automatic shutter speeds (8s to 1/250s), as well as a bulb mode (max 30s) or a fixed 1/60s mode. This model has the same aperture range as the Lomo'Instant.

Both cameras have a cable release fitting (with the Automat you can use the lens cap as a remote shutter button!) and tripod socket. They also allow the use of the Lomo Splitzer (which splits the image frame in half, blending two images together top to bottom), or various add-on lenses (close-up, fisheye or portrait/wide-angle, depending on which Lomo'Instant you have).

Lomo also offers a Fuji Wide compatible camera, which shares many features with the Automat (though this only has apertures f.8 or f.22) but adds a PC-Sync socket, allowing for studio flash. The Wide also has the option for add-on accessories (lens kit, opposite top right). This is the best Instax Wide compatible camera on the market.

MiNT

Hong Kong-based MiNT have created the only TLR (twin-lens reflex) camera compatible with Instax Mini film, the InstantFlex TL70. The camera looks more like a miniature Rolleiflex than an instant camera

and is made up of both metal and plastic. It has a three-element, 61mm glass lens, allowing accurate focus from 48cm (18in.) away. It is also the most manual of the Instax cameras, and the only one to include aperture priority and manual focus. It features an exposure indicator that tells you if your selected aperture is out of the correct exposure range (1/500 to 1s), and a flash (and on/off option), which is hidden behind the InstantFlex nameplate. There is also an exposure compensation dial allowing for low-key or hi-key images. It has a tripod mount and a bulb (B) mode, enabling exposures of up to 10 seconds.

A surprise feature is the 'f.bokeh' selector, allowing a non-circular aperture for beautiful night-time lighting effects. You can also take as many multiple exposures as you like and choose when to eject your shot.

MiNT also produce a lens set, which includes a close-up lens (allowing focus as close as 18cm/7⅛ in.), a lens hood to avoid glare and ND-2, ND-4 and ND-8 filters, resulting in more options for creative photography. The camera is expensive but worth the cost.

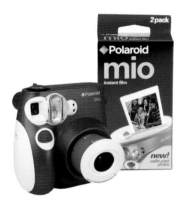

'New' Polaroid Cameras

No list of 'other' non-Polaroid cameras would be complete without a nod to 'new' Polaroid cameras: the Polaroid PIC-300 camera and PIF-300 film. These are in reality Fuji's own Instax Mini products rebranded: the PIC-300 is really a Fuji Instax Mini 7S and accepts Instax Mini film.

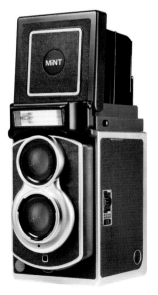

Above: Lomo'Instant Wide lens set; a rebranded Fuji Instax 7S and Polaroid 'Mio' film; MiNT TL70 lens packaging and set. **Left:** MiNT InstantFlex TL70 2.0.

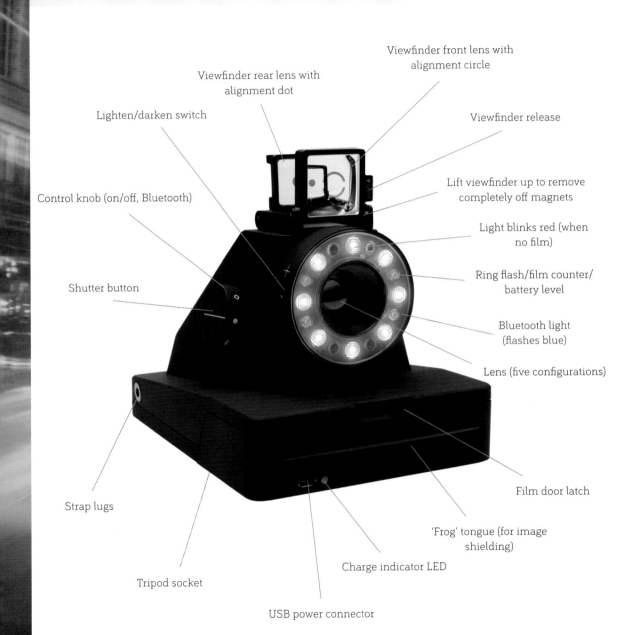

Viewfinder front lens with alignment circle

Viewfinder rear lens with alignment dot

Lighten/darken switch

Viewfinder release

Control knob (on/off, Bluetooth)

Lift viewfinder up to remove completely off magnets

Light blinks red (when no film)

Shutter button

Ring flash/film counter/ battery level

Bluetooth light (flashes blue)

Lens (five configurations)

Strap lugs

Film door latch

'Frog' tongue (for image shielding)

Charge indicator LED

Tripod socket

USB power connector

Impossible I-1

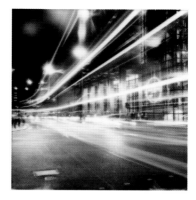

The year 2016 saw the introduction of the Impossible Project's I-Type system, with its compatible camera, the I-1. The I-1 is the first wholly new camera designed for an original Polaroid format since the i-Zone (see page 75).

The I-1 takes 600 film (though can accept SX-70 film, see pages 44–56, when in manual mode and manual metering), as well as the new I-Type film. I-Type films are slightly cheaper than some other Impossible formats due to being batteryless. Like the Instant Lab (see page 72), the I-1 is charged externally.

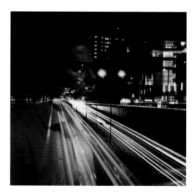

The camera is lightweight in comparison to the folding SX-70, coming in at just 440g (9lb). It is very easy to use and has a wide variety of shooting modes.

With built-in app integration, available for both iOS and Android, and Bluetooth connectivity the I-1 really is an analogue camera for the digital age. Future app updates and firmware upgrades will appear, expanding the camera's feature list. This digital crossover is what makes the camera a particularly powerful tool, since, thanks to the app, much of the camera's capability can be harnessed by manual overrides, making it a great option for creative techniques.

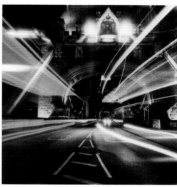

The I-1 is not completely faultless, and it is missing true manual focus but, just as many of Polaroid's products were steps on the way to the perfect instant system, it is a work in progress. For now, the advantages far outweigh the drawbacks, and the I-1 is the most technologically capable and flexible 600-film camera (see pages 58–63) ever made.

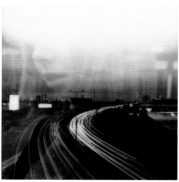

From top right: Ray Liu, I-1 shots taken on the I-1's manual setting. The last two are long exposures combined with 'normal' shots using the multiple exposures method.

User Guide

Note that the I-1 is subject to change as firmware upgrades are announced. Though the hardware itself will remain unchanged, the interface may adapt. All information listed here is correct at the time of printing.

Control Knob

On the right-hand side of the camera is the mode selector/shutter button. One click counter clockwise turns the camera on (autofocus with auto exposure), and a second click turns on the Bluetooth remote connectivity through the app (granting access to the app features and manual mode). A blue LED will light during pairing.

In the centre of this dial is the shutter button. The shutter button has two positions: a slight depress allows the camera to send an infrared beam to the subject, detecting its distance. On automatic mode, this tells the camera which lens to use. Press the shutter in fully to take a picture and your image will eject. Autofocus works from around 30cm (1ft) from the lens to infinity.

When manual mode is enabled, all controls operate from the app itself (including the shutter button) and the camera's hardware functions are overridden. Lenses are user-selected, and the app uses infrared to meter the scene and inform you, on screen, if your exposure settings are within an appropriate range for the scene you wish to photograph.

Lighten/Darken Switch

As with an original Polaroid camera, the lighten/darken switch allows you to darken or lighten your picture (on this camera by one aperture stop). Usable in auto mode only.

Flash

This is the first instant camera with a ring flash. The flash consists of twelve LEDs, seven white and one red (for increased range) and four diffuser LEDS. When shooting with flash, all twelve will fire. The camera is particularly well suited to taking portraits: the ring flash minimizes red-eye though there is no red-eye-reduction feature.

You can turn the flash on or off via a switch on the left-hand side of the lens. With the app, you can also set it to full power, medium power, low power or off. Currently, the flash system has no capability to work with external flash units (slave flash), though an adaptor may become available.

Film Counter/Battery Indicator

The flash LEDs also double as the film counter and power indicator. When you first turn the camera on, one white LED is lit for every remaining film sheet. A single flashing LED means your pack is empty.

The camera has a rechargeable battery and remaining power is indicated by pressing the shutter button when the camera is off. The more lights, the more battery charge. You can also check remaining film and battery via the app. When the battery is almost empty, a small red LED light at the bottom right of the camera will blink.

This means there is not enough power for the flash. Impossible have calibrated the camera so that even when the battery is too low for the flash to fire,

5 6 7

you can still use the camera in flash-off mode. Note that you cannot power the camera via a film pack, even if you decide to use regular Impossible 600 film.

Lens and Focus

There are six lenses in total, and when not in manual mode, the camera swaps between them automatically. These lenses allow for five possible configurations, enabling a focal length of 82–109mm (3¼–4¼in.), with a 41-degree field of view.

Lens 3, the camera's default lens, is the most capable of all. In bright conditions, the camera often uses this lens and compensates with a small aperture. You can select it yourself on manual mode. This lens suffers the least degradation as you move away from its optimum focus point.

The I-1 can be hard to frame and focus accurately. The autofocus area is very small and favours the dead centre. When looking through the viewfinder, the autofocus area is marked by a dot and split circle printed on the two glass panels: these should align fully.

Once focused on your subject, hold the shutter button halfway if you wish to reframe your shot. This is useful if you want to shoot a subject sitting to the left or right of the frame. Simply set focus on a similarly distanced object then reframe.

Autofocus is achieved through infrared ranging using five focus zones. There is a 'sweet spot' for each lens, where optimum sharpness is achieved, though there is little tolerance either side of this. Focus quality decreases sharply as you move away from each lens's ideal distance. This is more pronounced in low light situations where apertures are wider. Also keep this in mind when using manual mode.

To help you achieve in-focus images, follow these guidelines to find the ideal focus point for each lens:

Lens 1: Macro (range 0.3–0.5m). Best at 40cm. Close-up of your subject's head and shoulders. Requires parallax correction (see Troubleshooting).

Lens 2: Close-up (range 0.5–1.0m). Best at 80cm. Portrait showing your subject's head and torso (perfect for 'selfies'). Requires parallax correction (see Troubleshooting).

Lens 3: Near-field (range 1.0–2.2m). Best at 1.5–1.8m. A small group (three to five people) can be in shot. At close distances within the range, some parallax correction may be needed (see Troubleshooting).

Lens 4: Mid-field (range 2.2–4.5m). Best at 3.3–3.5m. A large group of people can be in shot.

Lens 5: Far-field (Range 4.5–∞ m) – Best at more than 6m. Landscape shots.

Opposite: (1) If this light blinks, there is no film pack in the camera; (2) the lights illuminated reveal the number of shots left in the pack; (3) the lights show the amount of charge left in the battery, if there are less than three the flash will not fire; (4) when the blue light blinks, the camera is seeking to pair with your phone.

Above (left to right): Series of portraits showing focus zones: a macro shot with lens 1 (5); a close-up with lens 2 (6); and the third taken with lens 3 (7).

App Features

Scanner

The 'scanner' feature also appears on Impossible's Instant Lab app. It uses your phone's camera to photograph your instant pictures. This feature employs a parallax-cropping tool that allows you to tilt your images (to avoid glare and reflection), and straightens the images out afterwards **(8)**. With the I-1 app version, once scanned, you can attach information (shutter speed/aperture, etc.) to your image via a log, allowing you to replicate exposure settings at a later point.

'Color Paint'

The I-1 app uses your smartphone's screen as a 'torch', which you can use for light painting (see pages 126–29) or, in this case, to 'Color Paint' **(9)**. Since this is essentially a long-exposure, you need to place your camera on a steady surface or use a tripod. You can access a variety of colours of light via the colour slider and also change the colour as you paint.

 With 'Color Paint' activated, and the in-app shutter pressed, move your phone around with the screen facing the lens. Check your exposure time on screen and press the shutter button again when you wish to stop. For best results, turn your screen brightness up (the app currently has no brightness override).

Light Paint

Light painting **(10)** is a technique explored in 'Creative Techniques' (see pages 126–29). With the I-1, as with manual pack film cameras, you do not need to trick the camera into keeping the shutter open. Though similar to the 'Color Paint' setting above, this one makes use of the phone's native flash or 'torch', so that the beam is more targeted and has a white light. This is great for black-and-white films and for when you don't want a colour-tinted light source. To begin exposing, press the yellow shutter button on the app's screen. When you are finished, press the shutter button again to eject the photo.

Noise Trigger

With this feature sound triggers the camera's shutter. This is useful for shots where timing is key (e.g. if you want to photograph the start of a race). Adjust the sound sensitivity through the on-screen slider and

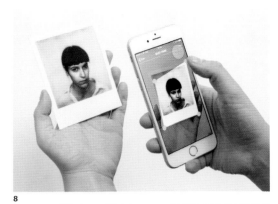

8

9

10

From top: Scanner mode in action; color paint mode can be used to create rainbow light trails; during light painting, the app automatically selects lens 3 (beware: macro subjects can be out of focus).

press the app's shutter button to set. The camera will fire once the decibel level crosses the slider threshold. You can use this mode with flash on/off and the lighten/darken switch.

Double Exposure

Once activated, this allows you to override the automatic ejection of your photo after an exposure has been made. This mode is compatible with flash on/off and the lighten/darken switch.

Until Impossible introduces expanded capability, here is an operative hack to take more than two exposures on the same film sheet:

1. Reduce the EV, by turning the lighten/darken switch to minus;
2. Go to the Double Exposure option and take your first image;
3. Turn off the camera and quit the app. This causes the camera to reset and forget that it took shot 1;
4. Switch the camera back on and access the app again. Take a second shot. Repeat the process until you have made all of your multiple exposures. On the final shot, you can use the camera's own shutter button allowing the eject.

If you want to shoot multiple exposures in manual mode, you will have to wait for an update, but there is a hybrid auto/manual workaround for double exposures. Follow the process above for shot 1, and then re-enter the app to make your second exposure through manual mode. Of course, you can also follow the multiple exposures method (see pages 108–13).

Self Timer

The built-in self-timer allows you to choose between 5, 10 or 20 seconds. Since this operates by remote, you can get into position before triggering the shutter's timer. You can then hide your phone so

it is not in shot. Again this allows flash on/off and lighten/darken settings.

Manual Mode

This mode is accessible only via the app. You can adjust aperture, shutter speed, flash strength and focus lens. These manual controls allow you to take control of the camera almost entirely.

The first option is to select your shooting lens, which can be done via the on-screen selector wheel. Another selector wheel allows control over three-flash intensity settings or to turn them off altogether. There are eight aperture options accessible from a slider, from f.10 to f.67, and another slider allowing for shutter speed selection, from 1/250th to 30 seconds.

As you adjust your settings, you will see the circle on the exposure scale move left and right across the horizontal line. This slides in relation to the camera's internal light metering. When your chosen settings are suitable for the scene, the circle should sit roughly in the middle of the horizontal scale.

Remote Trigger

This allows you to remotely press the shutter of your camera. This is perfect for incognito shots such as street scenes and in low light situations will prevent camera shake.

Above: The different app features of the I-1

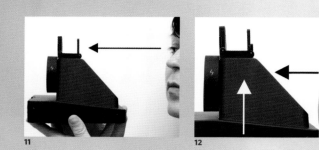

11 12 13 14

Troubleshooting

Framing/Focus

The camera is not an SLR like the folding SX-70 and 600 models and does not have a covered tube for focus as in non-folding models. As a result, the I-1 is difficult to focus accurately. It works best when positioned at around 5cm (2in.) from your eye, but at that distance the camera is quite unstable and holding your frame can be difficult.

To achieve a sharp focus, the dot in the first viewfinder glass must sit perfectly within the larger split circle in the second glass. Begin by holding the camera around 20cm (8in.) away **(11)**, aligning the dot inside the circle, then bring the camera slowly towards your eye **(12)**. The subject needs to fill around 70 per cent of the viewfinder area for the focus to function.

Due to the position of the viewfinder (above the camera's lens), the lens shoots at a lower plane than that of the viewfinder. This can cause unwanted cropping, particularly with nearby subjects. Correct the parallax issue by reframing after focus is set. Lift the camera on its vertical axis by a few centimetres, keeping the lens at the same plane.

Battery Life

From a full charge, you can shoot up to twenty packs of film continuously. If your camera was fully charged but has been left unused for several days, you may encounter a flat battery. This is because, when in standby mode, the capacitor is connected to the flash, meaning that even when off, the flash is draining charge.

The camera is not supplied with a wall plug and, at present, charging from a computer USB port is unreliable as it does not provide enough power.

Use a wall-pluggable USB (e.g. an iPhone's wall plug **(13)**. In the field you can also use external USB rechargeable battery packs.

Flash

When the battery level is low, the flash will stop functioning. The camera will still work for flashless shooting until the battery is dead.

Reset

If your camera is behaving bizarrely and will not charge or power up, you may need to reset the micro processor:

1. Charge for 1–2 hours (if possible);
2. Make sure the camera is then turned off;
3. Open the film door, and identify the small recessed reset button that sits just behind the film door latch on the main camera body **(14)**;
4. Using a pointed instrument (e.g. a pen) press it down for around 20 seconds;
5. Release the button, close the film door and turn the camera on. It should now power up as normal.

Shooting Impossible Film

Impossible film is still under development and, as such, the film speed can vary across a pack, and also across film type. Black-and-white films are rated at 160 ASA and colour films at 640 ASA but you should allow for a variation of around one-third of a stop. Black-and-white film develops much faster than colour film and you will be able to start seeing the results of your shot in just a couple of minutes. Colour film takes between 20 and 30 minutes to fully develop.

Film Storage
Refrigerate where you can, and store flat (not upright). Make sure your never freezes (the expansion will cause its pods to pop). Before using the film, allow it to adjust to room temperature. Extreme heat or cold will see your images lose contrast and affect their colour. When it is cold outside, keep the images close to keep them warm, or in extremely hot conditions, keep them cool. Film should be used within twelve months of the production date (and before expiry, if marked).

After Exposure
Impossible film is still sensitive to light when it ejects from the camera, particularly when the picture is still in its blueish phase. Shield your pictures during development. Impossible have also produced an accessory called the 'Frog tongue' that you could use. It inserts into the camera (see page 82) and can also be affixed to any integral camera.

Archiving
Sometimes Impossible images do not dry out properly, and this causes long-term image degradation. In humid climates, store them in the dark in sealed boxes (with silica gel pouches to absorb excess moisture) for about six months, before transferring them to a cool, dry place where the air can circulate (to stop the emulsion from cracking).

Right, from top: Impossible film packaging; silica gel pouch for absorbing moisture; an incorrectly stored Impossible image showing discolouration and degradation.

How To
Scanning

To scan accurately, turn off any backlight correction, auto exposure, dust-removal features and the unsharp mask filter. Aim to 'retouch' manually and make your onscreen image match the physical print as closely as possible.

If scanning integral films, in particular Impossible film (due to its particular front plastic) you will inevitably encounter Newton's rings. Taking shape as multicoloured spherical banding, the rings are caused by the reflection of light between the surface of the film and the scanner glass as they come into contact, and most often can be seen when making enlargements, zooming in and after you have cleaned your scanner bed.

As a solution Impossible created scan adapters for both 600 (see pages 58–63) and SX-70 film (see pages 44–56) and Spectra-size (see pages 66–71) images. These were thick acrylic frames, with reusable adhesive recesses that stick to the back of the integral images, lifting them 1mm up from the scanner glass.

Impossible have now ceased to sell the adapters, so the only option is to make your own. A simple method is to cut rectangles 1–2mm smaller than your film sheet into a single sheet of 1–2mm-thick card. Position the film sheets within the frame, face down, and apply scotch tape to hold the prints in place while transferring them to the scanner bed. Scan as normal. The thickness of the card will not make a great difference to the clarity of small scans and avoids the kaleidoscopic 'oil-slick' effect of the rings.

After importing, use Photoshop's clone stamp and healing brush tools to remove dust.

Negatives/Inversion

You can also create beautiful scans from your 665, 55, 51 or New 55 negatives (see pages 182–85) after clearing them.

To achieve a quality negative scan, use a film scanner. Make sure you select 'negative slide' and not 'reflective' in the scan mode of your scanner software. This sets the scanner to reverse the colours. If you do not have a film holder that fits your polaroid films, you can tape the edges of the film to the scanner so that it does not move and stays flat.

Impossible's scan adapter.

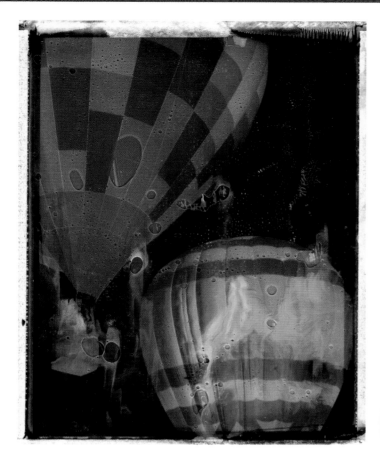

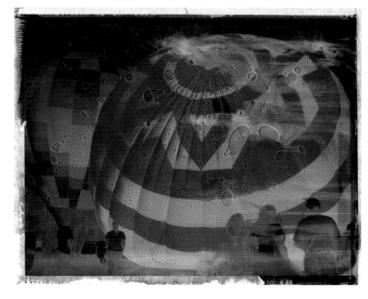

Above and right: Daniel Meade's beautiful hot air balloon images were created by scanning dried Polaroid peel-apart colour negatives. These were dampened before scanning and the wet images were placed directly onto the scanner glass. **Centre right:** Thomas Zamolo's scans of a partially cleared New 55 negative

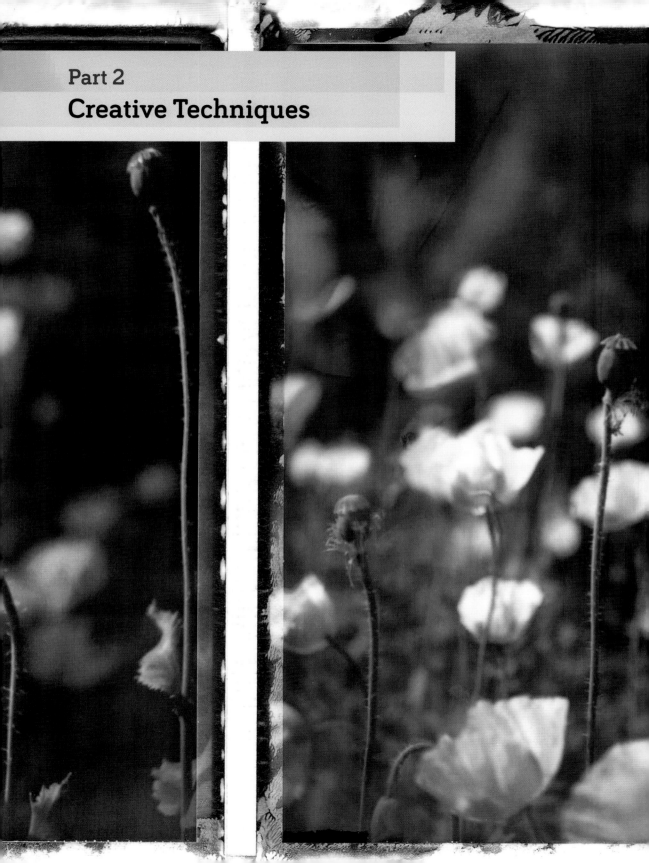

Part 2
Creative Techniques

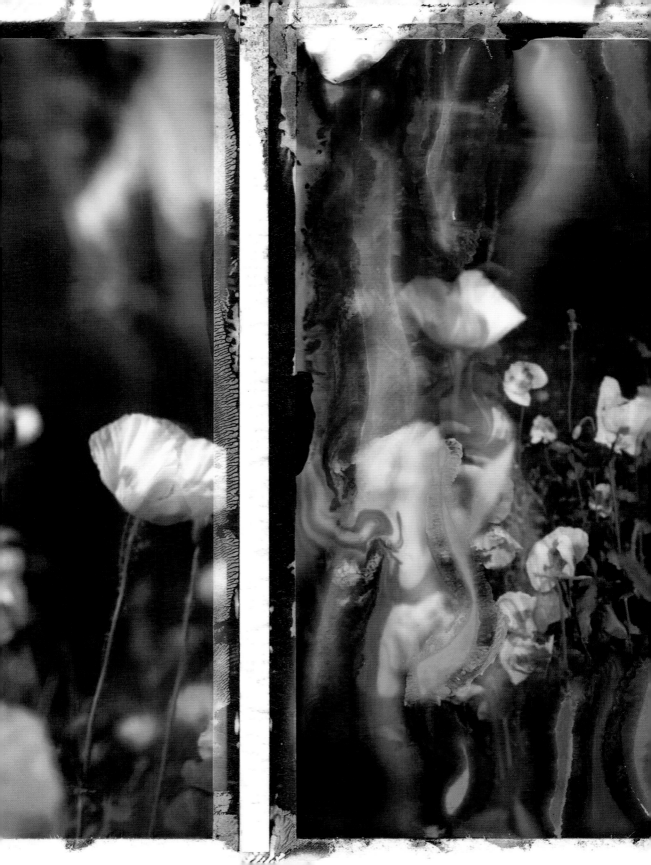

Instant photography is as manipulable as any other photographic medium. Like all photographic processes, it involves working with light: reflecting it, blocking it and so on. It also has very specific chemical compositions, many of which vary across film types. The film also reacts to heat and cold, and to pressure. With so many variables with which to work, by its very nature instant film encourages experimentation.

Most techniques are simple to execute, requiring just a few basic tools, sometimes none at all. The methods shown here fall largely into three simple categories – those involving the use of pressure, water and the manipulation of light – making instant photography a highly accessible creative medium.

Before you try out the techniques in this section, you should first familiarize yourself with your camera and its basic functions. How does it work? What makes it different from other models? Read also about the properties of specific films – referring to Film Primer: Peel-apart Film (see pages 22–23) and Film Primer: Integral Film (see pages 42–43) – as so doing will help you to understand why some techniques work with particular film types and not others. Also learn about the structure of film packs, referring to How To: Swapping Film in Integral Film Packs (see pages 64–65). This will help to prepare you for many of the projects included here. See also the Instant Film Compatibility Guide (see pages 224–29) to find out more about the different film types and cameras that can be used with each technique.

Just remember to be adventurous, take risks, and enjoy! These pages should be a source of inspiration and encourage you to experiment and invent your own tools and methods.

Transparency/Dry Lift

FILM Impossible
TIME 5 minutes
DIFFICULTY Easy

One of the best instant manipulations to start with is known as a 'transparency', 'peel' or 'dry lift'. This method can also be used in combination with many other creative techniques.

Transparencies can be achieved with almost all integral Polaroid and Impossible films – but not with Fuji Instax – and result in see-through images that look great when backlit. They can also be mounted onto transparent (or other) surfaces or sandwiched together. You can also use them to create analogue contact prints, including photograms on cyanotype paper (see pages 190–95).

This step-by-step will focus on how to create transparencies using Impossible film. It is best to use fresh, fully developed images that are no more than twenty-four hours old. Photos with more age than this can be more difficult to separate as a result of the developer emulsion within the image hardening over time.

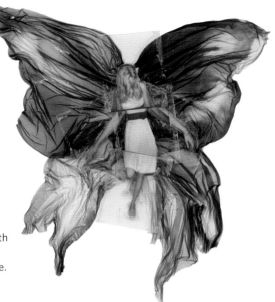

Materials

- Freshly shot Impossible image
- Scissors
- Hairdryer

Method

1 Take your image and cut carefully around the edges **(a)**. Remove 1–2mm all around – this will be just enough to allow the layers to separate.

2 Put the hairdryer on a low heat and position no closer than 10cm (4in.) from the image surface **(b)**. This will allow for even heat distribution, and stop the emulsion from bubbling.

3 Taking one of the corners at the top of the image frame, start to peel the plastic layers apart slowly and evenly **(c)**.

You should be able to easily separate the front of the picture from the black backing. The white chemicals within the frame should remain on the backing and the image stuck to the front window. If white developer is still stuck on your image, see Troubleshooting, opposite.

4 Enjoy the results **(d)** or take it to the next stage by layering together several transparencies or by applying other creative techniques (see Take it further, opposite).

Tip

Try sandwiching your images between two layers of glass, or placing them in a transparent clip frame. They will look very striking if lit from behind.

To preserve the image, paint the underside with a clear UV protector spray and use UV protective glass where possible.

You can also make transparencies with expired Polaroid integral films, though results are less consistent.

The rare film Fade2Black had to be peeled apart to avoid image loss and created beautiful transparencies.

- *Bubbling/tearing of the front image?* This is the result of overheating: reduce the temperature of the hairdryer.

- *White goo stuck onto the transparency's image area?* If you see this happening, stop peeling: the image has either been underheated, or is too old. Try heating again, gently, with the layers together. This should soften the white chemical so that it sticks to itself. Alternatively, separate the layers, wait for the image to cool and remove the white patches with a soft-bristled paintbrush. The patches should be powdery, flaky and crumble off. For stubborn areas, apply lukewarm water sparingly with a paintbrush and dab gently, avoiding the edges of the picture. Too much water will result in the image lifting from the front panel.

Take it further

Use your transparency for:

- Cyanotype printing (see pages 190–95);

- As a base for collage work (see pages 218–23);

- Scratching and scoring (see pages 160–61);

- Making an Impossible Negative, by keeping hold of the black backing (see pages 178–81).

a

b

c

d

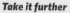

Opposite: Ritchard Ton's *Butterfly*, which was created with 600 film, the emulsion scraped away leaving only the figure, and then layered with emulsion lifts. **Above:** Ton's *Skater*, in which the chemical residue was removed, and multiple shots layered together.

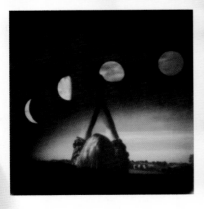
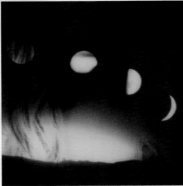

Top row: Penny Felts, Rhiannon Adam, Juli Werner. **Middle row:** Amanda Mason; Ina Echternach. **Left:** Benjamin Innocent (with Celina Wyss).

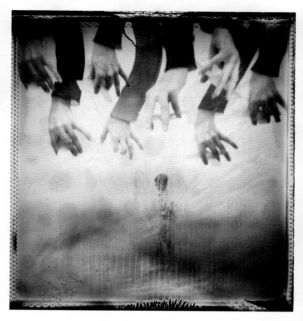

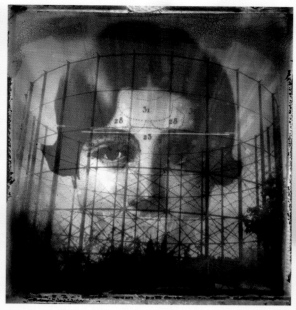

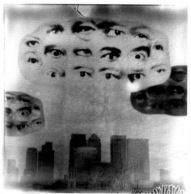

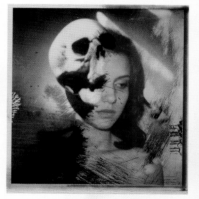

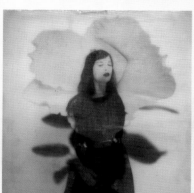

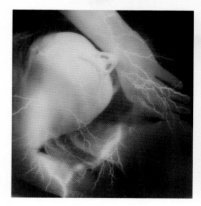

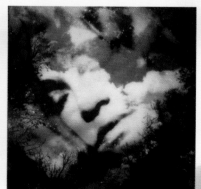

Top row: Nick Carn. **Middle row:** Nick Carn, Philippe Bourgouin, Sarah Seene. **Right:** Benjamin Innocent (with Celina Wyss).

Expired Polaroid Film

All Polaroid film has now expired. Working with expired film can result in unusual and striking effects in your images, but you could also be using ruined stock, so it's a good idea to manage your expectations!

Instant film relies on its internal chemicals being wet and spreadable but over time the chemicals dry up and the pods become hard. Integral film packs also contain a battery that has a tendency to drain until flat if the film is very old. This can result in slow camera operation and ejection, and horizontal lines appearing over the film sheet (that mirror the roller's undulations).

To avoid these pitfalls buy the most recently expired film that you can.

In general, integral films fare less well than their pack film counterparts. Sheet film also often dries out quickly. This is because it is wrapped in foiled paper rather than metal foil, allowing air to seep in.

If you are shooting sheet film always take your film out of the box and place it in a Ziploc bag in the fridge to preserve it.

When buying film ask the seller how it has been stored. This may seem like common sense, however, two batches of film bearing the same expiry date can produce entirely different results, and this is usually a consequence of how well it has been looked after.

It is important to keep all film in the fridge, and especially so with expired Polaroid film. If this

is not an option avoid storing it in humid spaces, and lay it flat, not upright.

Pack film, specifically Polaroid 669 pack film (see page 225), is the most reliable. You could use foil-wrapped twenty-five-year-old 669 and still achieve good results. This film can also be manipulated in many different ways. Over time all pack film emulsions may become blotchy and undeveloped patches may start to appear. Contrast and colour rendition will also weaken.

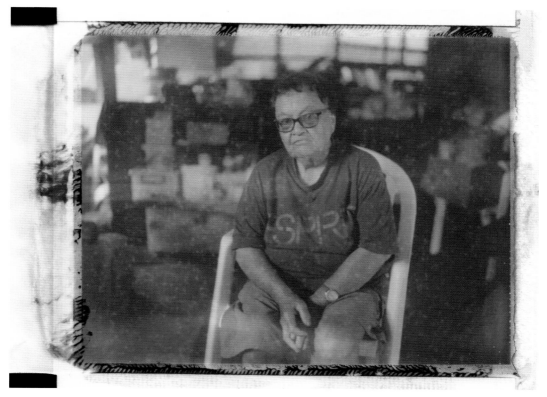

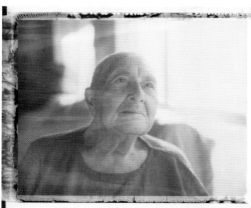

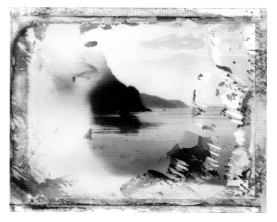

Opposite: A pack of completely dry Polaroid SX-70 film. **Top:** Polaroid pack film loses accurate colour rendition and contrast and can appear foggy and patchy. **Above:** Expired Polaroid pack films often exhibit surface streaks and swirls.

Above right: Dan Ryan makes use of expired pack film's random characteristics, distressing it further during development by crushing and bending it. Brown patches, like those on the right-hand side are typical of expired pack films. These can be washed off after development, or left, adding to the aged appearance.

Expired Polaroid 600, Polaroid Spectra (or Image), 500 (or JoyCam), SX-70 Artistic TZ and SX-70 Blend (based on the 600 film emulsion) and i-Zone films are in general not worth the risk. 600 and Spectra films tend to turn a bright yellow, lose all contrast and sometimes don't develop at all (as can be seen in the portrait, right).

You can buy film from Impossible for the 600, SX-70 and Spectra formats that is much more reliable than the original Polaroid emulsions. Impossible's 600 and Spectra films are also more manipulable. The only expired integral film that is worth buying is original SX-70 because of its unique capability for emulsion manipulation and potential for beautiful and unusual effects.

Left: Expired film shots by Toby Hancock **(1)**, Marion Lanciaux **(2)**, Dan Ryan **(3, 5)** and Rhiannon Adam **(4, 6)**. The most recent batches of original SX-70 and Time Zero films are from 2007, though in this year of production the chemistry changed slightly, which means that the film has fared less well (and is less well suited to emulsion manipulations) than earlier batches. The film sheets are thinner, and tend to turn very dark. They often exhibit brown, undeveloped patches **(4)**. The most recent year in which the original formula was retained is 2006, and this is often more reliable than film from 2007.

You can spot an expired SX-70 shot by the characteristic yellow streaking, heavy blue/green cast and occasional peppering of tiny black spots **(3)**. These effects are not manipulations but the result of expired film being shot as normal.

Lanciaux layered together multiple shots with large undeveloped patches to create her image **(2)**. The undeveloped areas have no chemical at all, and when the image is split open, the window will be completely clear in these areas.

Opposite: Further examples of expired Time Zero/SX-70 film.

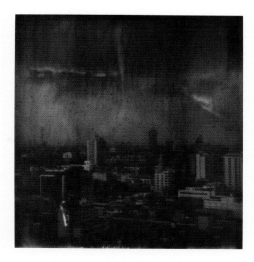

Three years out of date

Five years out of date

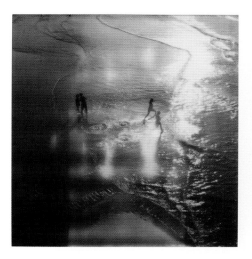

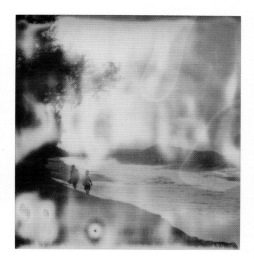

Seven years out of date

Eight years out of date

Long Exposures

FILM Impossible/Polaroid integral
TIME 2–10 minutes
DIFFICULTY Moderate

Shooting long exposures with an automatic pack film camera is easy, since the camera does the work for you. If you have a manual pack film camera, it is also possible to meter and use a tripod to achieve a long exposure.

Integral film cameras, however, have an exposure time limit (SX-70s, see pages 44–56, stopping at around 2 minutes; and box-type 600 cameras, see pages 58–63, 0.25 seconds). If you are using one of these you will need to force the camera's shutter to stay open indefinitely so that light can continue to reach the film sheet.

The new Impossible I-1 camera (see pages 82–90) and MiNT's SLR 670-M and 670-S (see page 45) have a bulb exposure capability, which enables automatic shutter override. If, however, you own one of the several million integral Polaroid-manufactured cameras in the world, this technique is for you.

Materials

- Impossible/Polaroid integral camera with tripod socket (or use gaffa tape to attach the camera to your tripod)

- Tripod

- Compatible film (see pages 224–29)

Optional

- LED torch

- Digital SLR for metering or light meter/metering app

a

b

c

d

Method

1 Attach your camera to your tripod. Set the focus. If shooting distant subjects, set the lens to infinity without focusing. If you are shooting subjects that are nearby on a manual focus camera, you might want to use a torch to illuminate the subject, so that you have a hard line on which to focus.

2 Place your finger over the electric eye window. This will make it appear to the camera that the scene you are shooting is pitch black, and will enable long exposures in a variety of lighting conditions **(a)**. In brightly-lit locations set the exposure dial to darken to prevent overexposure.

3 With the electric eye still covered press the shutter button **(b)**. Your camera will expose for the maximum time of which it is capable. The film will then eject as normal. If you wish to expose for longer refer to steps 4 and 5.

4 To keep the shutter open for longer than the camera's limit, unlatch the film door while still covering the electric eye. This effectively switches the camera off and prevents the film from ejecting **(c)**. The camera will now be trapped in exposure mode.

Expose for the length of time desired. If you are attempting long exposures in well-lit areas – for example, along a roadside to capture light trails – you can cover the lower part of your camera, where the film door is open, with your hand to prevent light leaking into the pack.

When you have finished exposing, close the film door.

5 Although the film door is now shut the film will not automatically eject. Trip the shutter again to make this happen, holding your hand over the lens as you do so to prevent further exposure **(d)**. Keep the lens covered until you hear the camera's motor whir. This may take up to two minutes, depending on the maximum exposure time of your model and the external light conditions.

Once the motor whirs, your long exposure will eject. Wait for the results and admire....

David Teter's *Why I Drove 400 Miles to Take a Polaroid*, taken outside of Datil, New Mexico, using Polaroid 600 film and a SLR-680 camera.

Tip

Use a light meter or a digital camera to help gauge exposure. 600 films are rated at 640 ISO, while Impossible's SX-70 films are 160 ISO. The maximum aperture of a folding SX-70 camera is f.8, which is automatically selected in low light. Use these settings to calculate an appropriate exposure duration. There will be some reciprocity issues when using a digital camera for metering, but if it is all you have to hand, it will still be of help.

Take it further

• Use this technique to record single actions, by focusing on one motion – this motion will need to be very slow for you to capture it accurately – and keeping everything else in the scene still.

• After step 3 you can keep your camera closed and make a second exposure rather than moving on to step 4.

• If you do not cover the lens as in step 4 you could make a double exposure.

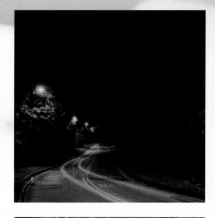

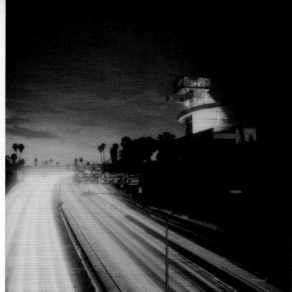

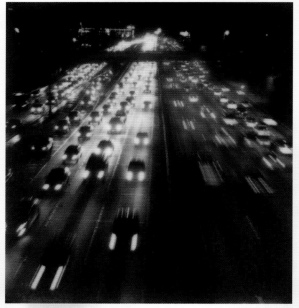

Clockwise from top left: SF Said's long exposure of light trails taken on Polaroid 600 film; two shots by Toby Hancock capturing light trails in Los Angeles; Hancock, Griffith Observatory, California, US; Jimmy Lam, Hong Kong at night taken with Impossible PX70 film in a SX-70 camera.

Right: South Bank, London, this image was exposed for 4 seconds using Impossible 600 film in a SLR 680 camera.

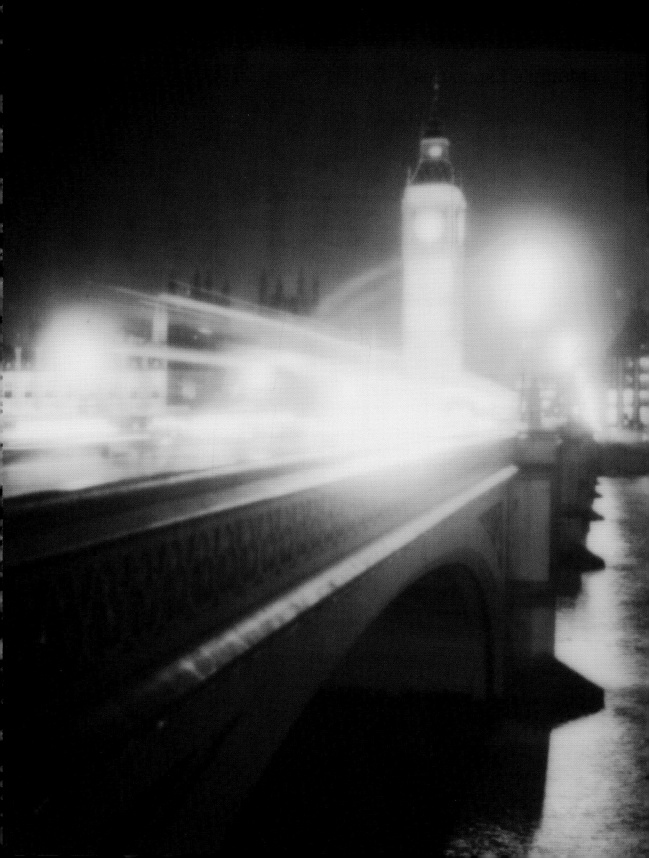

Multiple Exposures

FILM Any
TIME 15–30 minutes
DIFFICULTY Easy

Making multiple exposures is a very rewarding technique and if using a Polaroid camera you can see the results immediately. If you have an integral film camera you will need to override its auto-eject function to allow for more than one exposure (though if you have an Instant Lab, see page 73, this is not necessary).

Multiple exposures have to be made within the camera itself before the image is processed. There are several ways to do this. The following method works across all integral formats, including Fuji Instax (see page 78). The trick is to make a 'dummy' sheet of film – a film frame with a transparent window – that you can insert into your camera and which it will eject as normal. As you take your first shot, light will pass through the transparent window and onto the film sheet below. The dummy will then eject. The second shot you take will expose onto the same film sheet, which is now at the top of the film pack. The camera will eject this film sheet for processing, and there you have it, a double exposure!

If you own a Spectra camera (see pages 66–71), you will find a variation on this technique on page 113, though the step-by-step here can also be used. Another method in which you can use dummy sheets of film for manipulations is filtering and masking (see pages 114–23).

Note

This method can cause the camera to jam. Take care when rectifying any glitches so as not to damage your equipment. Refer to the troubleshooting section (if applicable) for your camera in Part 1 of this book for help. The best way to avoid camera jams is to use a Spectra (see pages 66–71).

Materials

- 'Dud' image
- Cutting mat
- Scalpel
- Acetate
- Clear transparent tape
- Darkroom or dark bag
- Pack of film
- Instant camera (with a lighten/darken wheel/slider)

Method

1 Select a dry 'dud' image, one that you don't mind discarding **(a)**.

2 Cut away the image area entirely, removing an extra 1–2mm (⅛in.) on each side **(b)**

Note

The film pack batteries in Impossible film made for use with 600, SX-70 and Spectra cameras are intended to last only for as many exposures as there are in the pack. There is usually plenty of power left after shooting a pack of film as normal, but you can run into problems if you use the entire pack for double exposures, so keep track of how many shots you have taken. This does not apply to Fuji Instax, which uses external batteries.

Materials

a

b

c

e

d

to avoid any misalignment of the dummy image and film sheet (this will result in parts of the image being unexposed).

3 Cut the acetate into two pieces slightly larger than the image area you have just removed to make your transparent window **(c)**. Tape these together to secure (the clearer the tape the better, as this will prevent masking on your final image).

4 Fix the acetate to the frame, applying tape to both the front and back so that the window is fully secure **(d)**.

5 Now, in complete darkness (in a darkroom or dark bag), take out your film pack and remove the dark slide so that you can insert your dummy image **(e)**. If you are unsure as to how to do this, refer to pages 64–65.

6 Insert the dummy sheet at the very top of the pack, above the first sheet of film **(f, overleaf)**.

If you are using a new pack of Impossible film, there will already be eight sheets of film inside the pack covered by a dark slide, and not enough space for your dummy sheet.

Tip

This technique works best when shooting subjects with defined edges, and areas of light and shade, as shown in this image by Rommel Pecson (below).

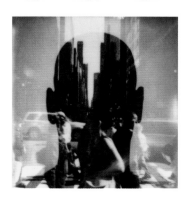

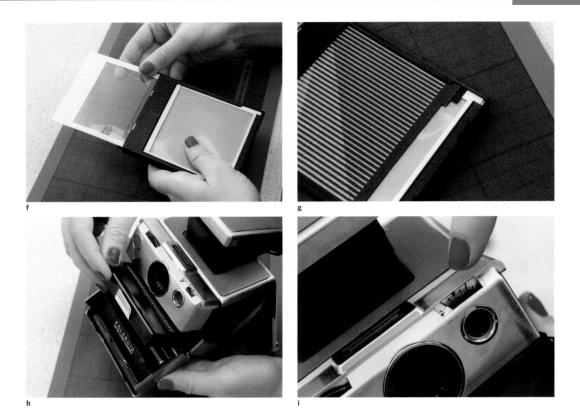

f

g

h

i

To make room you will need to remove both the dark slide and the first sheet of film from the pack, gently sliding them out, being careful not to press too hard. Store any unused sheets of film in a light-tight bag/box and reinsert them later.

7 Return the dark slide to the top of the pack. As you do this make sure that the tab at the top left of the slide aligns with the notch on your film pack **(g)**. Press gently on the centre of the dark slide in order to push it under the film pack frame. Your film pack is now ready!

8 Insert the film pack into the camera as normal **(h)** and allow the dark slide to eject.

9 Turn/slide the lighten/ darken wheel halfway towards darken for double exposures, and all the way to darken for triple exposures (so that you don't end up with blown out, overexposed multiple images) **(i)**.

You are now ready to shoot the first part of your double exposure. After taking the first picture, the dummy shot will eject. You can keep this for future use.

Then, when you are ready, shoot your next image: the result will be a wonderful double exposure.

Note

You can use a whole pack in this way – alternating dummy and active film sheets – to make up to a maximum of four double exposures. To make a triple exposure first remove two film sheets from the pack and then insert two dummy images.

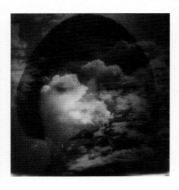

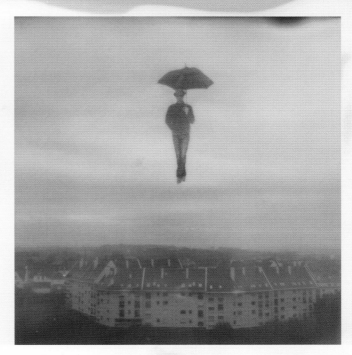

Above: Double exposure on Impossible SX-70 film. **Right:** Ludwig West's double exposure on Impossible SX-70 Push film. **Below right:** *Louvre Pyramid*, double exposure on expired Polaroid 669 film.

Multiple Exposures with Pack and Sheet Film

Making multiple exposures with pack film cameras/systems is simple, with there being no need for a darkroom or special equipment. This is because you have to pull the film through the rollers by hand for processing.

If you leave the film sheet in the camera after you have taken your first shot, you can simply press the shutter again to make a double exposure, and once more for a triple exposure, then remove the film once finished. To prevent overexposure, turn/slide the lighten/darken control (if you have one) towards darken as shown in step 9.

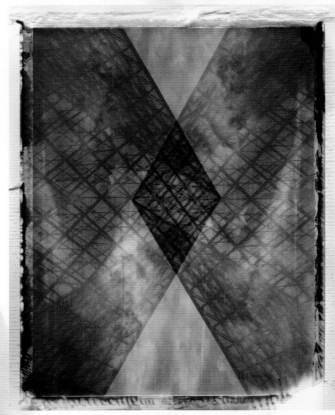

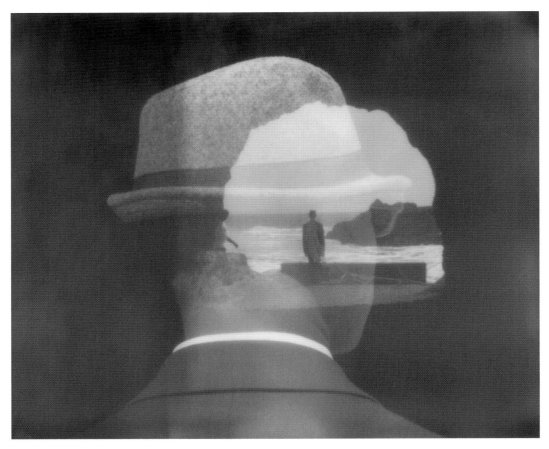

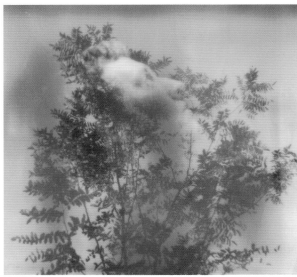

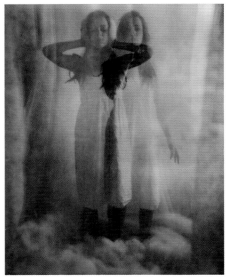

Top and above: Brandon C. Long's
Spectra double exposures.

Above: Penny Felts's *Silence*, a Spectra
double exposure.

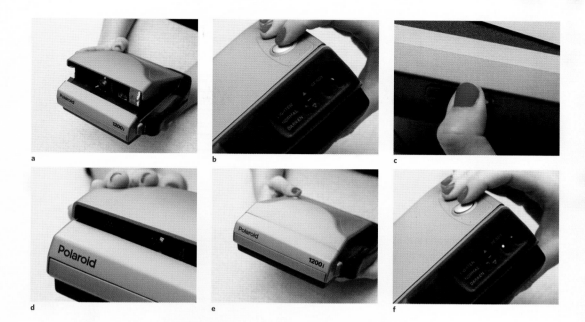

a

b

c

d

e

f

Multiple Exposures: Spectra Cameras

Materials

- Any folding Spectra camera (except the 1200FF), see pages 66–71

- Pack of compatible film (see pages 224–29)

Method

1. Open your camera **(a)**.

2. Turn the lighten/darken switch towards darken **(b)**.

3. Load your camera, identify your subject and press the shutter button: do not release the button.

4. With your other hand, slide the body release button backwards **(c)** and start to collapse the camera down **(d)**.

5. Once fully collapsed **(e)** you can let go of the shutter button. You have successfully interrupted the circuitry and reset the camera (the camera has forgotten that it took the first shot).

6. Open your camera and take a second shot **(f)**. The image will now eject and begin processing.

Self-timer Variation

For Spectra cameras with a self-timer function (mid-range and pro models, see pages 67–71), you can make double exposures without holding the shutter button down while closing.

1. Set the camera to darken, adjust the self-timer and press the shutter.

2. Wait for the shutter to click at the end of the timer period and do not switch off the timer. If you do, your picture will eject.

3. Just as before, simply close the camera to reset the system. You can use the self-timer to take the second part of your exposure, or you can turn the timer off to shoot as normal.

4. Take your second shot as normal and your double exposure will eject.

Cartridge Manipulations: Filtering and Masking

FILM Any
TIME 60 minutes
DIFFICULTY Hard

Thanks to the physical properties of the film and hardware, instant formats allow for greater experimentation than conventional film photography. Take integral film, for example: each sheet of film is completely self-contained and easy to access. If there is an issue, only the top sheet, rather than the whole pack, is usually affected. This is advantageous for several techniques in this book, including polagrams (see pages 186–89) and multiple exposures (see pages 108–13).

The methods of filtering and masking follow are not dissimilar to multiple exposures and involve selectively exposing the film to light, shapes or colour. The parts of the film that have been exposed to light appear brighter and more visible in the final image, those where the light is blocked or filtered (using a coloured gel, for example) will be dark or have a tint to them. In all these examples you are selectively controlling the light that reaches the film.

It is possible to create a variety of effects with filtering and masking. You could produce a single-shot mask (for example, by making pinprick holes in a dummy shot/dark slide to emulate 'stars') to affect either one image or multiple ones. Similarly you can create filters (for example, by drawing/writing onto acetate) for individual shots or for the whole pack. You can use the same principle to tape coloured gels over your film packs, or even make your images colourful and stripy by exposing through a filter made of lighting gel strips.

There are so many options for image-making here, that the following step-by-steps outline only the basic principles of the methods, leaving it up to you to experiment!

Mask or Filter?

Before you decide whether to make a mask or filter, consider the final effect that you want to achieve in your image, and if you want to customize your whole film pack or just one frame.

If the whole pack, you must securely tape your mask/filter to the top of the pack so that it stays in place as the film exits sheet by sheet. If you want to customize just one slide, you will need to create a mask/filer that you can insert at the top of the film pack: the camera will treat it as a sheet of film, pushing it out through the rollers after the shutter has been pressed.

Masks
A mask will block sections of your film from light completely, as in **(a)**, which was created by

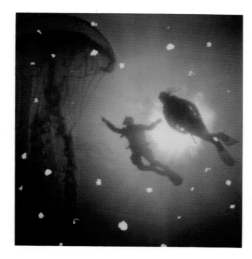

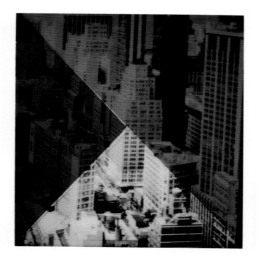

a

b

a single-shot mask inserted into the top of a film pack and the film double exposed. You can also use masks as a type of stencil, cutting shapes or even words into them, so that these elements are the only thing that becomes visible in the final image.

Filters

A filter is relatively transparent and will allow some light through to your film, as in **(b)**, which was made using colour acetate. You can also use filters to create small details that might be difficult to cut out of a mask (for example, using a marker pen to draw on the filter the shapes you don't want to be exposed in the final the image), as in **(a)**. You can use the filter method to make your own hand-drawn designs (using permanent colour pens or painting a wash over the filter) appear on the final image.

You could also laser print your designs onto printable acetate and cut it to size to make your filter. Alternatively, you could create neutral density filters, allowing you to use 600 film in an SX-70 camera (see pages 44–56), or transform the colour of your shots by covering the pack with lighting gels.

Filters are equally a good choice if you want to feature text in your image. You can write on top of a transparent dummy frame with black marker, insert it into your pack: the words will appear in black on your image.

In general, filters provide a greater range of options. They also produce softer and more ethereal results, whereas masks are good for sharp edges/lines. You can also use masks and filters in combination.

These methods all require some preparation and forward planning. Don't be afraid to experiment: filtering and masking is very much trial and error and it is highly likely that you may not achieve the effects you are after on your first try. But don't let this deter you.

Pack Filters and Masks

Method 1 (Pack-filtering)

1 On your cutting mat, cut a piece of acetate to size, using an old film pack or dark slide as a template. It should be slightly larger than the open exposure area of your film pack. Cut a notch in the top left-hand corner of your acetate, so that it roughly aligns with the notch on your film pack **(a)**. This will minimize the risk of jams.

2 Make a design on the filter with permanent markers (to avoid smudging) or, with paint, add a colour wash and allow to dry. This decoration will filter/tint the light as your film is exposed **(b)**.

3 Tape the filter to the top of your film pack **(c)**. Use the tape sparingly: too much will make the pack bulkier and cause jams.

If using integral film, make sure that any loose edges have been securely taped to avoid the filter snagging. To avoid jams, be careful not to tape up or obstruct openings such as the film exit slot or the small notch at the top left where the camera's pick arm pushes the film out.

4 Insert your film pack into your camera **(d)**. If shooting with a Polaroid integral film camera, the dark slide (which will now be sitting under your filter) should eject. If it does not, the pack may be too bulky or the pick arm blocked. Remove the film pack from the camera, adjust the tape and reinsert the film.

5 If using a Fuji Instax camera (see page 78) or Instant Lab

(see page 73) press the shutter/eject button to make the dark slide eject. If using a pack film camera, you will need to follow the usual process for removing the dark slide.

6 Set your camera's lighten/darken wheel **(e)**, or slider (if present). Most filters reduce the amount of light that reaches the film, so it's a good idea to turn the lighten/darken wheel towards lighten (white), or to overexpose slightly.

7 Now take a picture and watch it develop **(f, h)**. Your very first pack-filtered shot!

Materials (Methods 1 and 2)

- Cutting mat
- Craft knife/scissors
- Sheet of clear acetate
- Coloured permanent markers and/or lighting gels (filters)
- Sellotape
- Any (new) film pack
- Compatible camera
- Black card/dark slide (masks only)

Method 2 (Pack-masking)

Follow the process as in Method 1, though instead of using acetate, take a piece of black card and cut away the areas you wish to expose through **(g)**. Your image will only appear in the sections you have cut away, and everything else will be black.

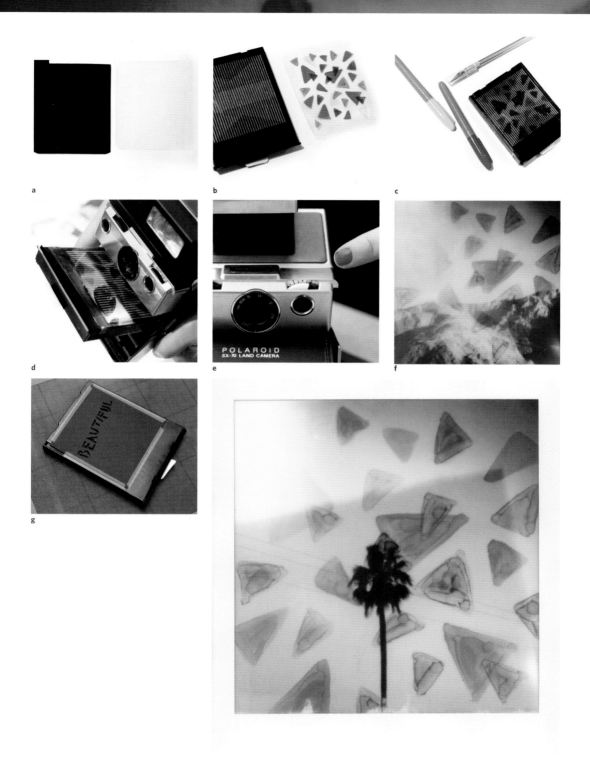

a

b

c

d

e

f

g

h

Single-shot Masks

This method works best with a part-used film pack. If you are working with a new pack, you will need to remove (in complete darkness to avoid exposure) 1–2 film sheets to make space for the mask.

This method will not work with pack-film cameras because the film sheets are all rolled together, making it almost impossible to insert single sheets into the pack.

Materials

- 'Dud' sheet of film (same format as your camera, see below)
- Cutting mat
- Craft knife/scissors
- Sellotape
- Integral film pack
- Compatible camera
- Compatible original dark slide (if you're not using a new pack)

Method 3

1 Make your mask. Take an old unwanted shot of compatible film and on your cutting mat remove with the craft knife the area you wish to expose **(a)**, leaving the rest intact. Make sure this shot is fully dry inside, otherwise chemicals from the pod may still be wet when going through the rollers, ooze out from the frame and damage the camera.

2 Tape up your mask **(b)**. If you have cut large sections away from your mask it may weaken and distort as it starts to eject from the camera, causing jams. You can use the tape to strengthen your cut-out design. Cover both sides completely so that none of the tape's sticky is exposed, fully encasing all the edges of your cuts. Press the layers of tape together tightly to avoid air bubbles in the cut-out areas (these can obscure the image as you shoot).

3 Have both your film pack and 'dummy frame' ready **(c)** and insert the 'dummy' into the pack. There are two ways to do this.

The first involves going into a completely dark space to prepare the film pack (see pages 64–65). Remember to remove a couple of shots from the pack to avoid pack tension. (If you cram too many film sheets into the pack jams will occur.)

After inserting your mask, return the dark slide to the pack, making sure that it is the right way up, with the small tab area aligned with the notch at top left of the pack.

The second and simpler option (since you are only masking one shot) is to – in darkness – remove your film pack from the camera and cover with a dark slide. Once this is in place, go back into the light and slide your mask into your film pack underneath the dark slide **(d)**, carefully to avoid light leaks. You can then insert the film pack into the camera as normal.

4 Press the shutter to make your first exposure, bearing in mind the design of your mask when choosing your subject. After you press the shutter, the mask will eject (you can keep this and re-use later).

5 Press the shutter again. This will now expose the whole frame, as well as the cut-out area of your mask for a second time (or see Tip). Your double-exposed, masked image will eject.

Tip

If you want simply to expose the mask cut-out and not make a double exposure **(e)**, you can block the camera's lens from light when pressing the shutter (step 5) or use a pack-mask (see pages 116–17).

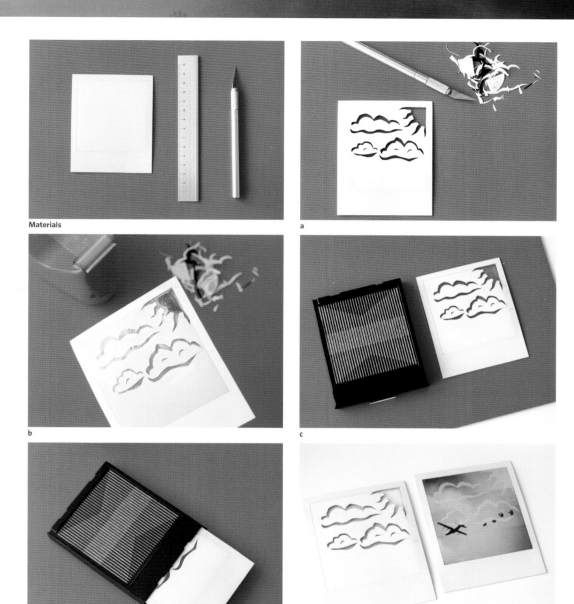

Materials

a

b

c

d

e

Single-shot Filters

Method 4

1 Make a frame. Take a 'dud' shot and on the cutting mat cut away the entire image area, leaving only the white frame intact. Make the hole slightly larger (by 1mm/⅛ in. or so) than the image area, to ensure that the receiver sheet is fully exposed (and doesn't suffer from dark bands on the edges once ejected).

2 Make your filter. Trim your acetate so that it is slightly larger than the hole in the film frame and tape the two together, covering up any loose edges. The acetate makes the frame sturdy enough to eject cleanly from your camera, while the tape creates a smooth sheet, minimizing the risk of jams or snags **(a)**. Draw on the acetate with marker pen to create your filter **(b)**. (You could also use a printer to create your designs.)

3 Insert the filter into your film pack under the dark slide (as shown on page 118).

Materials

- 'Dud' image
- Cutting mat
- Craft knife/scissors
- Thick acetate
- Sellotape
- Marker pen
- Integral film pack
- Compatible camera

4 You are now ready to shoot. Turn the lighten/darken wheel on your camera towards lighten (to compensate for the reduction of light caused by your filter). The level of compensation required depends on the density of your design. Once you have take your first shot the filter will eject **(c)** (save this for later use). The second shutter press will eject the shot that has been filtered **(d)**. As with single-shot masks (see pages 118–19), unless you wish to take a double exposure, you will need to cover the lens completely for the second shutter press.

Note

In this method you are essentially making a double exposure, although the affects of your filter will be quite subtle.

You can adjust exposure to compensate for the fact that you are exposing the same film sheet twice by turning the lighten/darken wheel or slider by at least a ¼ turn towards darken to underexpose each one **(e)**.

Tip

For a sturdier filter you could insert a colour gel in-between two sheets of acetate, seal together by taping around the edges and then fix to the frame on both sides.

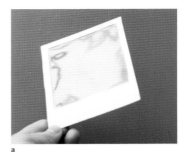
a

b

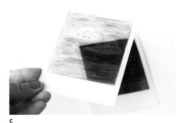
c

d

e

Take it further: Double masking

Make masks that are 'opposites' (one blocks while the other reveals) **(a)**.

When layered together, these masks will fully block the light **(b)**. When inserted one at a time, the film is blocked once and exposed once (there is no need to adjust the lighten and darken wheel/exposure control).

In example **(1)**, the image was exposed only once using the brown mask. In example **(2)** the final image was created by using both masks in succession.

First position one mask under the dark slide of a part-finished pack **(c)**. Insert the pack into the camera to make the dark slide eject. Next, shoot an image: the mask will eject **(d)**.

Go into a dark space and insert your second mask on top of the exposed film sheet (which will still be at the top of the pack). Cover the second mask with the dark slide and insert the pack into your camera.

Take another picture. The second mask will eject **(e)**. Your film has now been exposed with both masks.

Cover the lens with your hand to avoid exposing the film sheet again, and press the shutter for a third time, allowing your double-mask image to emerge **(f)**. When fully developed you will have a split image, as seen in example **(2)**.

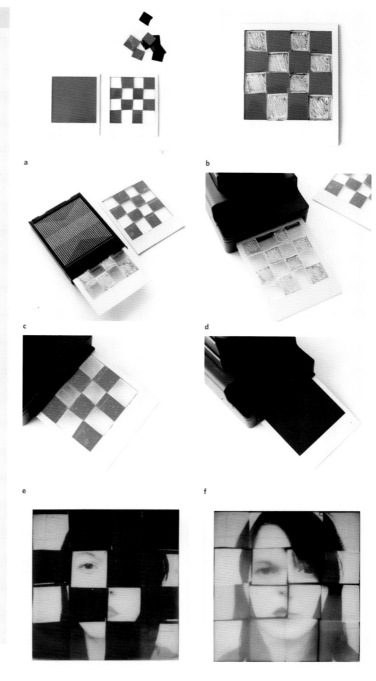

a

b

c

d

e

f

1

2

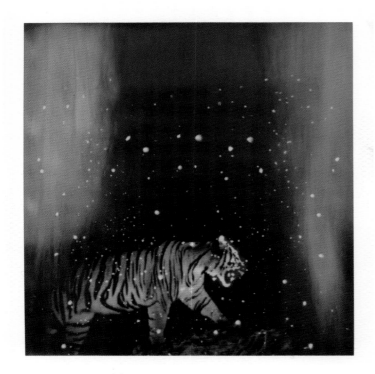

Clockwise from above: Enrique
Freaza's photographs made using
single-shot masks (above left and
top right) and a cartridge-filter
(centre right); Eduardo Martinez
Nieto's single-shot mask image.

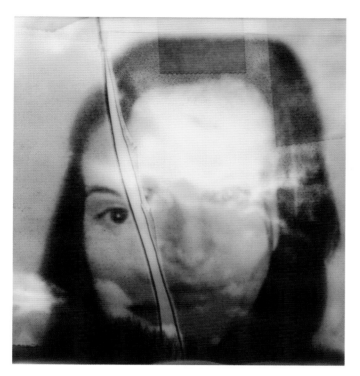

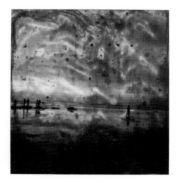

Clockwise from top left: Carmen De Vos, *Unconditional* and *Untitled*; Dominik Werdo's pack-filtered shot, Esther Schnickenacke, *Wet Sand*, Carmen De Vos, inside the Getty Museum.

Controlled Burn

FILM Impossible
TIME 15 minutes to several hours
DIFFICULTY Easy

Controlled burn is a process very similar to masking (see pages 114–23), but instead of making a mask and inserting it into your film pack before shooting, you lay it on top of your film sheet after a shot has been taken and begun to develop.

Note that Impossible film is much more sensitive to light than other film when it first ejects from the camera, hence the need to shield each sheet on exit with your hand or to use the Impossible 'frog tongue' (see page 89). This characteristic is usually a hindrance but here it can be used to creative effect. With the aid of time, sunshine and a piece of glass this technique can also be used for images that are not fresh (see Note, below).

Materials

- Dark slide/thick black card (at least the same size as the image area of your film, see below)
- Cutting mat
- Craft knife
- SX-70 (see pages 44–56)/ 600 (see pages 58–63/ Spectra (see pages 66–71) camera
- Compatible Impossible film (see pages 224–29)
- Piece of glass slightly bigger than your image

Optional

- Clipboard

Note

This technique is simple to achieve because of the light sensitivity of Impossible film. It may take up to a week to achieve equal levels of bleaching with other films. As Impossible film improves further, and the need to shield each shot after exposure is eventually eliminated, it will take longer than just a few minutes to achieve this manipulation.

Method

1 Take your dark slide or thick black card, place on your cutting mat and cut out a stencil design with the knife. The areas that have been cut away will appear as a different colour after the image has fully developed **(a)**.

2 Take a picture. Focus on a subject/scene that has dark areas so that when you place your stencil on top of the image there will be more contrast in colour **(b)**. As soon as it has ejected cover the picture with the stencil and place the glass on top **(c)**.

3 Transfer to a brightly-lit area, ideally in sunlight, no more than 30 seconds after you have taken your shot. To avoid the stencil/glass slipping you could use a clipboard to hold them together **(d)**.

4 Wait for your picture to fully develop and check the results (opposite). If you want to see a more pronounced contrast in colour, leave it in the sun for longer.

a

b

c

d

Take it further

A variation of controlled burn also works with pack film, all you need to do is peel apart the layers and insert a stencil in-between them during development. Working quickly, push the emulsion through the cut-out. This section of the image will continue to develop while in the blocked areas it will stop. With Fuji film you will see black sections where the two layers have made contact again after separation. This is because the negative has been solarized.

Light Painting

FILM Impossible/Polaroid integral
TIME 10 minutes
DIFFICULTY Hard

Light painting is a great, fun technique. You can use it to create beautiful illuminated swirls, writing and abstract shapes, as well as for photographic trickery, including multiple exposures (see pages 108–13). The theory is simple: in complete darkness you open the shutter of your camera for an extended period and use a torch to 'paint' or expose the areas that you want to appear on your print. The camera can only 'see' what you choose to highlight, so with your torch you are effectively 'burning in' the areas that you want to appear in your final print. Though not exclusive to instant photography, light painting using instant cameras does require a little ingenuity.

If using Polaroid (or Fuji) integral cameras for this process, you will need to override the maximum exposure time of these models (usually just by a few seconds) by keeping the shutter open for just long enough to make and capture your 'painting' effectively. The step-by-step in these pages will show you how to do this. For pack-film cameras, see Note, below.

Materials

- Impossible/Polaroid integral film
- Compatible camera with a tripod socket/adaptor
- Tripod
- Torch (with a narrow and controllable beam, for example, a LED)

Optional

- Coloured gels

Note

Manual pack film cameras feature an in-built bulb setting, allowing you to keep the shutter open for as long as required. With automatic pack film cameras, the shutter will time-out after a set period (around 10 seconds). To expose your film for longer cover the electric eye's photocell (if present). Next, to override the exposure time limit, trip the shutter after each time-out: keep doing this for as long as you wish to expose.

Method

1 Insert your film into the camera. Attach the camera to a tripod **(a)**. Prepare your scene/subject and focus the camera. Turn off the lights and test your torch, ensuring that the beam is as narrow as possible (for strong, clear lines). Turn the torch off.

2 In darkness, press the shutter button **(b)**. Now let go: your camera will continue to expose. Cover the lens as you do this to avoid ambient light and unwanted exposure.

3 Quickly open up the film compartment (this switches off the camera, trapping it in exposure mode and preventing the picture from ejecting) **(c)**. When you are ready to begin exposure uncover the lens.

4 Turn on the torch and 'paint in' with light **(d)** the areas that you want to be seen in your final image. If shooting in colour, you can use a coloured gel over your beam: this will create a tint in the image.

To achieve the 'triplets' picture illustrated **(e)**, first position your model to the left of your scene and shine the torchlight on them. Get close if necessary. It won't matter if you are in the shooting area as long as the parts that you

are illuminating are still in full view of the camera. Paint in the model's arms, legs, head, torso and any portion of the background that you want to be seen. Do this quickly, moving the beam accurately over the area you wish to expose. Remember, if you apply too much light your image will be overexposed and white. Once you are finished turn off the torch. You now have your first 'triplet'.

To create the second 'triplet' have your model move to the right of the scene and repeat, avoiding the area that you have just exposed (if there is too much overlap the background will show through). Repeat for the central figure. When you have finished, turn off the torch.

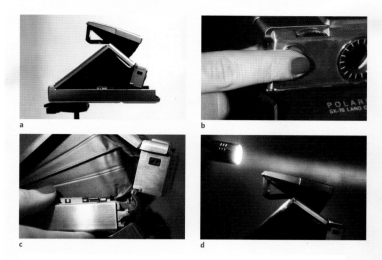

a b

c d

5 Close the front of the camera **(f)** and cover the lens once more.

6 The shot will not auto-eject. You will need to press the shutter button again to make this happen. Keep the lens covered with your hand as you do so **(g)** and wait until you can hear the motor whir before you remove your hand (to avoid any ambient light being absorbed by the film).

You can repeat step 4 as many times as you wish, though bear in mind that the more 'painting' you do the more overexposed your final shot may be.

e

f

g

Twins: a variation of the method described on pages 126–27.

A layered exposure created by quick light flashes.

described on pages 126–27.

Note

This technique requires practice and a good understanding of your camera. Don't be discouraged by failure at first. If you have a digital camera with a tripod socket, bulb setting and film-speed selector, practise the timing of exposures by matching the digital ISO to your integral film speed.

You can achieve similar results by making very quick exposures, which can be done by switching a light off and on during exposure. If so doing it is best to turn your camera's wheel to darken.

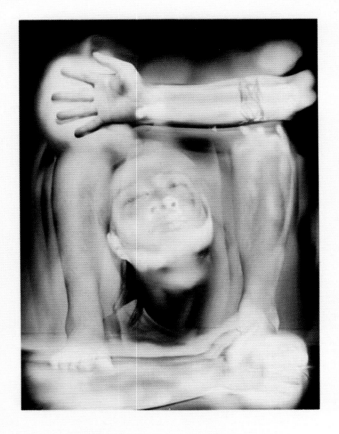

Above: Drew Baker's light painting on Fuji FP-100C pack film, encompassing five exposures.

Centre right and right: Baker's light paintings, made using sparklers and laser torches.

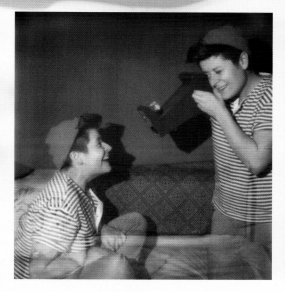

WONDER

SUPER

Top row: *Big Shot*, double-painted exposure on Impossible black-and-white SX-70 film; *Triplets*, triple-painted exposure on Impossible black-and-white SX-70 film. **Middle row:** Mathieu Mellec's combined cartridge manipulations and light painting. **Bottom row:** Lucile Le Doze; Lou Noble.

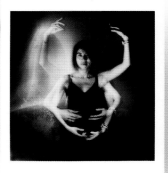

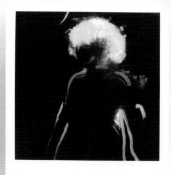

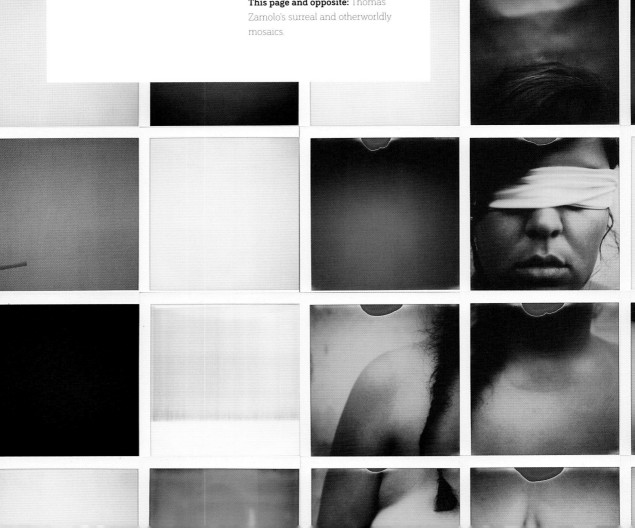

Mosaics

Instant photographers have been making mosaics for almost as long as Polaroid has existed. This is a great technique for creating large-scale works from multiple prints.

Instant mosaics saw a rise in popularity after David Hockney started exhibiting his perspective-altering photo montages in the 1980s. The birth of the first integral films (the SX-70 system, see pages 44–56) made the mosaic-making process even easier, since it was possible to layer the prints on top of one another and watch the mosaic grow in situ without having to wait for each image to dry first.

There are many contemporary instant photographers who use mosaics in their work and, as this inspiring artist showcase demonstrates, the possibilities really are endless.

This page and opposite: Thomas Zamolo's surreal and otherworldly mosaics.

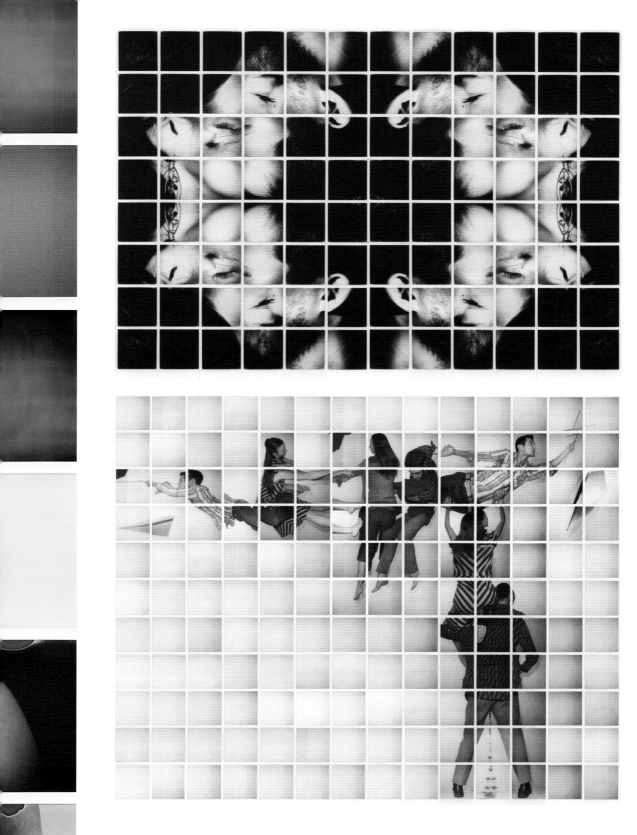

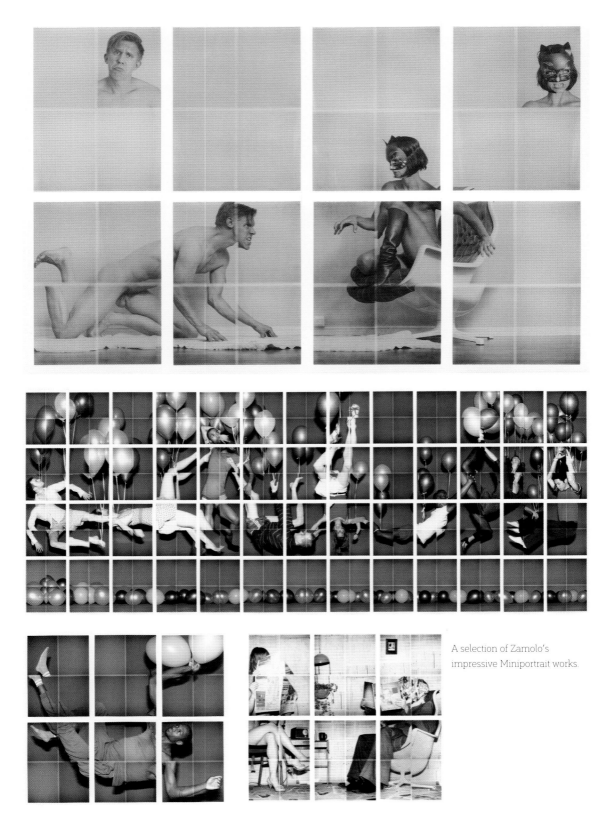

A selection of Zamolo's impressive Miniportrait works.

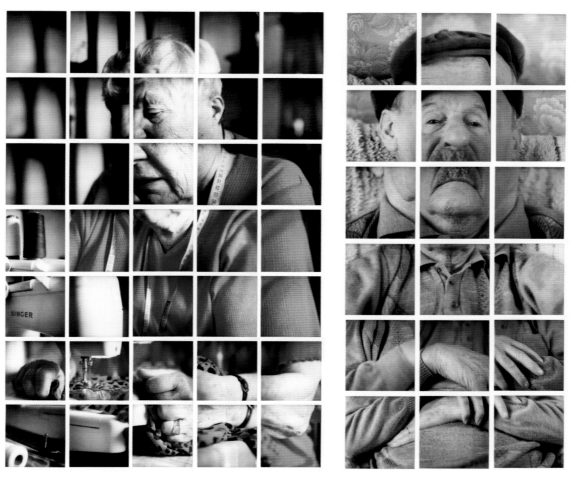

Like David Hockney and Daido Moriyama, Zamolo tiles together integral images to produce large-scale works that play with form and perspective.

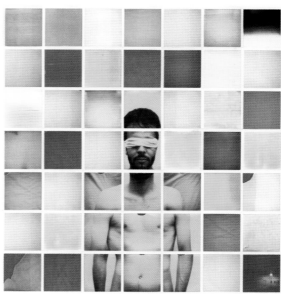

Image Transfers: Polaroid Peel-apart Film

FILM Polaroid peel-apart
TIME 20 minutes
DIFFICULTY Moderate

The principle of an image transfer is simple. Once you have shot a peel-apart image, you can halt the transfer of the dyes onto the receiving sheet of the Polaroid (the positive) by peeling the film apart early, so that the image stays on the 'negative' portion. You can then press this negative into a porous substrate and allow the dyes to transfer while still malleable, essentially making a positive print.

Image transfers can be made with some original expired colour Polaroid peel-apart film and, with some adaptation, Fuji FP-100C. Don't confuse the terminology 'image transfer' with 'emulsion transfer' (or 'emulsion lift', see pages 140–49). The latter of the two involves transferring a positive print that has fully developed and hardened onto a substrate such as paper.

You can also use fully developed pack film images and dried negatives – Fuji pack films produce much better results than Polaroid – to make transfers (see page 137).

Note

It is not possible to use Impossible film or Instax for this method. Only expired Polaroid or Fuji FP-100C film will work: both can be easily sourced online. Polaroid films 669, ID-UV, 690, 59 (5"×4" sheet), 559 (5"×4" pack) and 809 (8"×10") are best (see pages 224–29).

Note

Use freshly shot images and work quickly. It is best to try out this technique indoors, so the paper doesn't dry out too rapidly. With a little preparation transfers can also be made on the go.

Materials

- Watercolour paper (300gsm, acid free)
- Kitchen towel/fibreless cloth
- Cutting mat
- Polaroid peel-apart film camera or Daylab/Vivitar Instant Slide Printer (see page 72) and colour slides
- Compatible film (see pages 224–29)
- Roller

- Trays and running water

Optional

- Scissors
- Hairdryer
- White vinegar/bleach
- Rubber gloves
- Soft-bristled paintbrush
- Lighting gel sample booklet (if using a slide printer)

Method

1 Soak your paper in warm water for about 15–30 seconds or until it is limp **(a)**. Gently shake the paper to remove the excess water and place it on a hard, flat work surface. Blot with the kitchen towel/fibreless cloth.

2 Shoot an image (or use one that has been made with a Vivitar Instant Slide Printer/ Daylab, see pages 72-73). Pull the image from the camera to

Materials

a

b

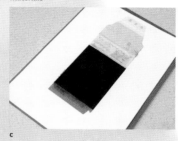
c

d

e

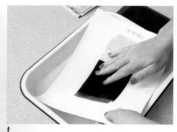

f

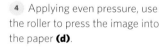
g

begin processing **(b)**. Allow to develop for 10–15 seconds. If you leave it for longer than this, too much dye will transfer to the 'positive', resulting in a less colourful negative. If you peel too early, however, the negative will be almost completely blue.

Tip

If you want a transfer with clean edges cut off the two flaps that catch the excess chemical (as your image is still developing). These can be found at the open end of the film sheet (opposite the chemical pods). If you leave these intact, a brown tint will appear on the left edge of your transfer (you can remove this later in a bleach bath, see page 136, step 9).

3 Once 10–15 seconds has elapsed, quickly separate the two layers of the image. Place the 'negative' face down on the paper **(c)**, pressing firmly so that

it is completely affixed. Make sure that the negative does not move as you do this, otherwise the transfer will be blurry.

4 Applying even pressure, use the roller to press the image into the paper **(d)**.

5 If you are working with a textured surface, like the watercolour paper recommended here, you may need to work the negative into the lumps and bumps to ensure full contact.
You can use your thumbs to do this, or take a soft cloth and rub it over the back of the negative **(e)** to ensure full contact.
Take care: if you apply too much pressure, emulsion can

'bleed' out from under the image; if you apply too little, the transfer will appear patchy.

6 You can keep the negative warm during development by submerging it in tepid water, being careful not to let it lift off the paper **(f)**, or by using a hairdryer on a low setting. This will give you more time to work.

7 Leave to develop for 1–2 minutes before peeling the negative very slowly away from the paper **(g)**. You can use a damp soft-bristled paintbrush as an aid if necessary or submerge the negative and paper in water to reduce the chances of damage.

8 With the negative now removed, you might observe brown streaking on the final image **(h)**. If you are happy with this effect leave your print to dry. To remove it, see step 9.

9 To remove streaking fill a tray with a white vinegar solution (1:4–5), submerge the transfer and agitate for about 30 seconds, at room temperature. You can also use a diluted bleach solution (1:15). Put on your gloves and apply with a paintbrush **(i)**. Both solutions can be used to brighten or add highlights to the transfer.

When you are happy with the results, rinse the paper gently with water.

10 Leave your transfer to dry flat. You will now have two images from the same shot: a transfer and a pale positive print **(j)**. The latter can be used for emulsion lifting (see pages 146–47), though the emulsion will be very thin and delicate.

11 The texture of the substrate can enhance the subject of the image, as can be seen right, where the 'rocky' mountains are emphasized by the coarse paper **(k)**.

Tip

You can further manipulate your transfer by rubbing out areas, or scoring/dyeing/tinting the surface.

Try transferring onto other surfaces too: unglazed ceramics, wood or gold leaf, for example.

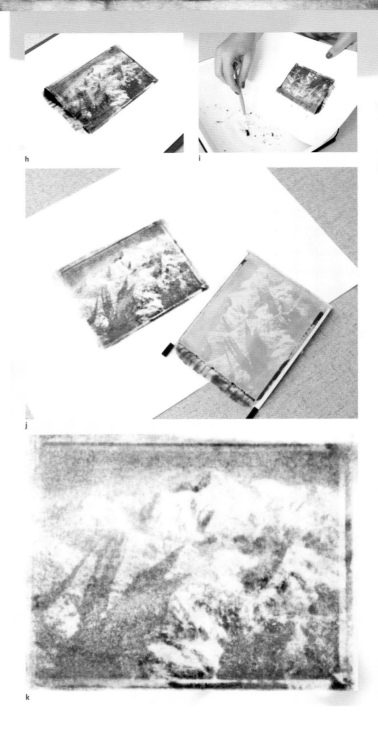

h

i

j

k

Advanced Method: Dry Polaroid Negatives

If your negative has dried out, or you want to make a transfer from a fully developed Polaroid, it is possible to revive your negatives and transfer the dye. The result will not be as crisp, colourful or defined as a transfer made while the image is still developing but it will still have its own unique character.

While best results come from images that are only a few hours old, you can use negatives that have been left to dry for several days.

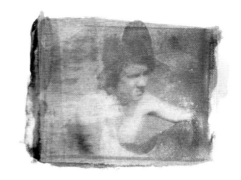

Materials

- Watercolour paper (at least 300gsm, acid free)

- 2 sheets of glass that will fit inside a microwave (one larger than the negative, the other bigger still, with 2-3 cm excess on each sides

- Dry Polaroid negative

- Running water

- Rubber roller

- Microwave (800W)

- Oven gloves

Method

1 Make the paper very wet and limp: the wetter the better for this variation of the technique.

2 Put the paper on top of the large piece of glass.

3 Position the dry negative face down on top of the paper.

4 Pour running water over the glass and paper, being careful not to move the negative.

5 Take your roller and gently press the negative into the paper to make full contact. Roll from the centre outward to ensure that it doesn't slip.

6 Place the smaller piece of glass on top of the negative. Lower slowly into running water. Starting at one end, allow the water to run under the glass and over the back of the negative. This will help to trap a thin layer of water between the layers of glass and stop the whole assembly from drying out in the microwave.

To remove air bubbles quickly lift the glass up and put it back down again.

7 Place this glass 'sandwich' in the microwave. Set the microwave to high, turn it on and leave for about 40 seconds.

8 When the time has elapsed, put on your oven gloves and remove the assembly from the microwave.

9 Place under running water again and gently remove the top layer of glass. Allow the water to run over the back of the image and soak the paper. The wetter the paper, the easier the transfer will be to peel.

10 Now peel the negative slowly up from the paper to reveal your transfer!

Tip

For better-quality transfers keep your negatives moist after shooting. Store them in a sealed plastic container or Ziploc bag immediately after they have been peeled with a few millilitres of water to prevent them from sticking together.

Transfer from two-day old Polaroid negative.

Image Transfers: Fuji Peel-apart Film

FILM Fuji peel-apart
TIME 10 minutes
DIFFICULTY Moderate

Fuji colour peel-apart film – FP-100C and the very rare 4"×5" Fuji FP-100C45 – transfer very differently to their Polaroid counterparts (see pages 134–37). When Fuji negatives are exposed to light the chemistry turns black. To avoid your transfer appearing as a black rectangle on your paper, you will need to peel the film apart in complete darkness (here, however, the process has been partially illuminated to reveal the steps). In this variation of the method there is no need to moisten the paper onto which you will be transferring your image.

a

b

c

Materials

- Fuji peel-apart film
- Watercolour paper (300gsm, acid free)
- Clipboard

Optional (see Tip)

- Lighting gel sample book

Method

1. Shoot an image. Once it has ejected, layer it together with the paper on the clipboard. The film should be at the top, positive side down, and the paper at the bottom **(a)**.

2. Turn off the lights and allow the film to develop for about 20 seconds. Next lift up the film and quickly peel the print away from the negative **(b)**.

3. With the print now removed, the negative can make contact with the dry paper **(c)** and you can turn on the lights.

4. Follow steps 4–7 from page 135 to complete the process.

d

e

Tip

Fuji transfers can be slightly yellow in colour **(d)**. If you are using a Vivitar Instant Slide Printer/Daylab (see page 72) to make your image, you can filter your shot with cyan and magenta to tone this down. Place a small piece of lighting gel over the top of your slide before exposing. Rosco's lighting gel sample book (see page 72), contains hundreds of different filters and these are the perfect size to cover a 35mm slide and colour correct your transfer **(e)**.

John Nelson's image transfer using Fuji
peel-apart film.

Emulsion Lifting: Impossible Film

FILM Impossible film
TIME 30–45 minutes
DIFFICULTY Moderate

Before Impossible began making film from scratch, emulsion lifts were only possible with certain pack and sheet films. Luckily, when Impossible changed the chemical formula of the film due to research constraints and chemical shortages, the new emulsion they created gave birth to a plethora of techniques, and also made some old ones achievable again.

All Impossible stock – colour, black-and-white and special-edition duochrome films – can be used in this method. Impossible's emulsions are uniquely stretchy, which means that, if you submerge them in warm water, it is possible to enlarge your emulsion lifts. This is a far more cost-effective solution than expired Polaroid film when your aim is to cover a large surface area (you won't have to use up as many sheets of film). If you use the Instant Lab (see page 72) you can also transfer images taken on a variety of different camera formats, allowing you to experiment with scale.

There are many variations of the following method, including some that encourage you to submerge your paper (rather than acetate) to lift the image. The step-by-step guide in these pages is the one that is most flexible, enabling you to make larger composite works with ease.

Materials

a

b

c

Note

Impossible's integral film is the only integral film format that will work with this technique. If you want to try emulsion lifting with Polaroid or Fuji you will need to use their peel-apart film formats. Polaroid's 669, 59 and ID-UV films will all work as will Fuji's FP-100C and FP-100C45.

Materials

- Impossible film images
 (no more than two weeks old)

- Scissors and scalpel

- 2 water trays
 (one containing cold water,
 the other lukewarm)

- Soft-bristled flat paintbrush

- Piece of thick acetate
 (avoid printer acetate, it
 has a special coating that
 comes off in water)

- Watercolour paper
 (at least 300gsm)

- Kettle

Optional

- Hairdryer

- Cutting mat
 (for more complex lifts)

- Acrylic gel medium
 (Liquitex matte gel/matte
 varnish spray)

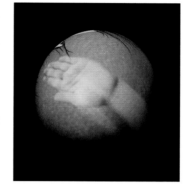

Tip

You can lift your photograph
onto almost any surface,
including wood (as Ina Enternach
has, above left), tin cans,
ceramics or eggshells (see
Bob Worobec, left). You can
even sculpt the emulsion
once it is dry (see Jennifer
Bouchard, above).

Method

1 Cut away a portion of the
white border of your Impossible
image, leaving the central image
window intact **(a)**.
 Underneath the border
lamination there is a dark
image edge, where the chemistry
hasn't been exposed to light.
If you are making multiple lifts
and don't want each lift to be
framed by this edging, cut it
off. If you wish to keep this
edging, trim just 2mm (⅛in.)
off the edges before you
separate the layers.

2 Separate the layers of your
image. Aim to keep the image
attached to the transparent
window during separation,
and to remove the black backing
from the print. To do this,

gently peel the image apart
using either your fingers or
a scalpel to find a suitable
opening point **(b)**.
 If the image is very stubborn
you can use a hairdryer to soften
the emulsion. Hold the hairdryer
at least 40cm (16in.) away
and keep it on a low setting to
avoid bubbling. This encourages
the layers to release.

3 When the layers have
separated you will be left
with two halves: the image
on the transparent plastic
window (this is what you will
be lifting) and the negative
backing (that you can save
and use for Impossible
negative reclamation (see
pages 178–81) **(c)**.

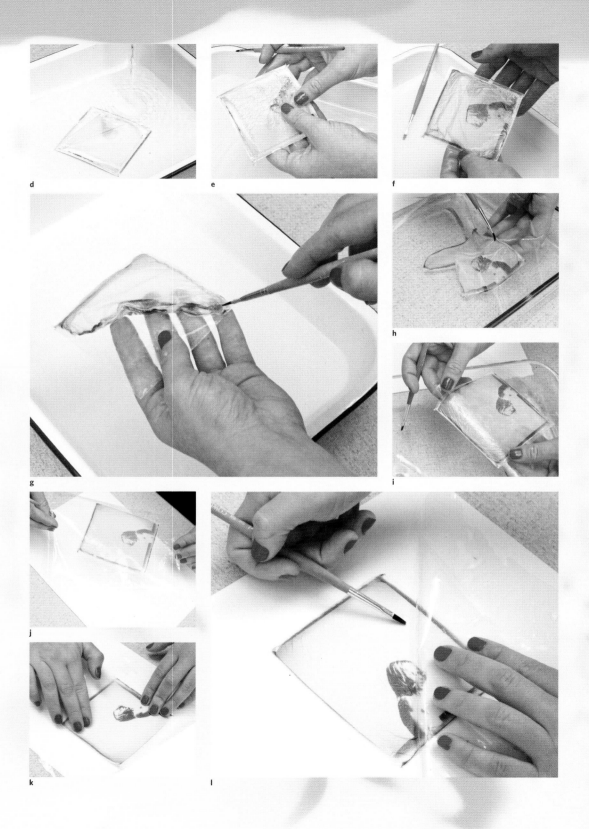

d

e

f

g

h

i

j

k

l

4 Clean and prepare the emulsion. This step requires some patience, but is one of the most important stages of this technique.

Place your image into a bath of clean, lukewarm water **(d)**. You might see some white residue left on the image after peeling. This is called titanium dioxide and is part of the developing chemistry. It is more difficult to remove from older images, so use fresh ones where possible. Soak the image in the water bath until the residue begins to flake. You can rub it off gently with your fingertips if necessary **(e)**.

More stubborn chemical can be removed with a soft-bristled paintbrush. Sweep the image in one direction, being careful not to tug too hard. The image is relatively resilient but won't survive jabbing motions or dragging. If you do this repeatedly it will rip. Stretch the image out and smooth away as many crinkles as possible so that you can reach the residue in these areas **(f)**.

It can help to gently lift the image in and out of the water, holding onto the clear plastic window with your thumbs. This clears any loose residue.

The water can become very milky in colour at this stage. If this starts to happen refill with fresh, to increase visibility and keep your lift clean.

The more time you spend on this stage the better the final outcome. If you don't fully remove this white powdery substance, your image won't stick to the substrate, and will later lift off and crack.

5 When fully clean, remove your image from the plastic. Gently pull it away from the window with the paintbrush, using small caressing movements **(g)**. Work quickly but methodically, starting from the edges of the image and working inward.

The image should eventually float free from the backing and into the water. Don't worry if the image folds in on itself.

6 Submerge the lift in cool water. The cool bath will prevent the image from stretching. (If this is the result that you are after, however, add hot water to the bath just before you make your lift. It will stretch when brushed onto your substrate.) There is little risk in leaving it in the cool bath for a few minutes, so don't worry about rushing this stage.

7 Transfer the lift to the acetate. First, check that the lift is the right way up by stretching it out in the water. The top side (the more vibrant side) is what you will need to place face down on top of the acetate.

When ready, partially submerge the acetate sheet **(h)**, positioning it under one edge of your lift. Use the brush to pull the lift up and on top of the plastic and to straighten it out. When ready, gently lift the acetate out of the water, being careful not to let the image slip off or crinkle. This can be fiddly!

8 With the acetate and lift now out of the water **(i)** use the brush to spread out the image again (if necessary) and to

remove any bubbles and leftover 'gloop'. Pay particular attention to the edges, straightening them where possible. More precision at this stage will save you time later.

If necessary, you can dip the corners of the lift back into the water – still holding it to the acetate to stop it from slipping off – so that the emulsion can unfurl itself.

9 Flip the acetate over **(j)**, and put it on top of the paper. Press down **(k)**, so that the image and paper make full contact. You can use your fingers or paintbrush to work it into the surface.

10 When ready, remove the acetate. Starting at one corner, roll the plastic back over itself very slowly, brushing out to the edges any air bubbles from under the lift as you go **(l)**. Ensure that the sharp corners of the acetate do not catch on or rip the lift. It may be difficult to separate the lift from the acetate at first. If it is unwilling, use the brush to prize the acetate away from the image.

11 If you are having trouble with the edges flipping over once on the substrate, dampen your paintbrush and slip it underneath the lift, positioning your finger just over the brush to hold it in place.

Pull outward gently to straighten **(m, overleaf)**.

12 If you want to layer other images on top of your lift you will need to make sure that it has a smooth surface, and that the edges sit flat on the substrate to which it has been

transferred. If the edges are slightly crumpled they will create a ridge in which air bubbles can form as you make subsequent lifts. Air bubbles expand and contract, causing cracks and splintering over time and Impossible film edges are especially prone to flipping over. However, if you are making individual lifts, you could push and pull at the edges further to create shapes and add texture **(n)**.

13 Gently sweep the image with the side of the brush to remove any unwanted air or water bubbles. The emulsion is very delicate at this stage, so take care not to let it snag or rip. Leave to dry.

Once fully dry you can add any finishing touches, including painting the top of your lift, for example **(o, p)**.

m

Tip

During the drying stage, and particularly with porous substrate materials such as watercolour paper, bubbling in your image can occur.

If you see this happen use a scalpel to cut a small hole in the top of each bubble, wet your fingers, then press the bubbles down. The cuts will be barely noticeable in the final lift. Check your lifts every 30 minutes for bubbles as they are drying.

Once finished, you can protect the image against harmful UV, and general wear and tear by applying a matte acrylic gel medium. Gel medium is often used to thicken paint, so should be employed sparingly.

You can apply a thin layer of the gel to your lift with a clean brush. Cover the entire substrate so that there is not a noticeable difference between the surface of the lift and the paper.

You can also use spray varnish to protect your image but this is often tinted and doesn't prevent cracking as well as gel.

n

o

Take it further

Try lifting onto glass to make projection prints (see pages 214–17) or cyanotypes (see pages 190–95). You could also place your lifts over other integral Impossible images (as Enrique Freaza and Anne Locquen have done, opposite).

p

Top row: Anne Locquen, emulsion lift over integral image; Martin Cartwright, Impossible lift laid over illustration from *Gray's Anatomy* (1858).
Middle row: Enrique Freaza, emulsion lifts. **Bottom row:** Enrique Freaza, layered emulsion-lift diptych; Anne Bowerman, *Twins*, made from layered Instant Lab images.

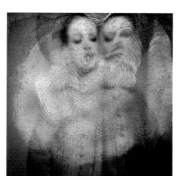

Niece-zilla terrorizes the city

Niece-zilla terrorizes the airport!!!

Emulsion Lifting: Polaroid Peel-apart Film

FILM Polaroid colour peel-apart
TIME 15 minutes
DIFFICULTY Hard

The technique of emulsion lifting with Polaroid peel-apart film follows roughly the same principles as emulsion lifting with Impossible film (see pages 140–45), however, in this method there is no need to split the image apart and remove the titanium dioxide before transferring it to your substrate.

Polaroid peel-apart emulsions are thinner than Impossible emulsions, so you have to take extra care to avoid wasting your shots (bearing in the mind the cost of expired film). Their delicacy also makes them more transparent and a better option for layering. They also mould better to most substrates, resulting in fewer air bubbles.

Materials

- Polaroid colour peel-apart image (made using Polacolor ER film, e.g. Type 669)
- 2 water trays
- Kettle
- Wide soft-bristled paintbrush (1cm/⅜ in. wide)
- Small, pointed soft-bristled paintbrush
- Watercolour paper (at least 300gsm)
- Scissors
- Acetate sheet (not printer acetate)

Optional

- Scalpel for popping unwanted bubbles
- Acrylic gel medium/UV spray to protect your lift

Method

1 Cut the white border off your picture: this contains adhesive that clings to your emulsion once it starts to lift, leaving unwanted ghosting and, if you are making composites, obscuring the layers beneath.

2 Fill the first tray with boiling water, then add just enough cold for you to comfortably submerge your hands.

3 Place the image in the water bath. Leave for a few minutes. If it starts to bubble excessively, add more cold water. The bubbles can burst and make holes in or cause the image to stretch.

4 When the edges start to lift, slip the wide soft-bristled brush under the emulsion and push it towards the middle of the picture, working all the way around. Never drag the emulsion. If you are finding it difficult to lift, leave it in the bath a little longer. If the water has cooled down, top up with warm.

5 Once you have removed the image from the backing, it will float free. If you notice a clear gelatinous substance attached to the picture pull this away and discard.

6 Fill the second tray with clean, room-temperature water. Transfer your image to the tray.

7 Now follow steps 5–13 on pages 143–44. Repeat the steps if you want to create composite pieces like the ones shown opposite.

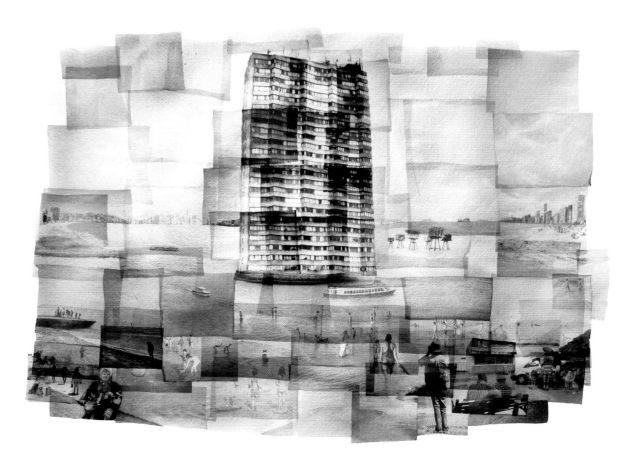

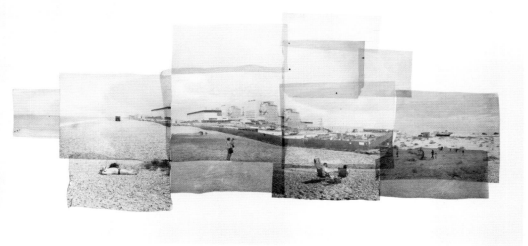

Top: *Dreamlands Wastelands*, composite emulsion lifts from Polaroid 669 and ID-UV films.

Above: Composite emulsion lifts made from Polaroid 669 and ID-UV films.

Emulsion Lifting: Fuji Peel-apart Film

FILM Fuji peel-apart
TIME 15 minutes
DIFFICULTY Hard

Fuji peel-apart film (FP-100C and FP-100C45 but not Instax) behaves slightly differently to Polaroid film when lifting, and lacks some of its delicacy. It is much more vibrant in colour than Polaroid (and also Impossible) but the lifts are not as malleable because Fuji emulsions are much less gelatinous. This can be both an advantage and disadvantage. The lifts are less prone to tearing during the separation stages but more brittle and crisp and require help to make them stick to the substrate. They are also less transparent.

This method is very similar to the technique for emulsion lifting with peel-apart Polaroid film (see pages 146–47) and Impossible (see pages 140–45), only you need to place your image in much hotter water for the emulsion to lift.

Materials

- 2 water trays
- Fuji peel-apart image (dry)
- Wide soft-bristled paintbrush (1cm/⅜in. wide)
- Small, pointed soft-bristled paintbrush
- Watercolour paper
- Scissors
- Acetate sheet (not printer acetate)

Optional

- Acrylic gel medium/UV spray to protect your lift

Method

1. Pour almost-boiling water (with a minimum temperature of 70°C) into the first of your trays and submerge the print, face up.

2. When the image floats off the backing, save some of the adhesive from the backing to paint on to your substrate before transferring the lift. Fuji lifts don't stick well: the adhesive helps them to stay in place. You can also use acrylic gel medium as an adhesive and apply this to your paper before transferring your lift. The gel also helps to prevent the lift from curling.

3. Now follow steps 7–13 on pages 143–44.

Above: Fuji emulsion lifts of a double exposure, painted and layered with nail varnish. **Opposite:** Lawrence Chiam's 'Living In a Wet Dream' series, made using Fuji FP-100C.

Tip

After drying, paint your Fuji lifts with gel once again, to minimize flaking and to protect them in the long-term.

Emulsion Manipulation: Polaroid Film

FILM Expired SX-70/Time Zero
TIME 15–30 minutes
DIFFICULTY Moderate

This technique was hugely popular in Polaroid's heyday. Many well-known photographers have used emulsion manipulation to create a wide variety of painterly, Impressionistic or Bacon-esque effects. This includes artist Lucas Samaras, who in his seminal series 'Photo-Transformations' (1973–76), pushed the boundaries of photography and showcased the possibilities of emulsion manipulation in lurid colour.

Contemporary photographers and Polaroid enthusiasts have also mastered the method, taking it in varied directions. Their diverse stylistic effects are a great source of inspiration. Impossible's emulsions are not well-suited to this method, though you can scrape into them to create lines and graphic shapes (as can be seen in the work of Ritchard Ton, pages 152–54; and Chad Coombs, page 155). With Polaroid manipulations, however, it is possible to move around the entire image, producing the watery, 'wobbly' look characteristic of this technique. Refer to Ritchard Ton's *Polamation* (see page 153) to see the different stages of an emulsion manipulation.

Unfortunately the films required for this technique, SX-70 or Time Zero, are difficult to find, with the last batches produced having expired in 2007. If kept correctly (in cold storage), the stock should still be manipulable. If you wish to purchase deadstock Polaroid, the best place to source it from is auction sites and local classifieds.

Materials

- Pack of SX-70/Time Zero film (with a recent expiry date)
- SX-70 camera
- Manipulation tools: clay modelling implements, chopsticks, nails, pen lids, hairpins, screws, cuticle sticks
- Heater/hotplate/hairdryer

Optional

- Sandpaper

Method

1 Shoot your picture and wait for about 10–15 minutes to let it develop fully. Keep the film warm during this time (so that the emulsion stays soft and is easier to manipulate). You can do this by using a hairdryer on a low setting and applying heat to the image every 10 seconds from a distance of 30cm (12in.), or for about 40 seconds continuously. You could also leave it in the sun or on a heater **(a)**.

Make sure that when you apply heat it is not by too much, or your image may curl. If you start manipulating too soon the emulsion will crack beneath the plastic front, although this can sometimes be a visually appealing effect in itself.

2 Now place the image face down on a hard surface and loosen as much of the emulsion as possible with one of your manipulation tools, by dragging it across the back. Flip the image over and continue work on the front **(b)**, using broad strokes to apply gentle pressure either across the whole image or in selected areas.

Don't press too hard or you will push away the emulsion completely and reveal the picture's black backing.

3 To pick out details use a thinner, more pointy tool **(c)** and, in a sweeping motion, feather the emulsion outward. To add texture place a piece

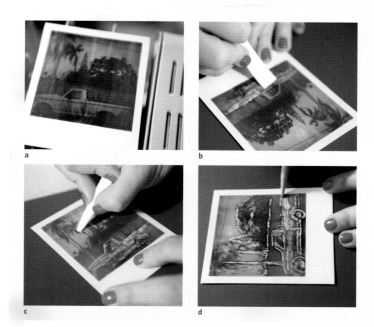

a

b

c

d

of sandpaper under your image and, with the blunt tool that you used for spreading, apply broad strokes to the area that you want to texturize. This effect will show up best in the less-detailed areas of your image.

4 You can now draw around objects and create outlines by applying more pressure or by using a sharper tool **(d)**, cutting through the chemical layers to reveal the black backing.

Stop when you are satisfied with the effects or store in a freezer if you want to pause the process and return to it later. You can manipulate the same image multiple times by reheating and then freezing it in this way.

5 Enjoy the results **(e)**!

Note

If you are working with film that has recently expired and which is dated between 11/06 and 1/07, wait for roughly two hours after shooting your image before you start manipulating. Polaroid changed the chemistry of this last production batch, the result being that the film takes longer to develop.

e

Top row: Filippo Centenari, *Shell* and *Fish*. **Middle row:** Toby Hancock, *Marty* and *Marcelo*. **Right:** Ritchard Ton, *Root* and *Pensacola Beach*.

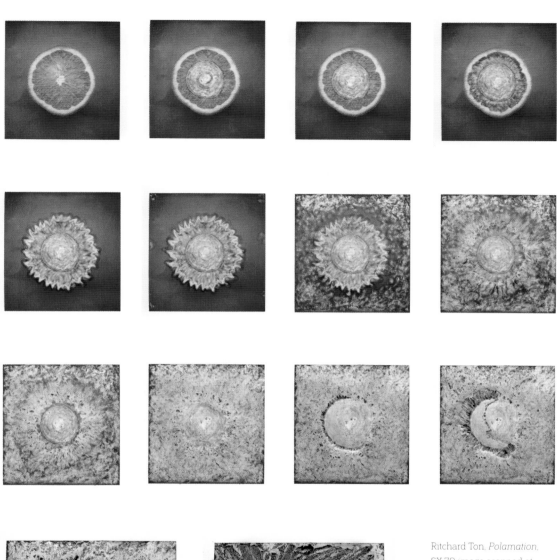

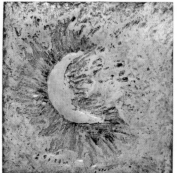 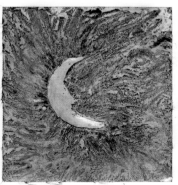

Ritchard Ton, *Polamation*,
SX-70 image scanned at
various stages of manipulation
(the selection shown here is
from a series of 100 images).

Emulsion Manipulation: Impossible Film

FILM Impossible
TIME 30 minutes
DIFFICULTY Easy

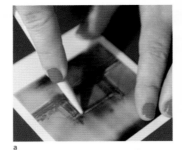
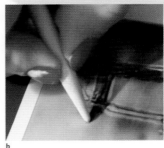

a
b

Emulsion manipulation can be achieved with any Impossible film, though you will not be able to move the emulsion around as freely as with Polaroid's SX-70 or Time Zero film (see pages 150–53).

Unlike the Polaroid method you shouldn't wait for the image to finish processing before manipulation **(a, b)**. You will need to apply very firm pressure to produce marks on Impossible film. Use a blunt instrument to draw lines and ripples in the emulsion as the film develops. Impossible film will also need thorough heating with a hairdryer to keep the emulsion warm as you work, though be aware that is likely to cause a colour shift.

Though the effects are not quite as impressive as with SX-70/Time Zero film, this method will allow you to add some texture and variation to your images. Impossible manipulations can be achieved with both colour and black-and-white films.

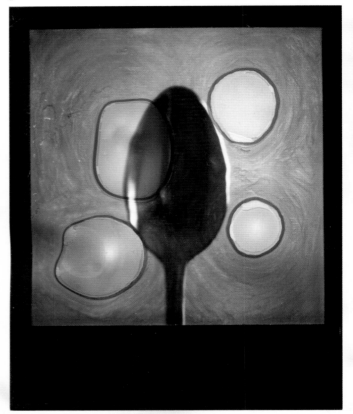

Above: Ritchard Ton, *Spoon*, manipulated Impossible PX 100 black-and-white film.
Right: Ritchard Ton, *Gun*, manipulated PX70 image.

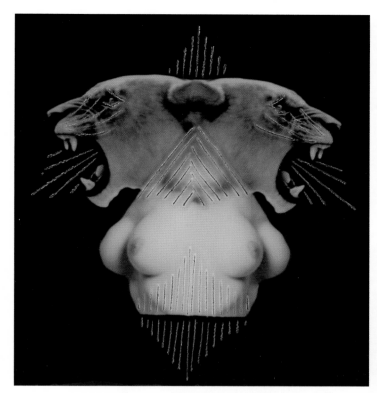

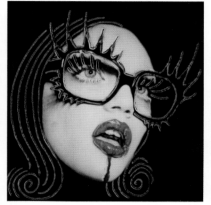

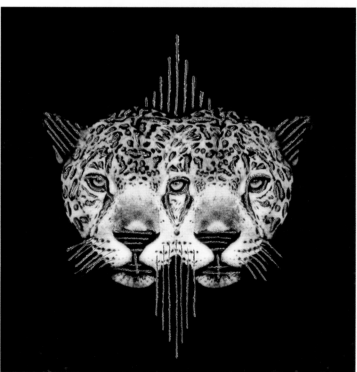

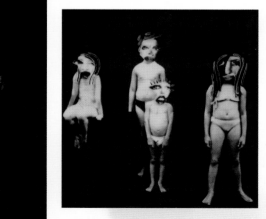

Impossible Project manipulations
by Chad Coombs.

Finger Painting

FILM Polaroid/Fuji peel-apart
TIME 2 minutes
DIFFICULTY Moderate

If you're looking for a peel-apart film manipulation that you can achieve on the go without the need for water, a darkroom or chemicals this technique is for you.

'Finger painting' essentially involves moving the developer gel inside the film sandwich around with your fingers during development, and results in a blurry, watery quality. It can be mastered using any expired colour Polaroid pack and sheet film. It also works with Fuji pack film, though the results are less impressive. Colour emulsions yield dramatic changes due to the composition and slower development time of the film.

The method itself is almost too simple, but it can take a few attempts to perfect. Films with different expiry dates can have more, or less, viscous chemicals and the results can vary significantly.

Materials

- Polaroid/Fuji peel-apart (colour) film
- Compatible camera or slide printer
- Hairdryer or heater

Method

1 Shoot a picture. Colourful, graphic images work best since fine detail will be lost during manipulation. Pull the film from the camera to start processing **(a)**.

2 Position the film sheet, face down, on a hard work surface **(b)**.

3 Apply pressure. Drag your fingers across the film sheet, lightly at first and then with more force **(c)**. Add less pressure in the parts of the image that you want to be visible and more in areas such as the edges.

Continue to manipulate the emulsion until the development time elapses. This can take up to two minutes (depending on the age of the film and the climate of the space in which you are working).

To further intensify the colours and aid the colour separation apply heat with a hairdryer on a low setting (or rest the print on top of a warm radiator) for about 15–20 seconds after you have finished manipulation.

4 Peel your print apart to separate the layers **(d)**. You will notice that the negative has many pressure marks and the chemicals are unevenly distributed **(e)**.

5 When you have finished, set the image aside to dry.

6 The result **(f)**! Note the colour variations across the image. The lighter areas are where more pressure was applied.

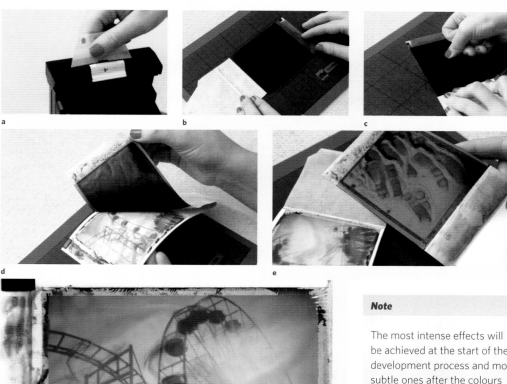

a

b

c

d

e

f

The most intense effects will be achieved at the start of the development process and more subtle ones after the colours have had time to partially develop across the whole print. The more pressure you apply, the more varied the colours will be.

Since you are manipulating while the dyes are migrating from the negative to the positive, you will be restricting their development in some areas while increasing their intensity in others. This creates the streak-like effect that is characteristic of this technique.

Blurring occurs when too much pressure is applied and the film layers slip and misalign (see the interrupted processing method, pages 206–9). This also results in a faint 'offset' effect.

Tip

Use tools to create more prominent marks in the emulsion: for example, a pen cap to draw sharp lines or a pencil eraser to make smudges.

Don't forget, if you press too hard you will cause premature separation of the layers and stop the image from appearing altogether.

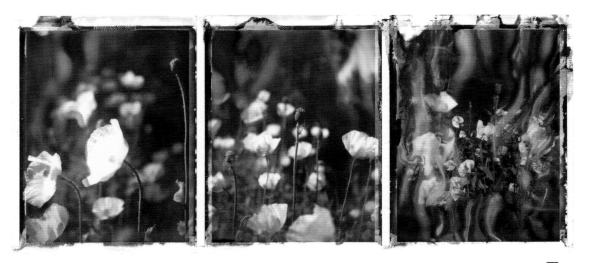

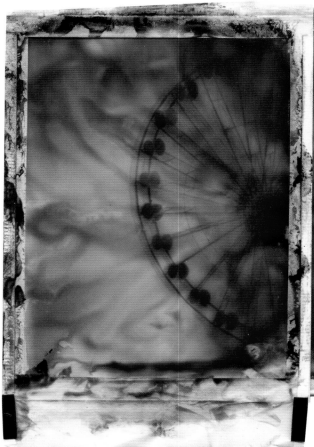
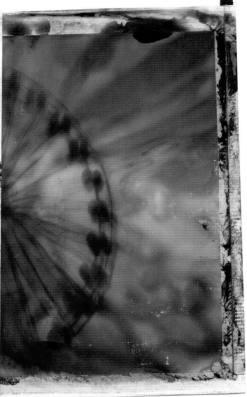

Top: Maija Karisma, *Papaver Triptych*,
finger painting with Polaroid 669 film.
Above: Ritchard Ton, *Wellenflung*,
double-pack film composite,
backwards peeled, and finger painted.

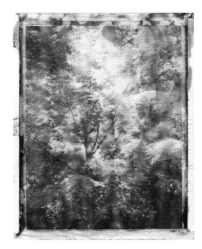

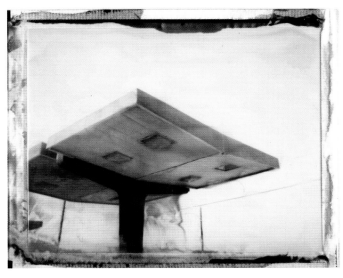

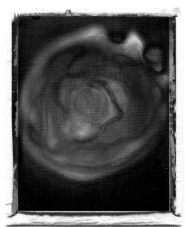

Top row: Maritza de la Vega's finger painting; David Salinas, *Gas Station*, manipulated using Polaroid ID-UV film.

Middle row: Ritchard Ton, *Untitled*; David Salinas, *Polaroid Jet*, manipulated using Polaroid ID-UV film.

Right: Finger-painted image using Polaroid 669 film.

Scratching and Scoring

FILM Any
TIME 10 minutes
DIFFICULTY Easy

Scratching and scoring result in images with a sketchy hand-drawn quality and be executed in conjunction with many of the other techniques in this book. Method 2 (opposite) will even show you how to revitalize your failed images.

To achieve either of the methods shown in these pages you will need to access the emulsion of your prints. This is more easily done with peel-apart film (since the emulsion is not encased in plastic) but it is also possible with integral film, which will be the focus of this step-by-step. As when making transparencies/dry lifts (see pages 96–99), to access the emulsion and image layer of integral shots you have to separate the layers of the image first. It is best to do this once the image is fully dry to prevent the emulsion from stretching and tearing.

Materials

- Dry integral image

- Scalpel and cutting mat

- Tools for scratching/scoring: rollers, pen lids, putty knives, spoons, nails

- Clear adhesive tape

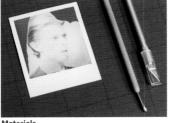
Materials

a

b

c

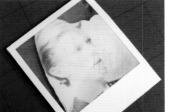
d

e

Method 1

1 Place the image face down on a cutting mat, and run a scalpel under the top border to open the film frame **(a)**.

2 Once this part of the border has been lifted **(b)**, you should be able to easily peel up the rest **(c)** with your fingers.

3 Take a sharp tool and scratch into the image layer (the front panel) **(d)** to create see-through areas **(e)**.

4 Once you have finished, you can reassemble your image by taping the layers back together. Before so doing, you could insert coloured paper or apply paint to the top of the white chemical-covered back, to reveal colour through the scrapes and scratches.

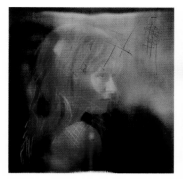

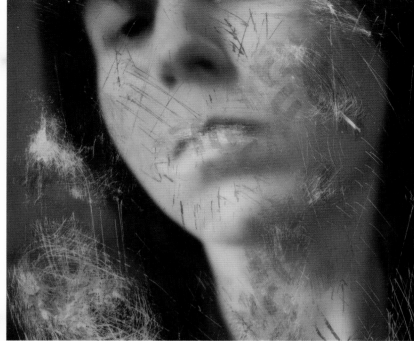

Above: Zora Strangefields's scratched manipulation. **Right:** Shot with Polaroid's original Spectra film, parts of the image layer were removed, tinted with watercolour pencils and layered onto origami paper.

Method 2

This method allows you to breathe life into your 'dud' shots, including those where no image has appeared at all. Peel apart, as in Method 1, step 2, but rather than scratching/scoring the image layer, work into the chemical layer instead. You can score lines into the white residue, using your tools to reveal the hidden negative beneath. With colour film, the different tones of the negative will show through your marks. Once you have drawn your picture, tape the film sandwich back together and there you have it, a Polaroid line drawing!

Above: Chad Coombs scans the uncleared negative backs of his manipulations (see page 155) or draws directly into the white titanium dioxide layer, as illustrated here.

Polaroid Decay

FILM Any integral
TIME 5 minutes preparation, 3 months for the decay
DIFFICULTY Easy

There are times when even instant film's peculiar charms cannot disguise failed images. Rather than throwing these photos away, however, you could start to collect them for future use.

Many instant photographers have taken their failures as starting points for experiments. Daniel Meade's series 'Abstract Analog Textures' (see page 165) features different integral film types that have been submerged in a mixture of bleach and water for prolonged periods. The shift in colour across the films is striking, with each one really showcasing the unique properties of each chemical emulsion.

Louis Little's 'Sunken Polaroids' series (see page 164) emerged from his experiments with Impossible films. Early batches of the film were often unpredictable, and Little collected the waste shots he had produced, later transforming them into beautiful, abstract artworks.

This method is very simple – all you need is a lot of patience.

Materials

- 'Failed' integral image
- Large plastic tub with lid
- Heavy waterproof weight (a large stone or brick)
- Well-ventilated area (the film will release an odour over time)

Note

This process involves dissolving the dyes and emulsion of the images as water seeps in through their drying vents and eventually to the back of the image. The emulsion also stretches in the water, creating creases and folds in the image.

You can create different effects by adding other substances to the water (e.g. bleach, chemicals and dyes).

Method

1 Place your image face down in the plastic tub and position the weight on top, to secure.

2 Fill the tub with enough cold water so that your weight and picture are completely submerged **(a)**. Cover with the lid (the water can be become quite stagnant and foul-smelling over time).

3 Leave to 'decay'. The image will noticeably transform after a few weeks and its black backing will start to disintegrate, turning the water a murky colour **(b)**. Check progress regularly. Don't pour away any water from inside the tub as this will now contain film chemicals that can aid in the destruction of the image.

4 When satisfied with the results, retrieve the image, wipe down the borders (which should have remained largely intact) and leave to dry. You could lay the image flat on a rack to dry to stop the wet emulsion from sliding downward.

Now sit back and enjoy your new abstract masterpiece!

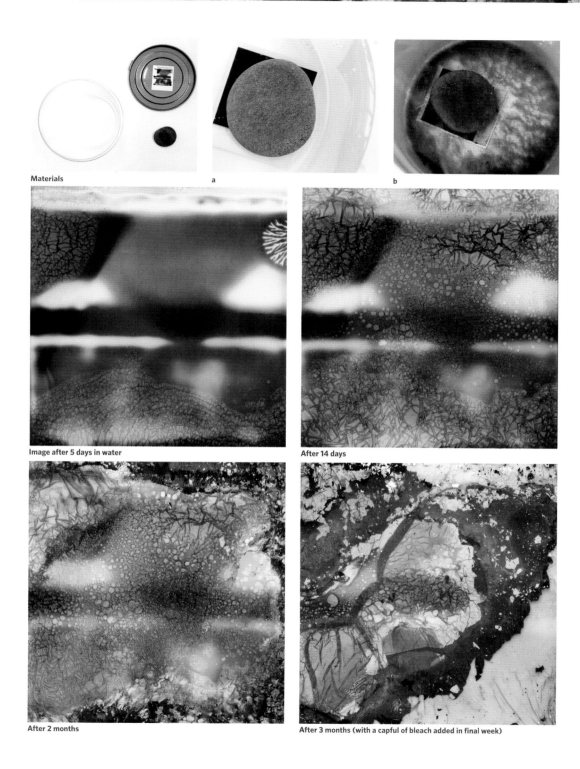

Materials

a

b

Image after 5 days in water

After 14 days

After 2 months

After 3 months (with a capful of bleach added in final week)

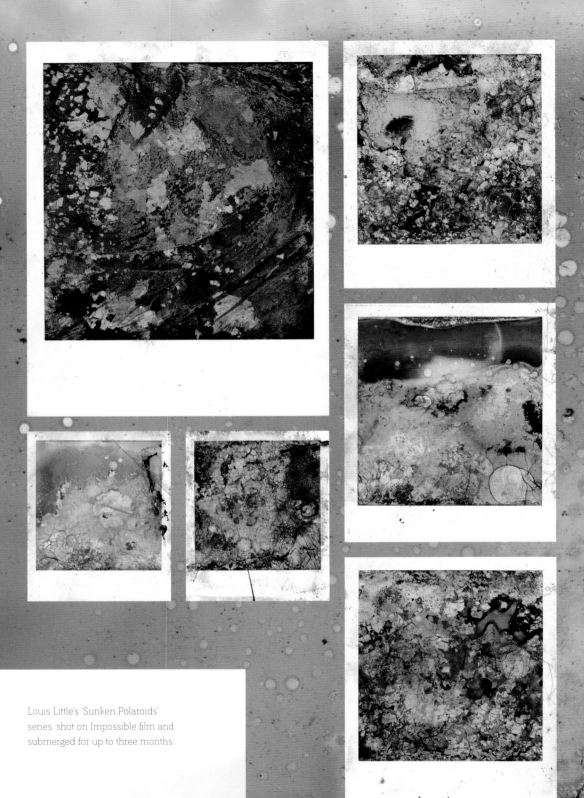

Louis Little's 'Sunken Polaroids'
series, shot on Impossible film and
submerged for up to three months.

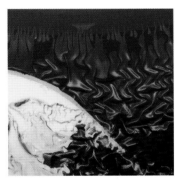

Daniel Meade's 'Abstract Analog Textures' series; each image was submerged in water with bleach for a few weeks.

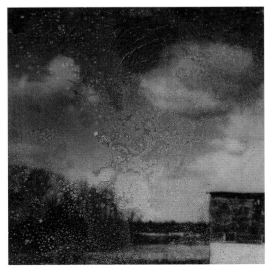

Microwaved Polaroids

FILM Impossible
TIME 15 minutes
DIFFICULTY Easy

Since Impossible film is particularly sensitive to heat you can force the development of your images by submerging them in a warm bath of water or by positioning them next to something hot (like an electric kettle as it warms up). However, this can result in colours that are a little bleached and too yellow/orange.

You could take the film's sensitivity to temperature to the extreme, by microwaving, toasting or even burning your instant pictures, to produce unexpected and unique effects.

While there are many options for heating Impossible film, this step-by-step will focus on microwaving. Do not use a very high-powered or expensive microwave for this method: integral film contains metallic foil so there is a risk of damage to your appliance. By following this method you will have relative control over the outcome but this won't fully safeguard against the potential risks.

Materials

- Freshly shot Impossible image
- Microwave with variable wattage
- 2 pieces of glass, each twice the size of your image
- Microfibre cleaning cloth/ kitchen towel/cardboard cut to the same size as your glass
- Microwave-safe container or plate large enough to hold your assembly when laid flat
- Tongs/oven gloves

Optional

- 2 plastic clips

Method

1 Have your materials ready before you begin. Once you have taken your image you will need to transfer it quickly to the microwave.

2 Pour a thin layer of water onto the first sheet of glass, cover it with the cleaning cloth and place your instant image, face-up, on top **(a)**. Pour water over this as well and again over the glass. Cover with the second sheet of glass. Pour water over the edges of the assembly so that it seeps in-between the layers of glass (use plastic clips to hold everything together if necessary).

3 Place in the microwave. Set to around 160W and turn on. Increase the power to 340W if little appears to be happening to the image. By slowly increasing the power in this way you will have more control over the process **(b)** and reduce the risk of damage to your appliance.

4 Microwave for roughly 60 seconds to 2 minutes **(c)**. Sparking inside the appliance might start to occur. If this becomes excessive, remove the glass assembly with your tongs/ oven gloves and pour more water in-between the layers to stop the image from drying out.

5 Watch your image through the microwave window to observe the shift in colour **(d)**. When you are happy with the results remove the assembly from the microwave with your

tongs/oven gloves and extract the image. It will now be almost fully developed and you should be able to see a picture emerging.

6 If small, swirly areas occur, this is the result of the film splitting open in the microwave and the water seeping in and pushing around the emulsion **(e)**. If you like this effect and want to exaggerate it further, pour more water into the cracks and tip the image from side to side (inserting a brush into the splits will also help to move the emulsion around). Finally, allow to dry and enjoy the results!

Note

You can also microwave and burn peel-apart films: a few seconds on a medium to low temperature will suffice.

Tip

If the white border of your image looks too singed and damaged, fold your damp cloth over the edges like a blanket before covering it with the glass **(f)**. Thin foil is concealed within the image border, causing it to burn. By keeping it cool and wet you will limit the damage. You can also isolate and protect important areas of your image using this method **(g)**, resulting in less 'burn' in those parts **(h)**.

Materials

a

b

c

d

e

f

g

h

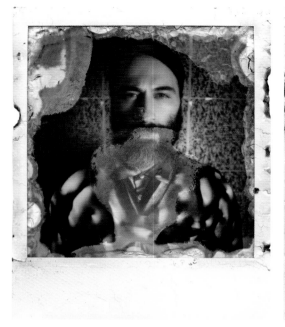
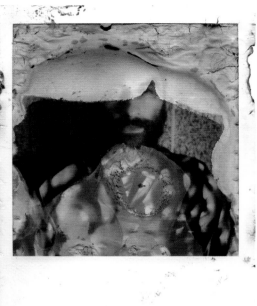
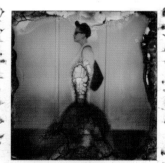
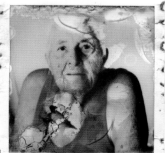
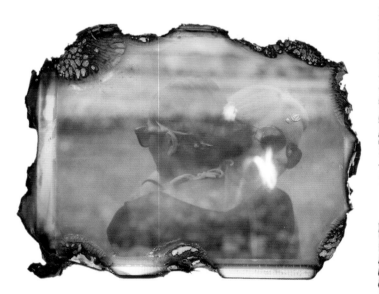

Clockwise from top left:
Two microwaved images by Oliver Blohm; two examples by the author, Brandon C. Long; a pack-film image, the edges of which have been burnt with a bare flame.

Below: Heated Impossible PX film by Brian Henry. **Right:** Amalia Sieber selectively burns pack film with a match.

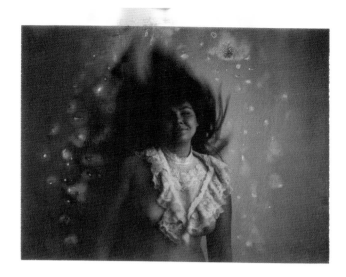

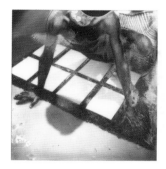

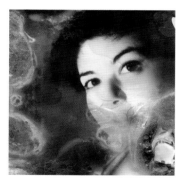

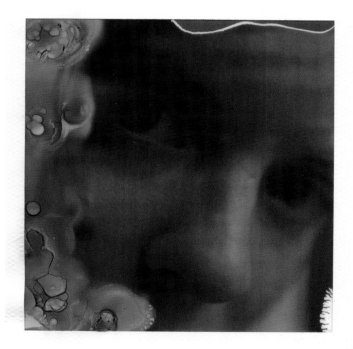

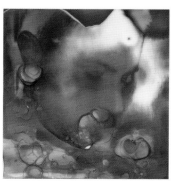

Centre left and above: Daniel Meade alternates freezing and heating (often using a blowtorch) in his images. **Right:** Enrique Freaza's microwaved Polaroid.

Polaroid Destruction

FILM Polaroid colour peel-apart/Fuji FP-100C
TIME 10-20 minutes
DIFFICULTY Easy

It is possible to create stunning one-of-a-kind artworks using little more than household cleaning products. This is experimentation at its simplest, most unpredictable and unexpectedly beautiful.

Peel-apart film yields the most exciting results when manipulated because of its easily accessible chemistry and layered colour development. You can work on your image either as it is developing or once it has finished. It is also possible to use shots that are months or years old for this technique.

Taking a few simple items, including oven cleaner, bleach, rubbing alcohol and drain-clearing crystals, you can create vibrant and psychedelic effects that emerge as the chemicals eat through the colour layers.

Raid your kitchen cupboards for domestic cleaner to see what you can find...then try it out to see what happens. Different intensities of chemical solution will result in varying effects in the final image. The biggest colour shifts will occur when using Fuji FP-100C.

Above and below: Polaroid 669 and ID-UV films manipulated with bleach and oven cleaner.

Materials

- Polaroid peel-apart/ Fuji FP-100C image

- Rubber gloves and protective eyewear

- Chemical of your choice (pure bleach, acetone, rubbing alcohol and oven cleaner are all good options)

- Paintbrushes

Method 1 (Fuji FP-100C)

1 Set up your work surface near a basin or bath (you will need to apply water to stop the process). Put on your gloves and eyewear and paint a weak chemical solution (e.g. 1:15 pure bleach to water) onto selected areas of your image **(a)** Wait for a few minutes. If little happens, leave the solution on the image for longer or increase in concentration.

2 You could also selectively bleach the negative **(b)** (see pages 174–77).

3 Apply water to halt the process and allow your print to dry **(c)**.

Method 2 (Polaroid Colour Peel-apart)

1 Put on your gloves and protective eyewear and pour neat pure bleach directly onto your image in selected areas **(a)**. The film illustrated is Polaroid 669, which requires a stronger concentration of solution to work effectively and results in a more bleached look than the colour shifts above.

2 Apply a strong cleaning substance (e.g. drain crystals, as used here) with a brush **(b)**.

3 Add water to halt the process, allow to dry and admire the results (right).

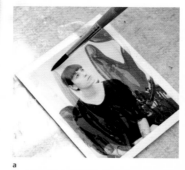

a

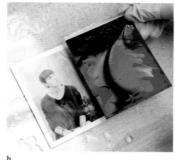

b

c

a

b

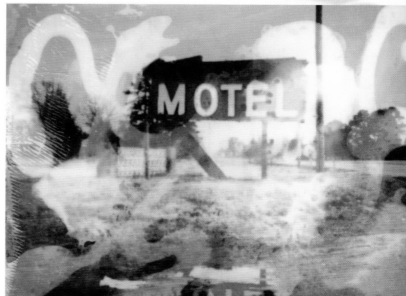

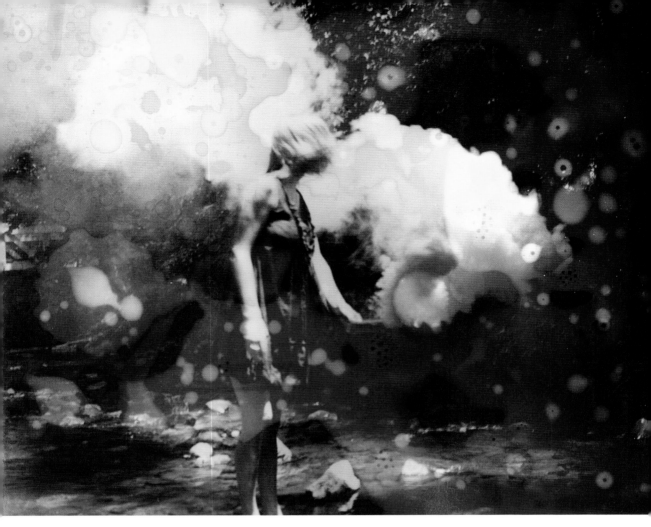

Above: Brian Henry's Polaroid 669, which was submerged in a warm bath of diluted bleach and spotted with drain crystals.

Right: 'Austin TX' placed this Fuji FP-100C shot, while still developing, into a volatile mixture of hydrochloric acid and aluminium.

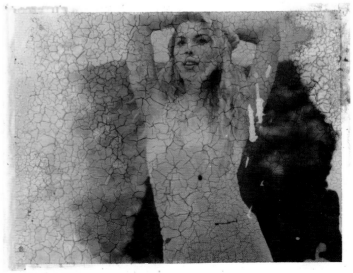

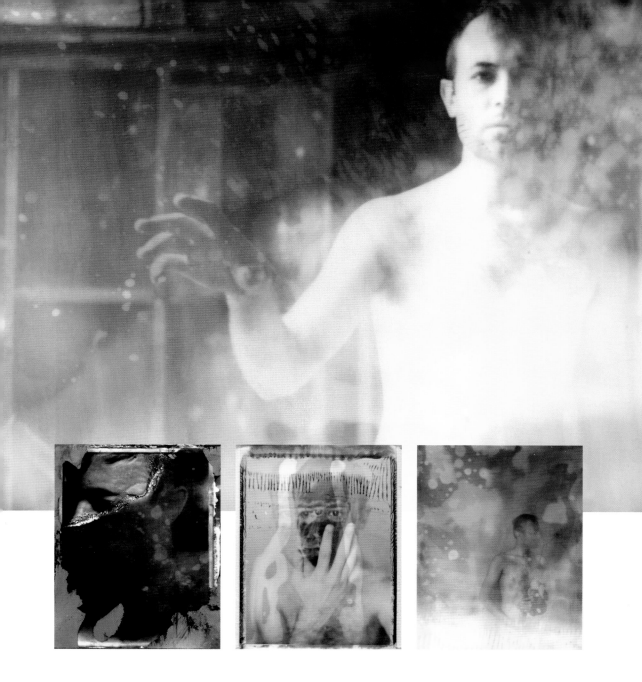

Above: Shot on Fuji FP-100B by Brian Henry, this image was partially peeled, water added and the layers pressed back together. The Fuji negative bleaching technique was used and the image scanned through the negative without the film being peeled apart.

Top, above and right: More experiments by Brian Henry

Fuji Negative Reclamation

FILM Fuji FP-100C
TIME 15–20 minutes
DIFFICULTY Easy

In Fuji peel-apart film you will find a hidden colour negative that can be reclaimed for use in other techniques, including scanning (see pages 90–91) and projection printing in a darkroom (see pages 214–17). When scanned this negative yields exquisite detail, since it is much higher in definition than the print itself.

To clear Fuji negatives, the process is very simple. This step-by-step guide involves Fuji FP-100C (though you can also bleach black-and-white stock) and will provide a colour negative. Though not as versatile or reliable as an E6 slide film or C-41 (standard colour), it will have its own unique qualities.

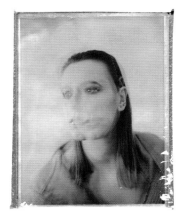

Above: Bleached negative of Fuji FP-100C double exposure, inverted in Photoshop.

Materials

- Fuji FP-100C film
- Piece of glass at least 2.5cm (1in.) greater in width/length than your negative
- Duct tape or electrical tape
- Kitchen towel
- Rubber gloves
- Bleach (containing the active ingredient hydrochloride)
- Clean soft-bristled paintbrush
- Scissors
- Running water/large bowl of water

Method

1 Remove all paper surrounds from the negative, so that only the film sheet is left **(a)**.

2 Tape the negative to your glass – with the matte black portion (the back) face up – on all sides, covering the edges of the film piece by 2–3mm (⅛ in.): just enough to hold the film in place without masking it too much. Make sure the tape is really secure: you don't want bleach seeping underneath and removing parts of the image **(b)**.

3 Prepare your work area, covering any surfaces that you want to protect from potential damage. Fill a large bowl or tray with room-temperature water and have some kitchen towels at the ready. Put on your gloves.

Pour a teaspoon of bleach onto the back of your image and spread it around gently with the paintbrush until the surface is entirely covered **(c)**.

4 The black coating will start to lift immediately, forming a thick black 'goo'. Continue spreading this goo around with your paintbrush, being careful not to scrape the negative (it is very fragile at this stage) **(d)**.

5 After a couple of minutes, dampen some kitchen towel and gently wipe the bleach off or rinse with water (being careful not to lift the tape) so you can check your negative. You can also remove stubborn residue with your paintbrush **(e)**. Repeat bleaching if necessary.

6 Once you are happy with the results, wash the negative thoroughly with clean water **(f)**, peel off the tape **(g)** and remove it from the glass.

a

b

c

d

e

f

g

h

i

7 Hold it up to the light: you will see that the front of your negative is still covered with the film's original developer chemical **(h)**. Remove this substance by soaking the negative in lukewarm water.

8 Once the negative is fully clean and clear, hang up to dry **(i)**. You can store your negatives in acid-free archival sleeves, or 5"×4" negative storage pockets, which are available from most darkroom suppliers and online.

Take it further

If you chose to make a projection print, and are developing a colour negative in black and white, you will need to boost the contrast by using a red filter. In colour darkroom printing, you can counteract the negative's green tint by using a magenta filter. Your final prints will exhibit streaks and spots. Alternatively, scan and invert your image, as pictured opposite.

Tip

You can also bleach the negative without the use of glass and tape. Pull the image from your camera, wait for it to develop, then carefully bleach the black backing of the negative/print sandwich. When you peel it apart you will have a print and a negative. If you start bleaching before your print has developed, you can selectively solarize it by allowing light to pass through the negative, which will turn the chemicals black during transfer.

Clockwise from top: Scott McClarin, a cleared Fuji FP-100C negative, inverted in Photoshop; Sean Rohde, Fuji FP-100C cleared negative; Phillippe Bourgouin, double exposure made with a slide printer onto Fuji FP-100C, negative bleached, cleared and inverted.

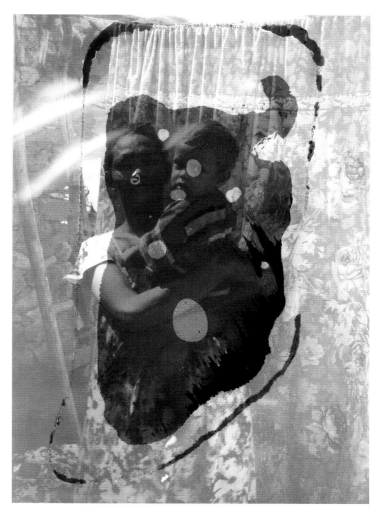

Clockwise from top left: Enrique Freaza, FP-100C peeled early, negative cleared, scanned and inverted; two shots taken by Brian Henry (the first on FP-100B, the second on FP-100C), both sides were bleached; Ade G. Capa, Fuji negative scan.

Impossible Negative Reclamation

FILM Impossible
TIME 15 minutes
DIFFICULTY Moderate

Reclaiming Impossible negatives is a remarkably simple technique. Best results are achieved with high-contrast images that have strong areas of light and dark, since these make for more striking negatives for scanning (see pages 90–91) and other methods, but any Impossible image can be used. You must use a shot that has been taken recently (before the white developing agent – titanium dioxide – becomes too hard and difficult to remove). Reclaiming negatives is a great method for making use of your 'failed' images too: even if you have rejected the print, the negative will still have a unique quality of its own. This step-by-step will focus on the reclamation of colour negatives (black-and-white film can also be used, see Note, page 180).

Materials

- Fully developed Impossible image
- Scissors
- Rubber gloves
- Pure bleach (containing the active ingredient hydrochloride)
- Container for bleach solution
- Paintbrush
- Water

Note

Your Impossible negative can only be used for scanning and not for projection printing in a darkroom.

Method

1 Cut 1–2mm off the edges of your Impossible image and peel the front window away from the backing. Refer to the guide on pages 96–99 if you are unsure of how to do this.

Trim away everything, leaving only the white chemical-covered square under which your negative is hidden.

2 Put on your gloves and run lukewarm water over the negative, using either your fingers or the paintbrush **(a)**, to remove the white chemical residue.

You will see a faint image appearing as you do this **(b)**. Stop when the negative has turned a light purple-brown colour **(c)**. (Any cloudiness that remains will be removed in the next step.)

3 Apply first bleach. Dilute a capful of the pure bleach in water – at a ratio of 1:10 – in your container. Pour the solution onto the negative (or daub with a brush) and rub it over the surface. The image should start to increase in contrast, changing to a brownish-yellow colour **(d)**. This takes just a few seconds. When you scan and invert this the colours will change to purple/cyan.

4 Wash away the bleach thoroughly to fix the negative. You can of course stop here if you are happy with the results.

5 Second bleach. Bleaching your negative again will make it brighter and increase contrast. It will also turn a greenish-purple colour **(e)**. This will invert to a yellow/lilac tone when scanned.

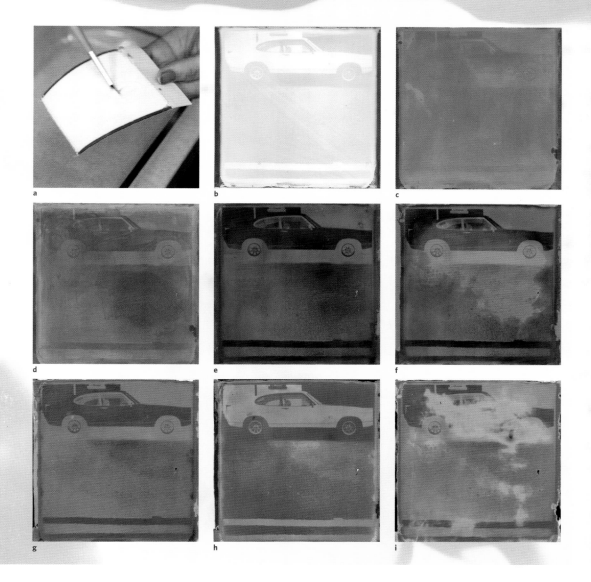

a

b

c

d

e

f

g

h

i

6 Second wash. Rinse the negative again thoroughly to stop the bleach. If you would like to see more random, patchy effects **(f)** you can skip this step.

7 Third bleach. Bleach your negative a final time. It is now at its most delicate, and if you leave the solution on for too long the image will be removed completely.

The negative will now turn cyan in colour **(g)**, inverting to a reddish-magenta **(h)** when scanned.

8 Third and final wash. Make sure there is no bleach residue on your film, otherwise you risk losing your image entirely **(i)**, as a result of the bleach burning right through to the black backing plastic.

j

Tip

You can also use a tool to lightly scrape into the lower layers of your negatives while they are still damp. You can also selectively colour your negative by varying the pressure of your strokes **(j)**.

k

l

Note

If you pour neat bleach onto your negative **(k)** it will cut through the layers too quickly for you to control the process, resulting in black patches where the image has been removed altogether **(l)**. This effect is quite striking and abstract. Be quick to wash the image if you see a result you like.

m

Note

Black-and-white negatives require only one stage of bleaching. However, because their emulsion is more easily damaged than with colour negatives if you bleach/rub too heavily, the image can quickly disappear to reveal the black backing.

This can help to create an aged/distressed effect **(m)** in your final image.

With full submersion, the black backing of the negative will also dissolve. To ensure that this residue sinks to the bottom stand the negative upright in the container.

Put on your gloves and protective eyewear and, starting with a weak bleach solution of 1:30, submerge the negative for 30–60 seconds before removing and rinsing. Lightly sweep a paintbrush over the surface to remove the colour layer.

Once you can see a solid colour across the whole negative, start a new bleach bath and leave it there for a few minutes or until the colour starts to change. Repeat for the final layer if desired.

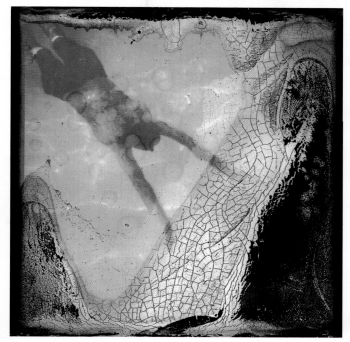

You could make your negative into a positive by using the Instant Lab (see page 73) and reversing the scanning process. If you have a digitized positive image, you could invert it in Photoshop, transfer to your mobile device and use as a source image on your Instant Lab. If you do this, your Impossible negative will become a positive image and the transparency a negative. You can use the transparency to create a positive cyanotype (see pages 190–95).

From top left: Two bleached colour negatives by Andrew Kua; bleached negative by Susanne Klostermann; selectively beached Impossible 8"×10" negative, inverted digitally Philippe Bourgoin.

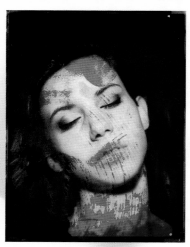

Negative Clearing

FILM Polaroid 55, 665 and New 55
TIME 10–30 minutes
DIFFICULTY Moderate

The introduction of true positive/negative instant film was a groundbreaking discovery by Polaroid, suddenly propelling the company to success within the professional photography market which had, until then, dismissed the Polaroid as a toy or gimmick. Positive/negative film enabled users to break away from the Polaroid's diminutive size by being able to create an immediately usable transparent negative for darkroom use, without the element of the 'unknown' usually involved in processing film.

Positive/negative film was available in black and white only, in both pack film and sheet film formats, 5″×4″ and 8″×10″ sheets. The best of these were Type 55, a 5″×4″ sheet loading film, and the pack film, Type 665, both of which boast an almost unmatched tonal range, and extremely fine grain. It is no wonder that photographer Ansel Adams often used it for his superbly detailed large-format work.

You can still find rare 665 and 55 stock online (unless you have access to a 5″×4″ large-format camera, 665 is your best option), although both are very costly. If you do purchase this film don't throw away the negative portion, it far exceeds the quality of the positive print in terms of sharpness.

When shooting 665 load it into a manual camera like a Polaroid 180 or 195 where possible, to give you the greatest control. Automatic cameras are geared towards creating accurately exposed prints rather than negatives, so you will need to set the lighten/darken knob towards lighten. This is because the two layers of the film are rated at different speeds. Polaroid 665 is rated at 80 ISO, but you will need to overexpose the film to produce a strong negative (between ISO 30 and ISO 50 depending on subject matter).

Though Type 665 and 55 are no longer being produced, a company called New 55 formed a few years ago to fill the void. New 55 film is made with an entirely new chemistry that is far more environmentally friendly than Polaroid's Type 55. New 55 is still in a phase of development but early tests have revealed beautiful image-making capabilities and crisp negatives. This film is perfect for trying out the cyanotype process (see pages 190–95).

If you are a seasoned Polaroid user, be aware that New 55 does have some quirks and it does not process in quite the same way as original Polaroid stock. The ISO speeds and processing times vary between production runs. Refer to the New 55 website and film packaging to help you get the most out of each batch of the film stock (www.new55.net). Though results can be a little inconsistent and unpredictable, there are certain interesting side-effects of the film's current chemistry (including the easy solarization of the negatives). If you love the solarized photographs of Man Ray, this film may just be what you are looking for.

Shooting Sheet Film

1 Slide a film envelope into a 545 sheet film holder. The holder must be in the load ('L') position **(a)**. Slide the package until you hear the click. Make sure that the correct side of the film is facing out towards the lens **(b)**. Insert the holder into the camera.

2 Pull out the envelope until it stops. Your film is now in position for exposure and you can take your picture.

3 After exposure, push the envelope all the way back in, returning to its starting position **(b)**.

4 Process your film by moving the switch on your film holder to 'P' (for process). To begin the chemical spread, grip the film envelope by the end and pull it all the way out of the holder smoothly and steadily. Lay the film down flat and wait for the prescribed processing time.

a

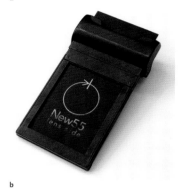

b

Clearing Polaroid 665 and 55

Materials

- Polaroid 665/55 film
- Rubber gloves
- Sodium sulfite powder
- Distilled water (if possible)
- Measuring jug
- Photographic tray
- Thermometer
- Tongs
- Drying line/clips for hanging
- Kodak Rapid Fixer (part B)

Method

1 Put on your gloves and dissolve sodium sulfite in warm water in your measuring jug to make an 18 per cent solution (450g/16oz of powder to 1.9L/3½pt of water). Stir until fully mixed, then allow the solution to cool to around 21°C (70°F). If you don't have access to weighing scales, measure roughly 8 tablespoons of powder to each litre of water.

2 Immerse your negative in the solution, emulsion side up, and agitate for approximately two minutes, then remove using the tongs. Take care not to touch the image area and hold only by the edges.

3 Rinse the image in running water for about 5 minutes (or you could place it in a tray and agitate for 20 seconds or so every minute, changing the water halfway through).

4 To help prevent excessive scratching and scraping, use a negative hardener, like Kodak Rapid Fixer part B, mixing it 4:1, water to hardener. Wash it in this solution for two minutes before moving on to the next step.

5 Rinse the negative and hang it up to dry.

Clearing New 55

Materials

- New 55 film
- Mixing jug
- Ilford Rapid Fixer
- Water
- 2 trays
- Rubber gloves
- Acrylic spray lacquer (e.g. Krylon special purpose spray lacquer)

Method

1 Take a picture as shown on page 183. While your film is processing, mix a 50:50 solution of Ilford Rapid Fixer and water in your jug and pour into your first tray. (New 55 has been designed specifically for use with this fixer.)

2 When the film has finished processing, remove the small silver release tab and pull the tongue assembly out of the sleeve.

3 Peel the print off in subdued light, shielding especially the negative to avoid solarization (if this is the effect you are after you can alternatively blast the negative with a torchlight to enhance the results).

4 Place the assembly, negative face-down, in the tray of fixer solution for 30–60 seconds.

5 Lift out of the tray and remove the negative from the tongue assembly. Next peel the strip of adhesive from the back of the negative, being careful not to scratch the delicate negative emulsion.

6 Put the negative back into the fixer solution: face up this time. Leave it in there for 1–2 minutes and agitate occasionally, loosening any residual chemical agent.

7 Put on your gloves and remove any floating 'goo' with your fingers.

8 Fill the second tray with water and submerge the negative, rinsing for 10–20 minutes and agitating occasionally. Change the water several times.

9 Hang it up to dry. The negative is very fragile, so take care not to scratch it, and keep it in a dust-free area while drying.
 Though the positive print needs no additional processing, you could spray it with a protective lacquer like Krylon.

Note

If you don't fix New 55 negatives, you will lose them altogether.

Tip

While shooting multiple 665 negatives when out and about, you can store them in a Ziploc bag with a few millilitres of water to prevent them from sticking to one other and scratching. This will keep them safe until the point at which you are ready to clear them. If the negatives have dried out, you can still clear them but the results won't be as pleasing.

Take it further

Now that you have both a positive and a negative image, use the latter to make projection prints in a darkroom (see pages 214–17) or develop as a normal black-and-white large-format negative. You could also use the negative to make polagrams (see pages 186–89) or cyanotypes (see pages 190–95).

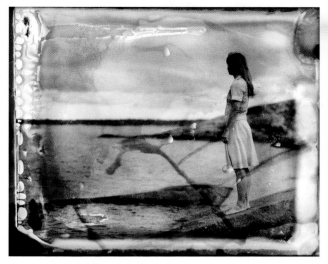

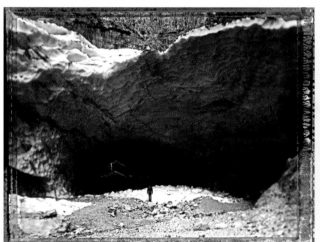

Clockwise from top left: scanned
New 55 Negative by Thomas Zamolo;
Polaroid Type 55 negative scan
by the author; positive print from
Polaroid Type 55 by the author;
two Polaroid Type 55 negative scans
by Bastian Kalous.

Polagrams

FILM Any
TIME 20 minutes
DIFFICULTY Moderate

In the 1830s William Henry Fox Talbot produced the very first photograms, by placing leaves and other material on photographic paper and leaving it out in the sun to expose. The result was a contact print with a dark 'background' where the paper had been exposed and white areas where the light had been blocked by the objects. Talbot named these X-ray-like images 'photogenic drawings', the word 'photo' originating from *phōs*, the Greek word for light. The technique was later taken up by many photographers, including Man Ray, who named his photograms 'Rayographs', in reference to himself.

The essential principles for making polagrams are exactly the same as for photograms, with peel-apart films yielding the X-ray-like images described above, and integral film the opposite (the exposed areas appear light and the blocked areas dark). However, when using instant film, the technique isn't entirely camera-less, since you will need to use your camera to split the internal chemical pods to ensure even coverage of the film.

Note that the illustrations for this step-by-step are partly illuminated to demonstrate the process. When you try it out yourself you will have to do so in complete darkness.

Method

1 Prepare your materials. When choosing your objects, small is key, with semi-translucent items giving the best results (e.g. flowers, leaves, strips of 35mm film, newspaper cuttings, even Impossible transparencies; see pages 128–31).

Objects with defined edges will also work well (e.g. safety pins, keys and buttons). You could also write a message on a transparent material such as acetate if you want to incorporate text into the final image.

2 Objects that sit perfectly flat on the film plane will result in crisp sharp-edged shapes. You can use a piece of glass to press them down. It can be helpful to place the items on a

Materials

- Selection of small objects or cut-outs that you want to expose in silhouette

- Any instant camera

- Compatible film

- External torch or flashgun

Optional

- Sheet of clear, thick acetate

- Scissors

- Small piece of glass (big enough to cover the exposure area of your film)

Tip

If you are making a polagram with integral film and want to use organic matter that doesn't naturally sit flat, it can be helpful to arrange your objects between two pieces of glass or encase them in two sheets of acetate cut to the size of your film frame so that you can align them more easily in the dark.

dud frame of film to ensure that they fit fully within the film window **(a)**.

3 Prepare your workspace. Place your objects where they can easily be found in the dark. If you are using acetate to encase your objects (see Tip, opposite), orientate your assembly correctly, since you won't be able to check this in the dark. Have your torch/flashgun to hand.

4 Turn off the lights and check that your work area is completely dark, covering up any light spills.

Open your camera. If using a new pack of integral film, remove the dark slide and slide one film frame out onto your work surface **(b)**, being careful not to burst the pods. The film cartridge has a small raised lip, which prevents large objects from making contact with the film surface, resulting in soft-edged shapes on your polagram. Removing a film sheet will help you to fix this (see pages 64–65). Place your objects on top. You can place a piece of glass on top of this to make sure everything is pressed flat to the film sheet if necessary.

If you are using pack film, remove the entire pack and arrange the objects on top of the cartridge without pulling a film sheet out.

5 Expose the film. Blast the film with a quick flash of light from your torch, from above. If you are using a flash unit, aim it at the ceiling and fire from a few feet away. Durations vary

between films but a very short burst of light should suffice **(c)**.

6 Remove the objects from the film sheet and reinsert your film into the cartridge, and into the camera (or you could try hand development, see pages 200–1). Close the camera fully **(d)** and turn on the lights.

If using integral film, your camera will have already ejected your film sheet, which will now start processing. If you are using a pack film camera, pull the film sheet out as normal.

If you are using a Fuji Instax camera that does not automatically eject the dark slide, put your hand firmly over the lens, blocking any light from entering, and press the shutter button. Remove your hand after the film sheet has fully ejected.

Note

High ISO films (like Spectra and 600 and I-Type that are rated at 640 ISO) require less light than SX-70. Fuji Instax films are yet faster and need even less light.

Materials

a

b

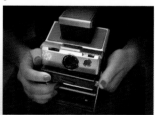

c

d

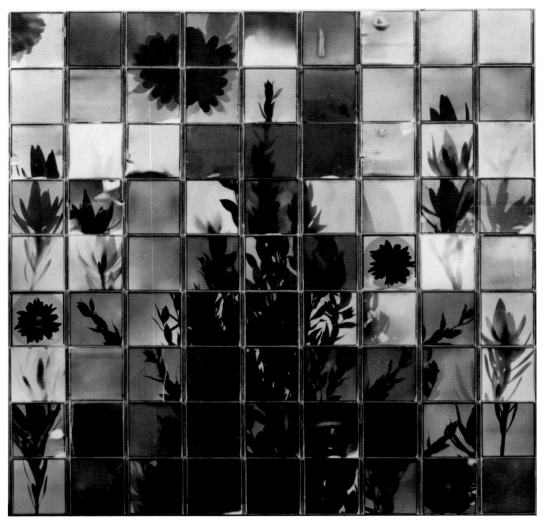

Above and opposite top: Patrick Winfield's polagram mosaics.

Right: Simone Bærentzen's triple-layered polagram on Impossible film.

Opposite, bottom left: Michael Mendez, polagram on pack film.

Opposite, bottom right: Nick Marshall, polagram on FP-100C

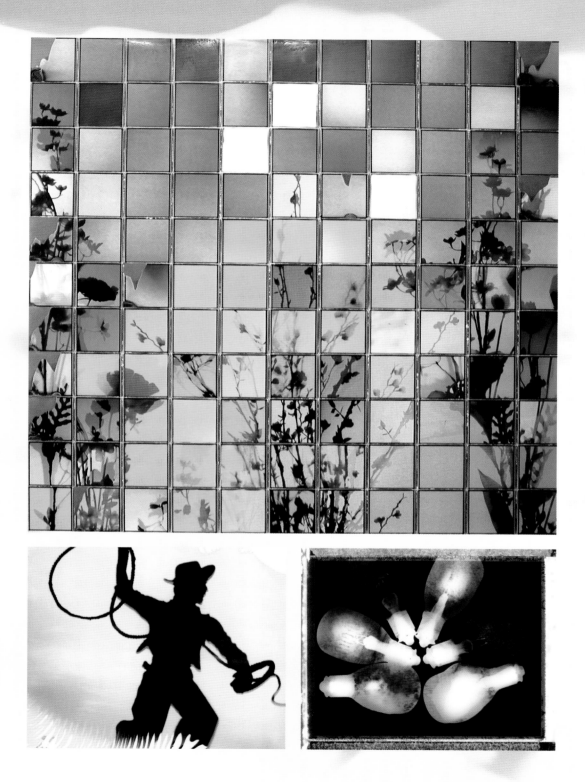

Cyanotypes

FILM Impossible/New 55
TIME 30 minutes-2 hours
DIFFICULTY Medium

A cyanotype is a form of contact print or photogram. Creating one involves placing objects or negatives onto photosensitive material, which is then exposed to light and developed. The resulting print will be a deep Prussian blue. Cyanotypes were originally used to make copies of engineering plans and technical sketches, which is why these became known as 'blueprints'.

When Polaroid was producing true positive/negative film, such as 665, 55 and 51, photographers were able to use the negative from their prints for various photographic processes, including cyanotypes. It was possible to contact print a high-quality blue-toned print at exactly the same size as your negative without the need for a darkroom.

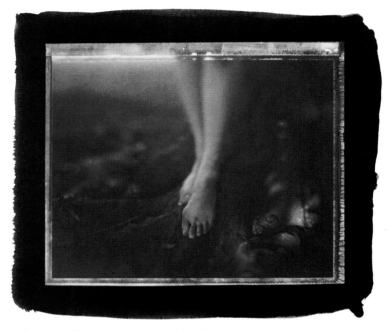

Toshihiro Oshima. Cyanotype from Type 55

Though these Polaroid films are no longer being made, stock does occasionally appear on auction sites from time to time. The New 55 project have also produced a variation of Type 55 that is compatible with existing Polaroid hardware. It is the only peel-apart film currently in production. To learn more about New 55 film refer to pages 22 and 178–81.

Using monochrome Polaroid/New 55 negatives is not your only option. You can also reclaim a usable negative from Fuji FP-100C through bleaching.

It doesn't stop there – you can make all kinds of contact prints (including cyanotypes) with Impossible transparencies too.

Whatever the origins of your source material, the chemical process is the same. First you paint a light-sensitive solution onto a surface and allow to dry. Next you add materials – a negative, transparency or object(s) – onto the surface and expose it to UV light, bleaching the unobstructed areas.

The print is developed in two stages: first the bleaching, then the wash (two-stage development processes all require the photographer to begin with a negative source to create a positive final product).

During the wash, the areas that were bleached by the UV light become a deep blue, and the blocked areas white.

This step-by-step will focus on how to make cyanotypes with Impossible transparencies, but there are other options should you wish to try them:

- Impossible transparency (see pages 178–81)

- Fuji FP-100C/FP-100B negative (see pages 174–77)

- Polaroid Type 665/55 monochrome negative (see page 183)

- New 55 monochrome negative (see pages 184–85)

- A scanned and inverted Polaroid, printed on acetate (see pages 90–91)

Tip

Impossible transparencies produce negative X-ray-like cyanotypes. You can get around this by creating a transparency from a polagram (see pages 186–89) or by scanning and inverting your pictures and using an Instant Lab (see page 73) to transfer them onto your instant film before making a transparency.

If you choose to scan and invert your Polaroids, and print these on to acetate to make your negatives (as photographer Britta Hershman has done, right), there is the option to enlarge your instant prints.

You can also take the process further by tinting and toning your prints (Hershman submerges her prints in coffee to give them an aged look, right).

Britta Hershman works with Impossible 600 film and scans her film prints (original 600 shot shown top left), inverts them and converts to black and white and enhances the contrast, then prints onto acetate. This acetate 'negative' she uses to create her cyanotype, after which the cyanotype is immersed in coffee to achieve a brown tone.

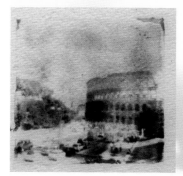

Materials

- Impossible transparency
- Piece of Plexiglas/acrylic slightly bigger than your transparency
- Sunlight (or UV exposure unit)
- Water

Optional

- Tray

Basic method (15 minutes)

- Sunprint paper

Intermediate method (1 hour)

- 25g/1oz ferric ammonium citrate
- 10g/½oz potassium ferricyanide
- 2 plastic spoons
- 2 brown glass bottles
- Measuring jug
- Paintbrush (with no metal parts)
- Protective wear (gloves, respirator face mask, goggles, old clothes)
- Watercolour paper

Optional

- Bleaching agent: white vinegar, lemon juice, hydrogen peroxide
- Toner: black coffee, tea, red wine and so on

Method

1 Create your Impossible transparency (see pages 178–81).

2 Prepare your cyanotype surface following one of the two options below:

Basic method
Use a sheet of pre-prepared cyanotype paper (Sunprint paper is readily available from most art suppliers and online). Now skip to step 4.

Intermediate method
Prepare your own cyanotype paper. Before you start, put on your protective wear and cover your work surface. Work in subdued light. To make your own cyanotype sensitizer you will need to mix equal quantities of parts A and B:

Part A: dissolve 25g (1oz) of ferric ammonium citrate powder in 100ml (4fl oz) of distilled water, mixing together with the plastic spoon. Store in the first of your bottles.

Part B: dissolve 10g (½oz) of potassium ferricyanide powder in 100ml (4fl oz) of water. Stir together with your second spoon, and store in the second of your bottles.

Overall, when mixed together, these two chemical solutions should be sufficient for approximately fifty 8"×10" prints, or one hundred single Polaroid-sized prints. Only mix parts A and B together as you need them, since once mixed, their shelf life is short.

For longevity, store the two solutions separately in brown bottles in the dark, at room temperature. The chemicals will remain active for several months.

3 *Intermediate method*
Prepare your surface. Take your brush and paint a thin, even, layer of the sensitizer onto your surface: first horizontally, then vertically, for full coverage. Again, do this in a dimly lit area (avoiding UV light), preferably indoors under a low-powered tungsten bulb. Once coated, leave to dry in a dark space for a few hours.

You can paint the solution onto almost any surface, though natural substrates are best: watercolour paper, smooth wood, fabric and so on. You can even expose on glass (adding gelatin to the mixture to make it thicker and more quick-drying). For very porous surfaces, you may need to repeat this coating step.

You can coat multiple sheets at the same time and store them in a light-safe bag/box for later use.

4 *Basic/Intermediate methods*
Prepare your exposure. Lay your transparency right-side up on your light-sensitive paper **(a)**, then cover with the Plexiglas to press it down evenly onto the surface. If you are using Sunprint paper (as pictured), use the kit as instructed. You may find it helpful to place the paper and Plexiglas assembly onto a portable, hard flat surface

(like a clipboard), so that you can easily move it to a sunny area later.

5 *Basic/Intermediate methods*
Make your exposure. You can do this either in bright sunlight or use a UV exposure unit, like the gel nail varnish curing unit illustrated **(b, c)**. You can also use exposure units designed for screenprinting or tanning; or simply insert a UV bulb into a conventional lamp.

Exposure times can vary from a few minutes to hours, depending on the light intensity and temperature, and also the surface that is sensitized. In bright sunlight exposure times are usually between 1 and 6 minutes (this will at least double in overcast conditions). With Sunprint paper, you will see the blue of your paper turning to almost white as it exposes.

A well-exposed image will reverse completely. For hand-coated surfaces, the highlights and mid-tones will turn a darker green/blue, while the shadows will be inverted and appear solarized.

6 *Basic/Intermediate methods*
Wash your exposed paper. Rinse in a tray of cold water or hold under gently running water **(d)** until the image inverts and an intense blue is revealed in the exposed areas. With hand-coated papers, wash until the green staining has completely vanished. Allow your print to dry or move on to step 7.

7 *(Optional)* You can now tone and intensify the colours of your finished cyanotype. If you dip the paper quickly in a weak hydrogen peroxide solution or a lemon juice/water or white vinegar/water solution you will brighten the whites and enhance the blues.

You can also tint your cyanotype. There are many options for toning: including using coffee, tea or wine tannins. You could, like Britta Hershman (see page 191), place the finished print upside down in a tray full of black coffee for anywhere from 30 minutes to 12 hours – the longer it is submerged, the more brown it will become and the less prominent the blue.

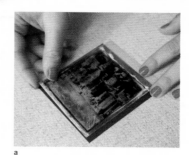

a

b

c

d

e

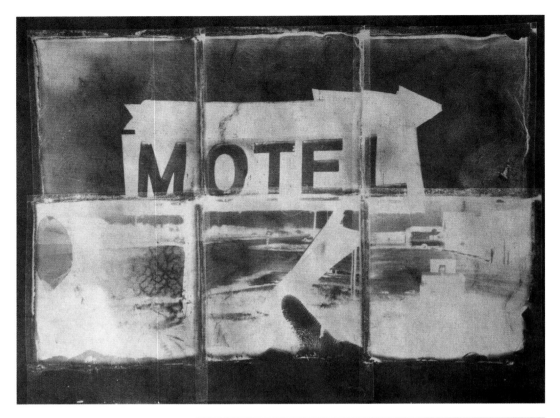

Above: *Motel*, six positive Impossible transparencies used to make a cyanotype 'mosaic'.

Right: *Motel II*, a cyanotype toned with red wine and tea and selectively bleached with lemon juice.

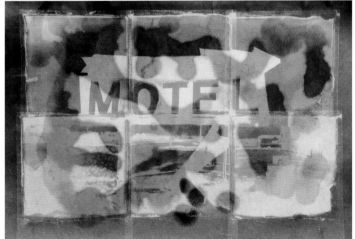

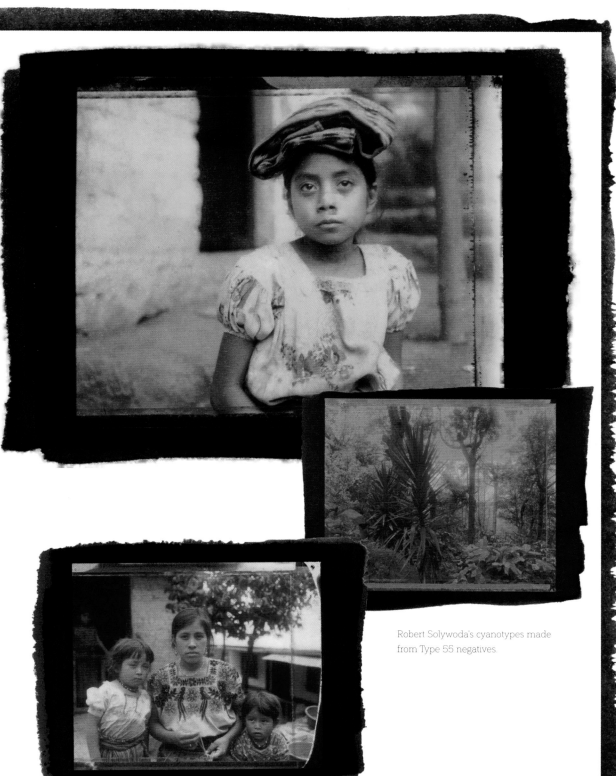

Robert Solywoda's cyanotypes made from Type 55 negatives.

Experimental Painting

FILM Impossible integral
TIME 15 minutes
DIFFICULTY Easy

There are many ways to make beautiful images without the use of a camera, of which experimental painting is just one example. This method involves manipulating the film's emulsion with a variety of tools to create different marks and effects, after first popping the chemical pods manually to start development.

The technique can be taken in further directions too, for example, by exposing the film before it develops to flashes of light, or by laying strips of coloured acetate onto the film surface and then exposing it to light before you pop the pods. Use this step-by-step as a starting point for your experiments and to help familiarize yourself with the properties of the film that you are using.

Experimental paintings can be created with any integral or peel-apart film, however, this tutorial will focus on Impossible film, which, because it develops slowly, allows plenty of time for experimentation. This characteristic can also be taken advantage of when making Impossible emulsion manipulations (see pages 154-55).

Materials

- Pack of Impossible film

- Tools: rollers, pen lids, putty knives, spoons and nails

- Computer, scanner and image-editing software

Variation 2 only

- Light source and coloured gels

Method 1 (in daylight)

1 Remove one frame from your film pack and lay it on your work surface, face down. Take your roller and push it over the pods **(a)** to make them pop and start the chemical spread.

2 Start 'painting'. Work on the back panel (if you manipulate the front this will cause damage to the surface). Working from the bottom up, apply pressure, sliding different tools over the surface **(b)**. The marks you create will be present in the emulsion as it develops. This is one of the few instances where

you could also shake your Polaroid, since it adds to the surface defects.

3 Leave the image to develop for at least 5 minutes (if using Impossible colour film). Watch the colours change as the image develops. When you are happy with the result, cut 1–2mm off the edges of the film sheet **(c)**.

4 Next, starting at one corner, split open the image **(d)**. If the emulsion tugs at and tears from the front window, you may need to apply gentle heat with a hairdryer to help you peel it apart cleanly. If you do

not split the image open at this stage, it will keep developing until the film sheet turns almost completely white, and you will lose much of the texture of the chemistry.

5 Once the film is fully peeled allow to dry **(e)**.

6 (*Optional*) You can also scan the negative side of the film **(f)**, and invert it in Photoshop **(g)** (see pages 90-91).

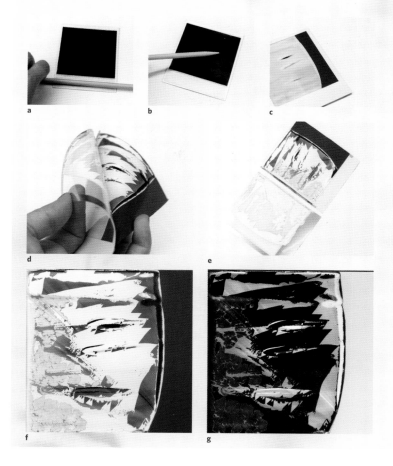

Tip

You could use the front panel of your images and layer these with other instant film shots (as photographer Hazel Davies has done; see page 199).

Method 2 (in darkness)

1 In a completely dark room remove one film sheet from a film pack. Take care to cover the rest of the pack to protect it from exposure when the lights are turned back on.

2 Expose the film frame to light and colour. Take a torch, place a coloured gel on top and flash with a quick burst of light. Alternatively, lay strips of colour acetate over your film frame and illuminate with a torch. Your exposures must be short to prevent the film from being overexposed. You could also lay stencils onto your film and shine light through these, essentially making a mask (see pages 114-23).

3 Pop the film's chemical pods. Roll the developer up through the film sheet and across the entire frame. Once the developer is dispersed, you can turn on the lights and continue moving the chemicals around as in Method 1, making marks and shapes with your manipulation tools.

4 After a couple of minutes of manipulation, allow the image to develop fully. You can then scan the whole film sheet rather than splitting it apart and using just the negative.

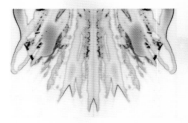

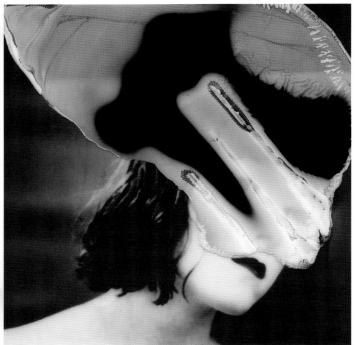

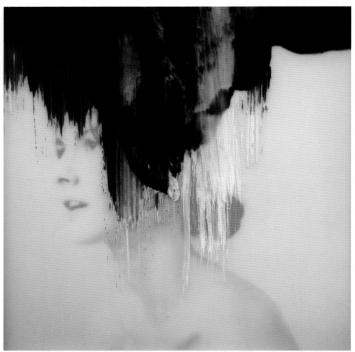

Above: Dominic Alves uses the experimental painting technique (Method 1) with Fuji Instax Mini film. He scans the images, flips and repeats them to create splashes of colour reminiscent of Rorschach ink-blot tests.

Top right and right: Annie France Noel creates chemical smears (using Method 1). She splits the film apart and layers the semi-developed positive over other images and sometimes scans her assemblages as their colours are still transforming.

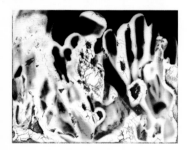

Hazel Davies's beautiful
manipulations in which she
scans and inverts colour
Impossible negatives

Hand Development: Integral Film

FILM Any integral
TIME 5 minutes (30 minutes development time)
DIFFICULTY Moderate

Hand development, like many of the techniques in this book, involves applying pressure to your prints to create uneven development. The effects sit somewhere between patchy expired film and experimental painting (see pages 196–99) and can make the familiar appear startlingly bizarre.

You can use this method in combination with many other techniques in this book and can even adapt it from the process of roller manipulation (see pages 202–5) by applying stickers or other obstructions directly to your roller and running this across the film sheet.

In order to hand develop your film, you will need to prevent your camera from auto ejecting the image and pushing it through the rollers. This step-by-step involves the use of the Instant Lab (see page 73) to stop automatic ejection, but there are other ways to prevent your integral images from so doing (see light painting, pages 126–29; and long exposures, pages 104–9). You can also use MiNT's InstantFlex TL70 (see page 80), a Fuji Instax Mini camera that allows for multiple exposures (see pages 108–13). Spectra cameras (see pages 66–71) are also well suited to this method for the same reason. This technique can also be used to process images exposed outside of the camera (e.g. polagrams, see pages 186–89).

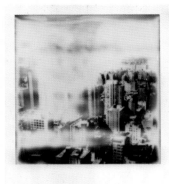

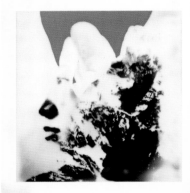

Above and below: Instant Lab images developed by hand with Impossible black-and-white film.

Materials

- Instant Lab (or other instant camera where you can prevent automatic ejection)
- Compatible integral film (see pages 224–29)
- Dark space
- Rubber roller
- Dark slide

Note

The steps pictured here have been taken in full light to demonstrate the process but this technique must be completed in total darkness!

Method

1 Take a picture with your Instant Lab/camera. Do not press the eject button **(a)**.

Find a room or area that you can make completely dark. Set up your workspace. Make sure that you know how to open the film compartment of your Instant Lab/camera in the dark. Have your roller nearby so that you can locate it easily.

2 Turn off the lights **(b)**. Open the film door and pull the pack out of your Instant Lab/camera. Cover the rest of the film pack with the dark slide.

3 In darkness, slide the top sheet of film out of the pack **(c)** and lay it face down on your work surface.

4 Quickly pass the roller over your film sheet, starting at the bottom. This will pop the pods and spread the chemical agent between the layers of the film. A couple of rolls upwards should suffice **(d)**.

If you press too hard, your image will appear white and yellow, if too little, your developer will not spread, leaving brown patches. You can adapt the pressure to suit your desired outcome.

5 Once the chemical has been spread, the film will begin to process. You can now turn on the lights and sit back and watch your hand-developed image reveal itself **(e)**. Full development can take up to 30 minutes.

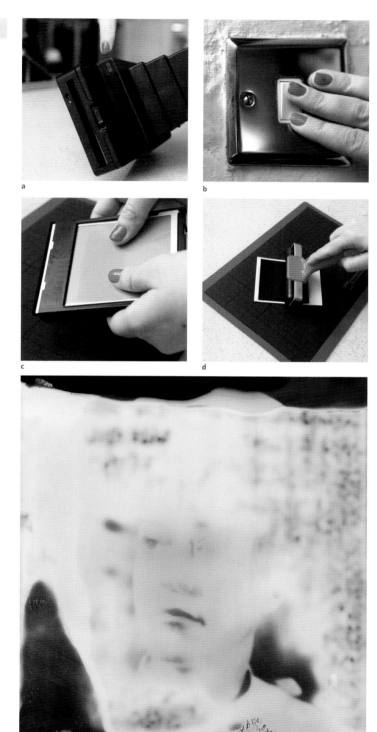

a

b

c

d

e

Roller Manipulation

FILM Any
TIME 5-30 minutes
DIFFICULTY Easy

Most Polaroid cameras, and all Impossible hardware, employ a roller system to expel the film from the camera and spread the developing chemicals evenly. Keeping the rollers clean and unobstructed is the best way to achieve consistent results from your camera.

It is very likely that your camera will suffer from dirty rollers at some point if you are shooting with SX-70 or 600 film. This is usually the result of chemicals leaking from the film into the camera (as the film has passed through) and building up on the rollers. This build-up causes uneven pressure across your pictures, with increased pressure producing a yellow cast. With expired SX-70 film the chemicals in the pods also begin to dry out and don't spread as easily, causing roller obstruction.

There are times, however, when these obstructions can yield interesting results. To purposefully create uneven chemical spread, you will need to attach an obstruction to the camera's rollers (it must be thin to avoid jamming): the result being repeat patterns on the film sheet. Attempt this method with a camera that you are not precious about, because roller damage can occur.

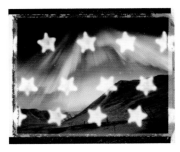

Obstructions can also be applied to the rollers of pack film cameras, as shown.

Materials

- Any instant camera
- Compatible film
- Your chosen obstruction (in this method, star stickers)

Tip

You can also apply obstructions to a roller and push firmly across the surface of your image as soon as it has ejected from the camera for similar, if less dramatic, effects.

Method

1 Open the film compartment of your camera **(a)**.

2 Apply your obstruction **(b)**. If you are using stickers, such as the ones pictured, press on to the rollers very firmly to secure **(c)**, then rotate a few times to make sure that the stickers are not catching. You can also cut motifs out of tape and apply these to the rollers. Avoid sticking anything on the areas to the far right and far left of the rollers, since these are the sections where the film border passes through.

3 Insert your film pack, allow the dark slide to eject as normal, and shoot an image **(d)**. As soon as the film exits the camera, your obstruction will be clearly imprinted on the surface.

4 Wait for full development and admire the results **(e, f, g)**. This manipulation will affect the whole pack, so remove your obstructions in the dark if you only want to try out this technique on a few film sheets. If using an integral Polaroid camera don't forget to insert a dark slide on top of the pack before reinserting the film (to avoid exposure and wasting a shot).

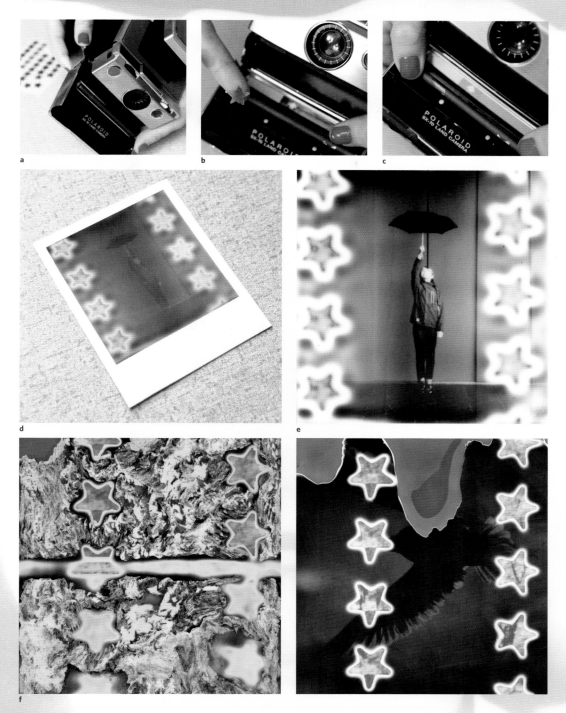

Above, centre right and bottom right:
Star stickers applied to the rollers of
an SX-70 camera.

Single-shot Roller Manipulation

This technique is a form of cartridge manipulation, since you manipulate your image 'in cartridge' before exposure. This method also works with pack film. Make stick-on shapes by cutting them out from thick tape, and stick them to the surface of the film sheet in the dark, before development **(a)**. After ejection, peel the tape off **(b)** and allow development to occur **(c)**. With this method you can manipulate one shot at a time.

a

b

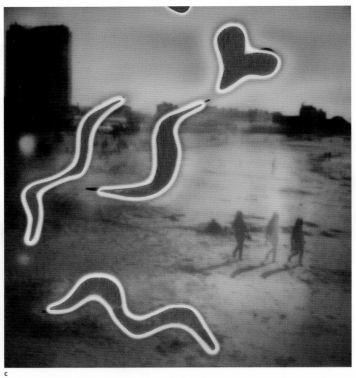

c

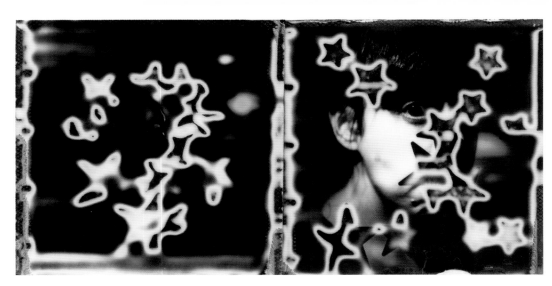

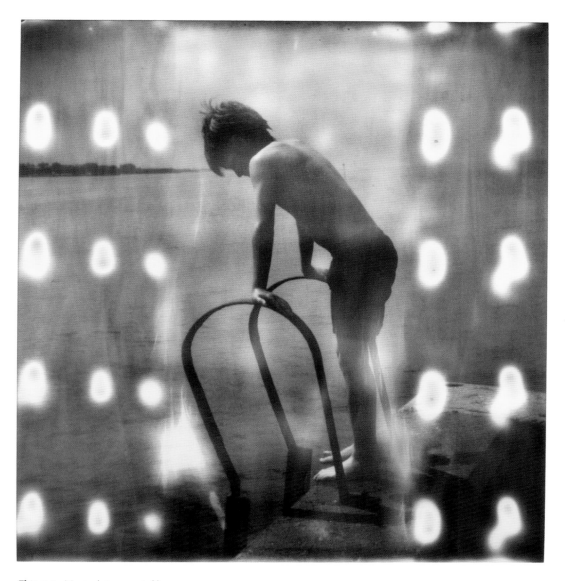

This page: Manipulation created by dried splotches of toothpaste being applied to the camera's rollers.

 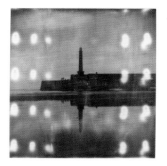

Opposite: Enrique Freaza makes use of the single-shot method, attaching stars to the image surface pre-exposure.

Interrupted Processing

FILM Polaroid colour peel-apart/Fuji FP-100C
TIME 2-3 minutes
DIFFICULTY Easy

This quick and simple manipulation technique is specific to peel-apart film (pack film and sheet film) and is a modification of the transfer method (see pages 134–39). Though both colour and black-and-white film can be used, colour yields the most interesting effects.

Different films produce varying results. One of the most interesting of these is the 3D offset look – where the cyan and magenta layers appear to be separate – which is achieved by peeling the print apart before the transfer of dyes is complete. By recombining the layers together while the chemicals are still active, the developing dyes are transferred in an offset position.

Materials

- Polaroid colour peel-apart/ Fuji FP-100C film
- Compatible camera
- Timer/stopwatch app
- Rubber roller

Method 1 (Polaroid Peel-apart)

1 Make an exposure (an image with a good contrast of light and dark will work best). Pull the first white tab directly out of the camera. Start your timer, then pull the print out of your camera by the second tab **(a)**.

2 Wait for at least 15 seconds, then peel apart the picture **(b)**, though not completely. The earlier you peel the film the more magenta it will contain. If you wait for longer, allowing for some of the cyan highlights to appear, the 3D 'offset' effect will start to emerge.

3 With the negative and positive still joined at the tab side **(c)** quickly solarize the negative. This is best achieved under a low light like a desk lamp.

4 Recombine the negative and positive **(d)**. You can misalign these slightly **(e)** if you want to create a 'ghosting' effect.

5 Take your roller, or use your thumbs, to apply light pressure to the film sandwich in one motion to ensure good contact between the layers **(f)**. Don't press too hard or you will create patches. Wait for it to develop fully, then peel apart **(g)**.

6 Your finished print should display colour separation and double-image ghosting **(h)**. You will see splotches of colour where the negative and positive did not make full contact.

Method 2 (Fuji FP-100C)

It is not possible to achieve full colour separation with Fuji FP-100C, but you can create some ghosting. Fuji film develops faster than Polaroid so if you peel apart and expose the negatives to light, the chemicals will turn black rather than white, transferring to your positive when you press your picture back together and resulting in a solid black or dark-brown image.

There are two ways to avoid this. First, you can follow Method 1 in complete darkness, peeling the layers apart, misaligning them and then pressing firmly back together (skipping the solarization stage).

Second, you can peel the image just before it finishes processing (at around 25 seconds), quickly press it back together with some offset and lightly roller so that the two sides make contact. This will result in the ghosting effect (there will likely be some purple

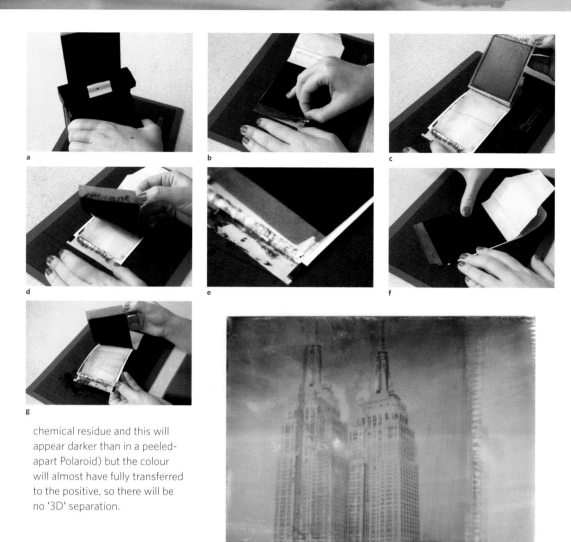

a

b

c

d

e

f

g

chemical residue and this will appear darker than in a peeled-apart Polaroid) but the colour will almost have fully transferred to the positive, so there will be no '3D' separation.

h

Take it further

There are variants on the interrupted processing technique, such as the 'slow peel'. With this method, instead of solarizing and recombining your film sandwich, peel your negative and positive apart slowly and at intervals: by 2cm (¾ in.) every 15 seconds with Polaroid film, and every 5 seconds with Fuji FP-100C. This will interrupt the development, making your image more vibrant in some sections and paler in others. You can also achieve variable banding by pulling your picture out of the camera slowly/at intervals during the chemical spread.

There are other experiments you can try too: why not make a 'double exposure' by interrupting the processing of two Polaroid shots simultaneously, then swapping the negative from one of your peel-apart film sheets onto the positive from the other?

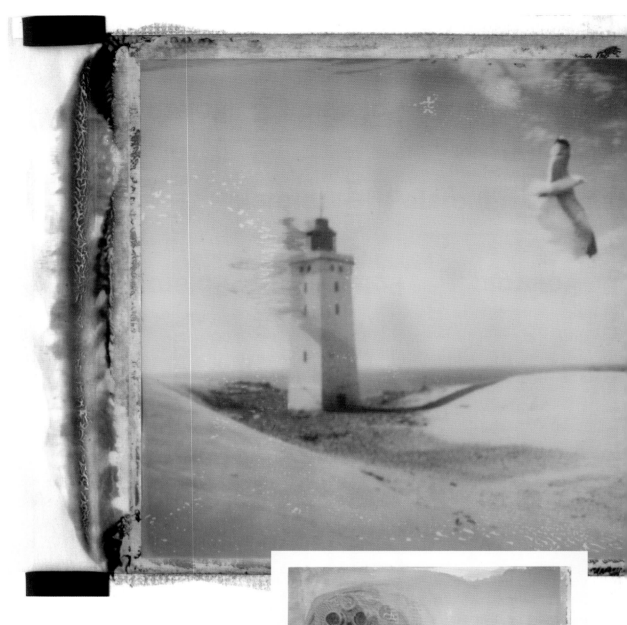

Selection of 'interrupted' images

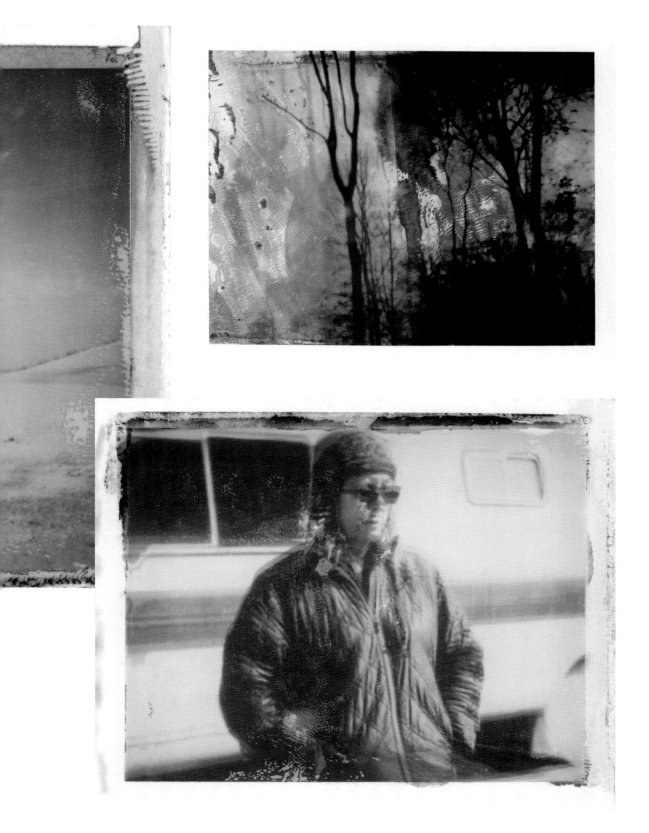

Colour Injection

FILM Any integral
TIME 10–30 minutes
DIFFICULTY Moderate

Some manipulations, such as colour injection, can be achieved both before or just after you have taken your exposure. This technique results in colour smears or blocks appearing in the final image. The effects are particularly striking with Impossible's black-and-white film, though all integral films including Fuji Instax, can be used.

Although this technique is easier to follow post-exposure, enabling you to work in the light rather than in the dark, the effects are quite different, and the colour smears will be less consistent. This step-by-step focuses on the slightly more advanced pre-exposure method. Before attempting this technique, practise swapping film (see pages 64–65) and familiarize yourself with the parts of an integral film sheet (see pages 42–43).

If you would prefer to work in the light, simply inject your film pod with colour as shown in steps 3 and 4 and, instead of following steps 5 and 6, use a roller to spread the chemicals across the image, being careful not to push too hard.

Materials

- Integral camera
- Pack of compatible film
- Tape
- Spare dark slide/piece of card
- Large gauge hypodermic needle and syringe
- Scalpel
- Viscous paint/ink/dye/nail varnish

Method

1 Find a dark space in which to work and prepare your film. Remove the dark slide from your film pack, followed by one sheet of film. Do this carefully so that the film's pod doesn't burst prematurely. Put aside the rest of the pack for later use and recover with the dark slide.

Lay the film sheet face up on your work surface. Tape the dark slide/piece of card to the front window, feeling the edges all around to ensure that it is fully covered. Tape around the edges too, to stop light entering in-between the dark slide and the film sheet. When finished, flip your film sheet over **(a)**.

2 Now that your film sheet is fully protected, you can turn the lights back on. Using the scalpel, gently cut into the chemical pod area at the bottom of the film sheet, being careful not to push through to the front **(b)**. It is best to cut into the upper section of the pod so that the colour you will be injecting is closer to the film area. The slit needs to be just wide enough for you to easily insert the needle of the syringe. You can make this incision very easily with your scalpel. Some developer may seep out at this point. For greater coverage, you may wish to make two incisions: one on the right and one on the left of the pod area.

3 Inject your film. Fill the syringe with a few millilitres of colour and inject into the chemical pod through the incision **(c)**. Be careful to insert only a small amount: if the pod become too full they might burst inside your camera.

4 Once you have finished injecting, wipe away any developer seepage and excess colour. Cover the slit(s) in the pod with tape. Limit any creases in the tape from which your dye could escape **(d)**. Also tape shut the air vents (if present) at the top of your film sheet.

5 Turn the light off again. Peel the tape off the edges of the film (but not off the pod) and remove the dark slide/card. Insert the film sheet back into your film pack and insert a dark slide on top of the pack.

6 Load the film into your camera (if you are using a Polaroid camera, the dark slide will eject automatically). You are now ready to shoot. If you are using a Fuji camera, remember to press the shutter button to eject your dark slide.

Take a picture, and watch as the rollers spread not only the chemical developer, but also the paint that you have just injected **(e)**.

As this substance mingles with the film's integral chemistry, weird and wonderful effects can occur: full transformation can sometimes take hours or even days. So that your print can dry and fix properly, you will need to remove the tape covering the air vents. It is best to wait for approximately 30 minutes after it has ejected before you do this.

7 You could scan the image (see pages 90–91) after the full developed time has elapsed to preserve the final result **(f)**.

Note

This technique can cause the pods to leak as they pass through the rollers. If you see any colour residue on the white print borders after ejection, you will need to clean your rollers immediately. Remove the film pack in the dark then take the camera into the light to clean the rollers and film-ejection slot.

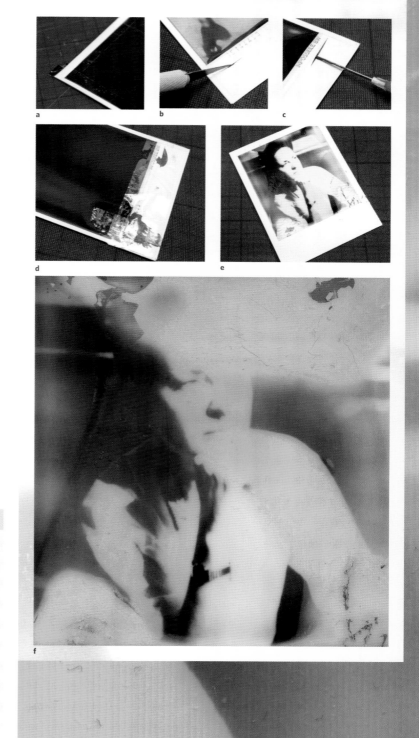

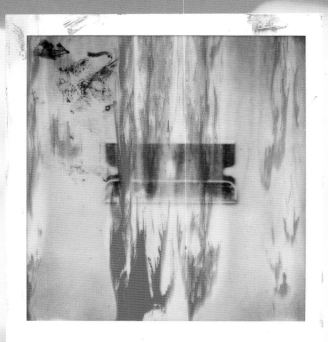

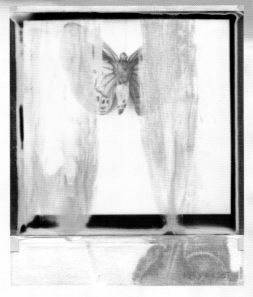

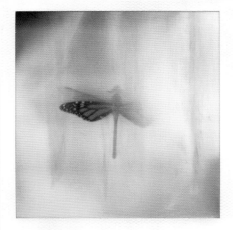

This page: A selection of works by Ritchard Ton, who uses a custom-made blackout envelope to shield his film, and then injects the pods in the light, pre-exposure.

Opposite: Post-exposure injection of nail varnish with Impossible black-and-white film.

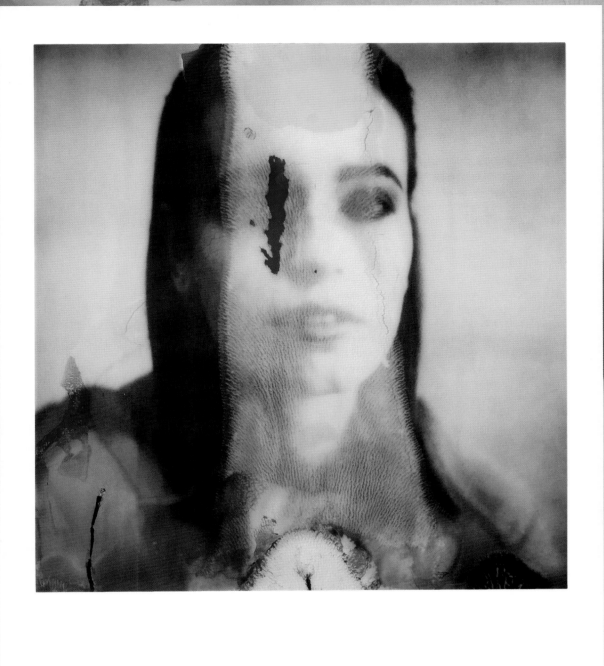

Projection Printing

FILM Any
TIME 30-60 minutes
DIFFICULTY Advanced

Projection printing involves the use of an enlarger in a darkroom to project negatives or slides onto a light-sensitive surface. This technique allows you to turn imagery (depending on the size of your enlarger's negative carrier) shot on slide film in almost any film camera format into instant pictures. Like traditional darkroom printing, you can dodge and burn areas, use filters and zoom and crop, with the added benefit that there is no need to develop, fix and wash your print after it has been exposed.

This method is particularly useful for making large-scale image transfers from slides using Fuji or expired Polaroid pack films, or for emulsion-lift composites. You can project your negatives/slides across multiple Polaroids at the same time to make composites that perfectly match. This method can also be used to create multiple exposures (see pages 108–13), to make copies for hand processing, collage or other emulsion manipulations. If you have access to a darkroom, or even a room that you can make completely dark and in which you can install an enlarger, this process could be for you.

Materials

- Positive (slide) film

- Enlarger

- Piece of thick white card, cut to size so it can slide into your film's pack/back (if using integral film see pages 64–65).

- Camera compatible with your film

- Piece of thick black card

Optional

- Small block of balsa wood

Method
Part 1: Setting up

1. Place a piece of slide film into the enlarger, face-up.

2. Open your film pack and slide the white card on top of your dark slide.

3. You can now turn on a safelight, if you have one. With the white card still on top, position the film pack under the enlarger. It must sit completely parallel to the film enlarger to achieve in-focus images. If using Impossible or expired Polaroid integral film packs that are slightly angled, prop the slimmer end up with a small block of balsa wood cut to size (or another object similar in size) so that the projector and film are parallel.

4. Switch the enlarger on to constant and compose and focus your image on the white card on top of the film sheet.

5. When you are happy with the composition, switch off your enlarger and safelight.

6. Holding the film-pack in position, slide both the white card and dark slide out of the film pack. If using integral film keep the dark slide nearby so that you can reinsert it later.

Part 2:
Working out your exposure

Make a test-strip to calculate the correct exposure for your film. Most instant films are more sensitive to light than darkroom papers and require significantly less light for exposure. For this reason use a slower-speed instant film, such as SX-70 or Fuji FP-100C, to allow for a greater margin of error.

Precise exposure times always vary according to the degree of enlargement and type of enlarger that you are using. For instant film material, set the enlarger at its minimum aperture before you start work.

This technique can take a few attempts to get right. If you make a test strip first you will only be sacrificing one sheet of film rather than many. Making a test strip involves uncovering your film in sections at regular

intervals, and then checking the image once fully developed to see which exposure time yields the best results.

If using SX-70 these intervals can range from between 1 and 10 seconds, and will form a good guide for your testing.

1 With the lights off set the enlarger to 2 seconds. Hold the pack in position and insert your black card, covering all but a 1.5cm- (⅝in.-)strip of your film.

2 Expose for 2 seconds. Now slide the black card another 1.5cm (⅝in.). Repeat until the entire film sheet been exposed and the black card has been pulled out entirely.

3 With the lights still off, reinsert the dark slide (only

necessary if using integral film) and put your film into your camera. As soon as the film is safely inside the camera, you can turn your lights back on.

4 Wait for your image to develop and check the exposure on your strips. Find the one that is closest to the exposure you desire. The darkest section will be the area of film that was exposed to light for the shortest period of time, and the lightest the longest. If the longest exposure is still too dark, you may need to make a second test strip, increasing the duration of each of exposure further.

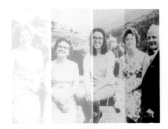

Above: Example of a test strip.

Right: The final image.

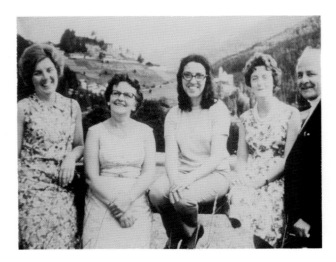

Part 3: Make your exposure

1 Set the enlarger's timer to match the desired result from the test strip.

2 Turn off all the lights, take the film pack out of the camera and slide the black and white pieces of card back into the film pack together, with the white on top. Switch the enlarger onto constant, reposition your film pack as in step 3 then turn off the enlarger light.

3 Remove both pieces of card, revealing the film for exposure. Expose the film sheet for the time determined in step 11, then repeat step 9 to begin processing.

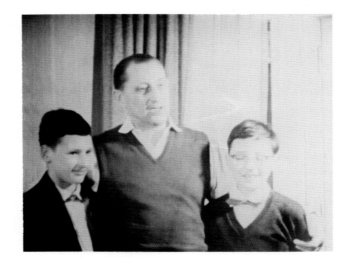

If you have other slides with similar brightness, you can skip testing and make a print using your previous settings. If it needs tweaking, you can make a second print, still using two sheets of film. This way, you have two full prints, rather than one print and a test strip.

Take it further

Use your enlarger's projection area to expose sections of a slide onto multiple instant film sheets to make a mosaic. You could also enlarge different parts of the same image at varying sizes to alter perspective.

To make integral film mosaics cut a guide frame into a sheet of mount board the same size as the image area of your final mosaic. For example, if you want to make a sixteen-image mosaic, you will need to cut the window to measure the width of four images laid side by side, and four images tall, with the borders overlapping. Using a frame makes it easier to lay the images out in the dark, because you can feel the edges of the windows for alignment. Before exposing or making a

test strip, set the focus area and enlarger distance. Place your frame under the enlarger, and switch it on. Focus the image into the cutout area of the frame. Turn off the enlarger and do not change any settings. Next make a test strip, as described in steps 7-10 (see pages 214–15). Now in the dark, set your enlarger to the desired exposure time as determined by the test, then lay your instant film sheets into the window area face up, with slight overlap. When everything is in position, make your exposure. When you have finished, insert your film back into your film pack(s) to process. If you are using integral film, you can load up to a maximum of eight exposed sheets into the film pack in a

stack, and reinsert the film pack into the camera. The first shot will eject as if it is the dark slide. To process subsequent shots (still in the dark) pull the film pack out and push it back in again repeatedly. You should now have a perfectly exposed number of shots to make up your mosaic.

You could also use this method for large-scale contact prints or polagrams (see pages 186–89). If you are making these with pack film, it is best to use multiple packs of film still loaded in their packs instead of laying them under the mount board mask, since it is very difficult to re-spool pack film and set the sheets flat under the enlarger when outside of their holders.

Arnaud Garcia's large-transfer
composites made with pack film.

Collage and Mixed Media

Why not use collage and mixed media to add to the uniqueness of your images? Polaroids are small and often perceived as a haphazard and casual way of photographing. Many Polaroid photographers purposefully manipulate their images, using the methods shown here, to transform their instant images into treasured and coveted artworks that expel these misconceptions.

The tactility of instant film encourages playfulness and layering. Why not challenge the conceived limitations of Polaroids by cutting into or stretching them or embellishing their surface. You could also layer or montage them together, paint on top of or inside them or sew patterns into or photograph them.

Each Polaroid is entirely unique. There is no negative from which exact copies can be made, so manipulating and taking your images apart does require confidence. Before you start work, it's always a good idea to have a goal in mind.

This section will provide some inspiration to get you started. Many of the examples shown here can be achieved with little more than some paint, a craft knife and a needle and thread. Don't be afraid to try something new. The only limits are your imagination.

Above: Ritchard Ton's Polaroid 'sculptures'. **Below:** Enrique Freaza's stitched-through image.

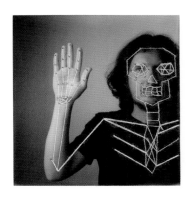

Sewing

Stitching through instant pictures, as seen in Jérôme Cimolaï's integral film images (right; middle) and Maritza De La Vega's beautifully embroidered peel-apart images (below, left and right), is a really striking mixed-media technique.

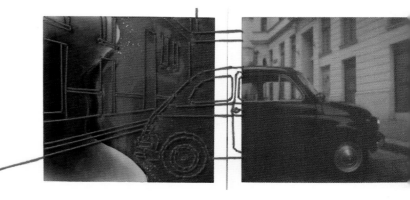

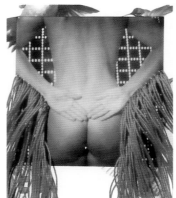

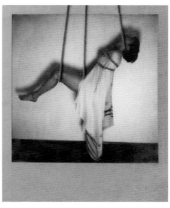

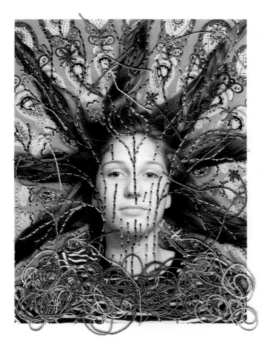

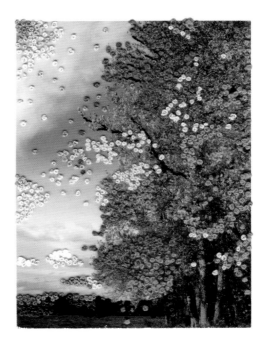

Painting

Why not peel your images apart and paint in-between the layers, or tint the image window with watercolours, acrylics, felt-tip pens, glass paint, spray paint or even glitter glue, as pictured here.

Right: Enrique Freaza adds glitter paint to the surface of this half-developed expired 600 film image.
Middle row: here the layers were peeled apart and a brush used to apply watercolour paint roughly between the layers. The titanium white chemical was left intact and allowed to mix with the paint to create a creamy colour before the picture was reassembled.
Bottom row: Zora Strangefields adds paint, pen and glitter to her Polaroids.

Edie Sunday, hand-tinted Polaroid pack
film images.

Cutting and Splicing

You could splice your pictures together to expand them horizontally/vertically or layer together different images. Below: Rhiannon Adam; right and middle row: Jérôme Cimolaï; bottom left: Filippo Centenari; bottom right: Zora Strangefields.

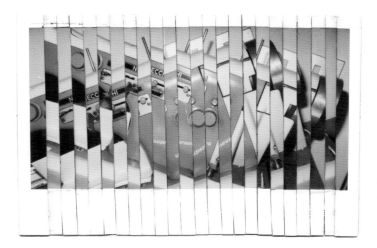

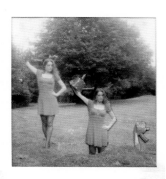

Inside/Outside the Frame

Why not use collage to play on perceptions of reality and what is possible within the confines of a Polaroid frame. Artist Zora Strangefields (right and centre right) creates impossible micro-worlds by painstakingly cutting out their constituent parts and building sets before rephotographing them in situ. Thomas Zamolo pays homage to the Polaroid as a world of its own (below), while Jérôme Cimolaï uses the Polaroid as a stage to blur the lines between fiction and reality (bottom row).

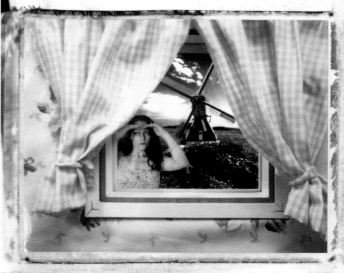

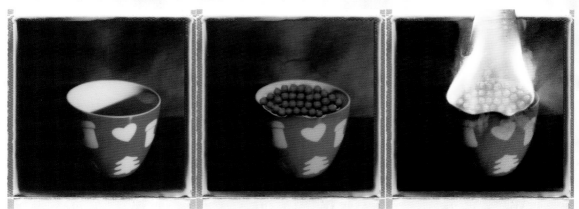

Instant Film Compatibility Guide

Film Name	Appearance	Speed	Type	Camera type	Notes	Year
40 (Polaroid)	Sepia tone	100	Roll (40 series)	Type 40 roll film cameras	Very first instant film for Model 95. 8 shots per roll, 3¼ × 4¼in.	1948–50
41 (Polaroid)	Black and white	100	Roll (40 series)	Type 40 roll film cameras	First true B/W film, required a coater. 8 shots per roll, 3¼ × 4¼in.	1950–59
42 (Polaroid)	Black and white	200	Roll (40 series)	Type 40 roll film cameras	First panchromatic instant film. 8 shots per roll, 3¼ × 4¼in.	1955–92
43 (Polaroid)	Black and white	200	Roll (40 series)	Type 40 roll film cameras	Included a non-reusable acetate negative.	1955–58
44 (Polaroid)	Black and white	400	Roll (40 series)	Type 40 roll film cameras	8 shots per roll, 3¼ × 4¼in.	1956–63
46 (Polaroid)	Black and white	800	Roll (40 series)	Type 40 roll film cameras	8 B/W slides per roll, 2¼ × 2¼in. slide. Required 'Dippit' fixing.	1957–64
46-L (Polaroid)	Black and white	800	Roll (40 series)	Type 40 roll film cameras	Slide film, as above though made larger lantern slides: 3¼ × 4in.	1959–87
47 (Polaroid)	Black and white	3000	Roll (40 series)	Type 40 roll film cameras	Fastest continuous tone photographic film available.	1959–92
48 (Polaroid)	Colour	75	Roll (40 series)	Type 40 roll film cameras	First colour roll film, 'Polacolor I'. 6 prints per roll. Had tendency to curl.	1963–76
31 (Polaroid)	Black and white	100	Roll (30 series)	Type 30 roll film cameras	Small roll film format in models inc. Highlander/J33, 2½ × 3¼in.	1964
32 (Polaroid)	Black and white	200	Roll (30 series)	Type 30 roll film cameras	Speed was increased to 400 ASA in 1959.	1955
37 (Polaroid)	Black and white	3000	Roll (30 series)	Type 30 roll film cameras	Panchromatic, like Type 47 only smaller.	1959
33 (Polaroid)	Colour	75	Roll (30 series)	Type 30 roll film cameras	Not a big commercial success due to several compatibility issues.	1963–69
20 (Polaroid)	Black and white	3000	Roll (20 series)	Type 20 roll film cameras	Designed for use with 20 series cameras, including Swinger Model 20.	1965–70
20C (Polaroid)	Black and white	3000	Roll (20 series)	Type 20 roll film cameras	First coaterless B/W film, and only coaterless roll film ever produced.	1970
105 (Polaroid)	Black and white	32/75 neg/pos	Pack/peel-apart (aka 100/660)	Type 100 cameras/ 405 backs	8 prints, 3¼ × 4¼in. Positive/negative film (later renamed to 665).	1974–77
107 (Polaroid)	Black and white	3000	Pack/peel-apart (aka 100/660)	Type 100 cameras/ 405 backs	One of the two original Type 100 films released. 15-second development.	1963–98
107C (Polaroid)	Black and white	3000	Pack/peel-apart (aka 100/660)	Type 100 cameras/ 405 backs	Coaterless, 30-second development. Ran alongside Type 667.	1978–96
108 (Polaroid)	Colour	75	Pack/peel-apart (aka 100/660)	Type 100 cameras/ 405 backs	The other original pack-film format, and first Polaroid colour film.	1963–2002
084 (Polaroid)	Black and white	3000	Pack/peel-apart (aka 100/660)	Type 100 cameras/ 405 backs	A pack film similar to 667, unrelated to the later Type 84.	1977–2002
606 (Polaroid)	Sepia	200	Pack/peel-apart (aka 100/660)	Type 100 cameras/ 405 backs	10 exposures per pack.	No data
611 (Polaroid)	Black and white	3000	Pack/peel-apart (aka 100/660)	Type 100 cameras/ 405 backs	For shooting CRT monitors needing low contrast. 15-second development.	1979
612 (Polaroid)	Black and white	20000	Pack/peel-apart (aka 100/660)	Type 100 cameras/ 405 backs	Highest-speed Polaroid ever made. For recording oscilloscope traces.	1981–98

Film Name	Appearance	Speed	Type	Camera type	Notes	Year
661 Polacolor ER (Polaroid)	Colour	80	Pack/peel-apart (aka 100/660)	Type 100 cameras/ 405 backs	ID Driving license film, replaced by 671 Not for retail sale 'Special Program' film.	1987- unknown
663 (Polaroid)	Black and white	800	Pack/peel-apart (aka 100/660)	Type 100 cameras/ 405 backs	Japanese market, later sold by Unsaleable for a limited time. Coaterless.	No data
664/Polapan Pro 100 (Polaroid)	Black and white	100	Pack/peel-apart (aka 100/660)	Type 100 cameras/ 405 backs	Panchromatic.	1977- 2007
665 (Polaroid)	Black and white	32/75 neg/pos	Pack/peel-apart (aka 100/660)	Type 100 cameras/ 405 backs	Positive/useable negative. Print requires coating. Neg 32 ISO, pos 75.	1977- 2006
667 (Polaroid)	Black and white	3000	Pack/peel-apart (aka 100/660)	Type 100 cameras/ 405 backs	Similar to 107C. Replaces original 107. Coaterless.	1977- 2007
668/Polacolor ER (Polaroid)	Colour	75	Pack/peel-apart (aka 100/660)	Type 100 cameras/ 405 backs	Pro-market version of 108/669.	1977- unknown
669/Polacolor ER (Polaroid)	Colour	80	Pack/peel-apart (aka 100/660)	Type 100 cameras/ 405 backs	Improved version of Type 108/668 Best film for emulsion lifting.	1981- 2008
671 (Polaroid)	Colour	100	Pack/peel-apart (aka 100/660)	Type 100 cameras/ 405 backs	Rare, 'special events' film. Sold in a paper wrapper only.	1975- unknown
672 (Polaroid)	Black and white	400	Pack/peel-apart (aka 100/660)	Type 100 cameras/ 405 backs	Polapan Pro 400, medium contrast panchromatic. Coaterless.	1998- 2007
679 (Polaroid)	Colour	100	Pack/peel-apart (aka 100/660)	Type 100 cameras/ 405 backs	Aka Polacolor Pro 100. Can transfer but will not lift.	1993- 2003
681 Polacolor ER (Polaroid)	Colour	80	Pack/peel-apart (aka 100/660)	Type 100 cameras/ 405 backs	Plastic-based; for PolaPress (laminator) applications/passport. Like ID-UV.	1991- unknown
689 (Polaroid)	Colour	100	Pack/peel-apart (aka 100/660)	Type 100 cameras/ 405 backs	Aka 'Pro Vivid'. Top of the range colour pack-film (improved version of 679).	1995- 2003
690 (Polaroid)	Colour	125	Pack/peel-apart (aka 100/660)	Type 100 cameras/ 405 backs	First and only self-terminating peel-apart. Can transfer, but will not lift.	2002-08
691 (Polaroid)	Colour	80/20 pos/tran	Pack/peel-apart (aka 100/660)	Type 100 cameras/ 405 backs	Designed for making colour transparencies. 8 per pack.	1985-98
Polacolor 64 Tungsten (Polaroid)	Colour	64	Pack/peel-apart (aka 100/660)	Type 100 cameras/ 405 backs	Tungsten balanced for 3200°K, but similar emulsion to 669. Polacolor ER.	1992- 2008
Polacolor ID/ID-UV (Polaroid)	Colour	80	Pack/peel-apart (aka 100/660)	Type 100 cameras/ 405 backs	Like 669, only with security imprint on surface visible under blacklight.	1993- 2008
125I/Studio (Polaroid)	Colour	125	Pack/peel-apart (aka 100/660)	Type 100 cameras/ 405 backs	Similar to 690. 'Studio Polaroid' was replaced by 125i aimed at passport use.	2003-08
Chocolate (Polaroid)	Brown tone	80	Pack/peel-apart (aka 100/660)	Type 100 cameras/ 405 backs	Rare film. Colour negative with black-and-white positive, giving chocolate tone. Sold by Unsaleable.	2007-08
Sepia (Polaroid)	Sepia	1600	Pack/peel-apart (aka 100/660)	Type 100 cameras/ 405 backs	Rare film. Sold by Unsaleable.	2007-08
Blue (Polaroid)	Blue tone	80	Pack/peel-apart (aka 100/660)	Type 100 cameras/ 405 backs	Rare film. Matte finish ('silk'). Sold by Unsaleable.	2007-08
84 (Polaroid)	Black and white	100	Pack/peel-apart Type 80	Type 80 cameras	Like 664. Coaterless.	2003-08
85 (Polaroid)	Black and white	32/80	Pack/peel-apart Type 80	Type 80 cameras	Like 665. Print required coating. Useable negative.	2003-08
87 (Polaroid)	Black and white	3000	Pack/peel-apart Type 80	Type 80 cameras	The first coaterless B/W pack film.	1974- 2006
88 Polacolor ER (Polaroid)	Colour	75	Pack/peel-apart Type 80	Type 80 cameras	Similar emulsion to 669. Went through various versions of the same name.	1971- 2006

Film Name	Appearance	Speed	Type	Camera type	Notes	Year
89 (Polaroid)	Colour	100	Pack/peel-apart Type 80	Type 80 cameras	Similar to Viva films and 689/679. Not suitable for emulsion lifts.	2003-06
Viva (Polaroid)	Colour	160	Pack/peel-apart Type 80	Type 80 cameras	Aimed at professional markets/ passport use. Not sold in the USA.	No data
Viva Colour gloss/ silk (Polaroid)	Colour	125	Pack/peel-apart Type 80	Type 80 cameras	Not sold in the USA or Canada. Available in glossy or 'silk' (matte).	unknown –2006
Viva 3000 (Polaroid)	Black and white	3000	Pack/peel-apart Type 80	Type 80 cameras	Same emulsion as type 87 and 667. Non-USA version.	2003-07
Chocolate 80 (Polaroid)	Brown tone	100	Pack/peel-apart Type 80	Type 80 cameras	Rare film. Same as chocolate Type 100, only square.	2007-08
552 (Polaroid)	Black and white	400	Pack/peel-apart Type 550	Polaroid 550 4"×5" camera backs	Professional film, same emulsion as the sheet film Type 52. Similar to 672.	1981-96
553 (Polaroid)	Black and white	800	Pack/peel-apart Type 550	Polaroid 550 4"×5" camera backs	Professional film, same emulsion as Type 63 and 663. Coaterless.	1986–2004
554 (Polaroid)	Black and white	100	Pack/peel-apart Type 550	Polaroid 550 4"×5" camera backs	Same emulsion as 664, 84, 54, 804. Coaterless. Polapan Pro 100.	1988–2004
558 (Polaroid)	Colour	80	Pack/peel-apart Type 550	Polaroid 550 4"×5" camera backs	Polacolor 2 film, one of two original type 550 pack-films, alongside 552.	1981–2004
559 (Polaroid)	Colour	80	Pack/peel-apart Type 550	Polaroid 550 4"×5" camera backs	Same emulsion as 669, 88, 59, 809. Polacolor ER. Also available in silk.	1981–2004
572 (Polaroid)	Black and white	400	Pack/peel-apart Type 550	Polaroid 550 4"×5" camera backs	Polapan 400. Same as 672, 52.	unknown –2004
579 (Polaroid)	Colour	100	Pack/peel-apart Type 550	Polaroid 550 4"×5" camera backs	Like 679. Emulsion was upgraded in 1999 to P6 chemistry (improved colour).	1996–2008
51 (Polaroid)	Black and white	640/80 pos/neg	Sheet film	4"×5" sheet film (for 545 backs)	Positive/resusable negative. High-contrast film.	1967–2008
52 (Polaroid)	Black and white	200	Sheet film	4"×5" sheet film (for 545 backs)	Emulsion like Type 42. Speed was later increased, below. Required coating.	1958–61
52 (Polaroid)	Black and white	400	Sheet film	4"×5" sheet film (for 545 backs)	Print requires coating. Like 552 and 672.	1967–2007
53 (Polaroid)	Black and white	200	Sheet film	4"×5" sheet film (for 545 backs)	Panchromatic, with acetate negative.	1958– unknown
53 (Polaroid)	Black and white	800	Sheet film	4"×5" sheet film (for 545 backs)	Coaterless, medium contrast, wide tonal range. 30-second development.	1986–2007
54 (Polaroid)	Black and white	100	Sheet film	4"×5" sheet film (for 545 backs)	Wide tonal range. Polapan Pro 100, like 664, 84, 804. Coaterless.	unknown – 2008
55 (Polaroid)	Black and white	25/50 pos/neg	Sheet film	4"×5" sheet film (for 545 backs)	Positive/negative. Still very desirable. Very high-definition negative.	1961–2008
56 (Polaroid)	Polapan Sepia	400	Sheet film	4"×5" sheet film (for 545 backs)	Medium contrast, panchromatic. Similar to 606.	1996–2007
57 (Polaroid)	Black and white	3000	Sheet film	4"×5" sheet film (for 545 backs)	Like 667, 107, 107C, 87.	1961–2007
58 Polacolor ER (Polaroid)	Colour	75	Sheet film	4"×5" sheet film (for 545 backs)	Same emulsion as 48 and 38. Polacolor 1 version required print mounting.	1963–75
58 Polacolor ER (Polaroid)	Colour	75	Sheet film	4"×5" sheet film (for 545 backs)	Polacolor 2 version of above, no longer requiring print mounting.	1975–81
59 Polacolor ER (Polaroid)	Colour	80	Sheet film	4"×5" sheet film (for 545 backs)	Improved version of Type 58; similar to Type 669 except for format.	1981–2007

Film Name	Appearance	Speed	Type	Camera type	Notes	Year
Polacolor 64 Tungsten (Polaroid)	Colour	64	Sheet film	4"×5" sheet film (for 545 backs)	Confusingly has the same name as the 100 type pack-film variant.	1992–2007
72 (Polaroid)	Black and white	400	Sheet film	4"×5" sheet film (for 545 backs)	Polapan 400. Emulsion is like 572 and 672.	unknown–2007
79 (Polaroid)	Colour	100	Sheet film	4"×5" sheet film (for 545 backs)	Also known as Polacolor Pro 100. Emulsion like 579, 679, 689.	1996–2007
510 (Polaroid)	Black and white	10000	Sheet film	4"×5" sheet film (for 545 backs)	High speed, ultra-high contrast for oscilloscope recording.	1965–67
803 (Polaroid)	Black and white	800	Sheet film	8"×10" sheet film holder/processor	Required separate processor and holder. Coaterless.	1987–2007
804 (Polaroid)	Black and white	100	Sheet film	8"×10" sheet film holder/processor	Separate processor and holder. Polapan Pro 100. Like 554, 664, etc. Coaterless.	1989–2007
808 (Polaroid)	Colour	80	Sheet film	8"×10" sheet film holder/processor	Required separate processor and holder. Like 58, 668/108.	1977–84
809 (Polaroid)	Colour	80	Sheet film	8"×10" sheet film holder/processor	Improved version of Type 808; similar emulsion to Type 59 and 669. Required separate processor and holder.	1981–2007
811 (Polaroid)	Black and white	200	Sheet film	8"×10" sheet film holder/processor	Separate processor and holder.	1978–unknown
891 (Polaroid)	Colour	80/20 pos/tran	Sheet film	8"×10" sheet film holder/processor	Separate processor and holder. Polaroid Colorgraph film for transparency.	1980–98
20×24 P3 Polacolor ER (made by Polaroid and later, 20×24 Holdings)	Colour	80	20"×24" roll film	20"×24" film for Polaroid 20×24 camera	XL version of 669, 809, etc. John Reuter's lab still mixes this. Film was updated in line with Polaroid's smaller formats so introduction dates vary.	See Notes (left)
20×24 P7 Polacolor (made by Polaroid and later, 20×24 Holdings)	Colour	100	20"×24" Roll film	20"×24" film for Polaroid 20×24 camera	XL version of 690, Pro 100 etc. John Reuter's lab still mixes this. Film was updated in line with Polaroid's smaller formats so introduction dates vary.	See Notes (left)
20×24 Polapan 400 (Polaroid)	Black and white	400	20"×24" Roll film	20"×24" film for Polaroid 20×24 camera	Like 672, with a wide tonal range. No longer available.	As above
SX-70 (Polaroid)	Colour	150	Integral (battery included)	SX-70 cameras	First integral film. Later colour peel-apart films made use of SX-70 dyes.	1972–76
Time Zero/ SX-70 Time Zero (Polaroid)	Colour	150	Integral (battery included)	SX-70 cameras	Reduced development time of SX-70. Had various naming incarnations.	1978–2006
778 (Polaroid)	Colour	150	Integral (battery included)	SX-70 cameras	Professional version of SX-70. Best 10 per cent of each production run.	1978–2006
708 (Polaroid)	Colour	150	Integral	Face Place Photobooth	An oddity. No battery, used in Face Place photobooth and non-powered film backs.	1977–unknown
SX-70 Blend	Colour	150	Integral (battery included)	SX-70 cameras	Non manipulable. ND filter over pack to use in an SX-70, otherwise like 600.	2006–07
Artistic TZ (Polaroid chemistry, marketed by Polapremium/ Unsaleable)	Colour	150	Integral (battery included)	SX-70 cameras	Limited-edition film using expired Polaroid chemicals from the Enschede factory before full closure. Unsaleable/ Polapremium became Impossible. Like all SX-70 based films, it is manipulable.	2007
Fade to Black (Polaroid chemistry, marketed by Polapremium/ Unsaleable)	Colour	150	Integral (battery included)	SX-70 cameras	Fades to black in 24 hours (again using expired chemicals). To stop the process you had to peel the layers apart when the image reached the desired tone. Manipulable.	2009

Film Name	Appearance	Speed	Type	Camera type	Notes	Year
600 (Polaroid)	Colour	640	Integral (battery included)	600 series integral cameras	Various incarnations, including 600 plus, platinum, 780 Turbo and high definition. Non-manipulable.	1981–2008
600 matte/Alter image/Write-On (Polaroid)	Colour	640	Integral (battery included)	600 series integral cameras	Had a matte image surface that could be written on. Included various special editions: Barbie, Looney Toons, etc.	1997–unknown
600 black and white (Polaroid)	Black and white	640	Integral (battery included)	600 series integral cameras	Also known as extreme monochrome. Quite unstable, low in contrast.	1997–2002
600 copy and fax (Polaroid)	Black and white	640	Integral (battery included)	600 series integral cameras	Film cartridge has a built-in halftone screen, for easy copying.	1998–2002
779 (Polaroid)	Colour	640	Integral (battery included)	600 series integral cameras	Professional version of 600 film.	1989
2000 film, later 700 (Polaroid)	Colour	640	Integral (battery included)	700/2000 series integral cameras only (the pack is modified slightly to fit only in these models, though could be adapted)	Introduced to developing markets at low cost to further instant photography market. To stop export to mature markets, in 1996 a dedicated camera was introduced to China, the model 2000, and later the 780/790. These accepted 600, 2000 and later 700.	1996–unknown
Image (Polaroid)	Colour	600	Integral (battery included)	Spectra/Image cameras	Very similar to 600 film, but wide format. Image areas 9.2 × 7.3 cm. International version.	1986–2007
Spectra (Polaroid)	Colour	640	Integral (battery included)	Spectra/Image cameras	Rebranded and improved multiple times, including High Definition, Platinum and 700 (not to be confused with the 600 style 700 above). Same as Image film.	1986–2007
Spectra Grid film (Polaroid)	Colour	640	Integral (battery included)	Spectra/Image cameras	Included pre-exposed grid lines, for use in medical applications/Macro 3 and 5.	1998–unknown
Type 1200 (Polaroid)	Colour	640	Integral (battery included)	Spectra/Image cameras	12 exposures per pack, otherwise the same as Spectra.	2002–07
Type 990 (Polaroid)	Colour	640	Integral (battery included)	Spectra/Image cameras	Pro version of Spectra/Image High Definition.	unknown–2007
Image Softtone (Polaroid chemistry, marketed by Polapremium/ Unsaleable)	Colour	640	Integral (battery included)	Spectra/Image cameras	Limited run marketed by the team that later became the Impossible Project. Sold in a Giambarba designed slipcase, made from expired chemicals. Low contrast, pastel hues.	2007–08
ColorShot (Polaroid)	Colour	640	Integral	ColourShot Printer	Batteryless film made for use with the Windows based ColorShot printer.	1998
Captiva 95 (Polaroid)	Colour	640	Integral (battery included)	Captiva/Vision/ JoyCam cameras	10 shots per pack. Introduced with Captiva camera. $2\frac{7}{8} \times 2\frac{1}{8}$ (7.3 × 5.4 cm)	1993–98
Vision 95 (Polaroid)	Colour	640	Integral (battery included)	Captiva/Vision/ JoyCam cameras	International markets version of the above. Interchangeable.	1993–98
Type 500 (Polaroid)	Colour	640	Integral (battery included)	Captiva/Vision/ JoyCam cameras	Improved version of Captiva/JoyCam films with standardized naming.	1998–2006
Phototape 608 (Polaroid)	Colour	40	Movie film (silent)	Polavision camera/ viewer	Required Polavision processor. No sound. Original Polavision film.	1977–80
Phototape 617 (Polaroid)	Black and white	125	Movie film (silent)	Polavision camera/ viewer	Panchromatic, aimed at scientific applications.	1980–88
Phototape 618 (Polaroid)	Colour	40	Movie film (silent)	Polavision camera/ viewer	Revised version of 608, made after Polaroid had discontinued the cameras.	1980–88
PolaBlue CN (Polaroid)	Blue on white	8	Instant 35mm slide film	35mm cameras and autoprocessor	12 exposures. Based upon Polavision system of development.	1987–unknown

Film Name	Appearance	Speed	Type	Camera type	Notes	Year
PolaChrome CS (Polaroid)	Colour	40	Instant 35mm slide film	35mm cameras and autoprocessor	24 or 36 exposures. Additive colour version of the slide film.	1983–unknown
PolaChrome HCP (Polaroid)	Colour	40	Instant 35mm slide film	35mm cameras and autoprocessor	12 exposures. High contrast, saturated, version of colour film.	1986–unknown
PolaGraph (Polaroid)	Black and white	400	Instant 35mm slide film	35mm cameras and autoprocessor	12 exposures. High contrast. Aimed at line-art reproduction.	1983–unknown
PolaGraph HC (Polaroid)	Black and white	400	Instant 35mm slide film	35mm cameras and autoprocessor	24 or 36 exposures. High contrast. Aimed at line-art reproduction.	1983–unknown
Polapan CT (Polaroid)	Black and white	125	Instant 35mm slide film	35mm cameras and autoprocessor	12 or 36 exposures. Medium contrast, continuous tone, general purpose.	1983–unknown
FP-100C (Fuji)	Colour	100	Pack/peel-apart	Type 100 pack cameras/backs	Compatible with Type 100 Polaroid cameras and backs. Still very useful.	1987–2016
FP-100B (Fuji)	Black and white	100	Pack/peel-apart	Type 100 pack cameras/backs	Fuji did also make a shortlived 500 speed variant.	c. 1985–2011
FP-3000B (Fuji)	Black and white	3000	Pack/peel-apart	Type 100 pack cameras/backs	Fine grained, panchromatic. Well suited to industrial applications.	c. 1985–2013
FP100C-45 (Fuji)	Colour	100	Pack/peel-apart	Polaroid 550 4"×5" camera backs	As with FP-100C, you can lift, transfer and access the negative.	c. 1985–2012
FP-100B-45 (Fuji)	Black and white	100	Pack/peel-apart	Polaroid 550 4"×5" camera backs	Discontinued.	c. 1985–2011
FP-3000B-45 (Fuji)	Black and white	3000	Pack/peel-apart	Polaroid 550 4"×5" camera backs	Discontinued.	c. 1985–2012
NEW 55 (also made by New 55)	Black and white	Variable (check batch)	Sheet film	4"×5" sheet film (for 545 backs)	Positive/negative (see New 55 reclamation).	2014–present
Color film for SX-70 (Impossible)	Colour	125 (varies)	Integral (battery included)	SX-70 cameras	8 shots per pack. Early versions called 'PX-70'.	2010–present
B&W film for SX-70 (Impossible)	Black and white	100	Integral (battery included)	SX-70 cameras	8 shots per pack. Early versions were prone to 'killer crystal'.	2010–present
Color film for 600 (Impossible)	Colour	680	Integral (battery included)	600 series integral cameras	8 shots per pack. Early versions also known as PX-680.	2010–present
B&W film 600 (Impossible)	Black and white	600	Integral (battery included)	600 series integral cameras	8 shots per pack. Early versions include Silver Shade, UV+ and Cool and were prone to 'killer crystal'.	2010–present
Color film for Spectra (Impossible)	Colour	680	Integral (battery included)	Spectra and Image branded cameras	8 shots per pack. Early versions known as 'PZ'.	2011–present
B&W film for Image/Spectra (Impossible)	Black and white (8 shots per pack)	680	Integral	Spectra/Image cameras	Early versions known as 'PZ'. Roughly follows Impossible's 600 B/W.	2011–present
B&W film for 8"×10" (Impossible)	Black and white (10 shots per box)	640	8"×10" sheet film (semi-integral)	8"×10" sheet film holder/processor	Requires separate processor and holder to push integral layers together. Formerly known as PQ.	2014–present
Color film for 8"×10" (Impossible)	Colour (10 shots per box)	640	8"×10" sheet film (semi-integral)	8"×10" sheet film holder/processor	Requires separate processor and holder to push integral layers together. Formerly known as PQ.	2012–present

Note: Many other 600 films exist, all are compatible with 600 cameras. Most of these involve special borders or masks, or are foreign-market versions. I-Zone films are not listed here, as their compatibility is self-explanatory and their tenure shortlived.

Dates listed are for manufacturing periods, not expiry dates. As a rule, add one to two years to the final manufacturing date to determine expiry.

Acknowledgments

First, I'd like to thank Edwin Land for bringing Polaroid to life, and Florian Kaps for keeping the dream alive. Without these two remarkable men, I may never have had the pleasure of the extended instant photography family of which I find myself a part.

The world of instant photography has changed my life. Thanks to the warmth of those within it, I have friends in almost every city across the globe. With you all, photography is no longer a solitary pursuit, and you have all played your part in the journey of realizing this project. In particular, to EZS, CDV, Rommel Pecson, Enrique Freaza, Richard Bevan, Philippe Bourgoin and the original Polanoid.net crew – thank you for the friendship and the adventures!

Thank you to every artist that allowed me to reproduce their work, and to those who have given up precious time to share stories and expertise. To Deborah Douglas at the MIT Museum for allowing me to root through boxes, to Chris Bonanos for answering all of my questions, to John Reuter and Nafis Azad of the 20"x24" studio, thanks for the tour, the conversation, the lunch and the picture, to Bob Crowley and Sam Hiser at New 55 for their time, to Paul Giambarba for a wonderful day on the Cape, to Elsa Dorfman for always being a source of inspiration, to Melissa Murphy at the Baker Library for the archive imagery and to Franz Edtberger for the many pictures of his collection. Extra special thanks must go also to the team at MiNT cameras, and at The Impossible Project (including Stephen Herchen, Pierre Darnton, Alex Holbrook, Amy Heaton, Heinz Boesch and Oskar Smołokowski).

To Barbara Conway, my secondary school art teacher who allowed my Polaroid fascination to flourish – thank you for always being open-minded! To Kate Slotover, who pushed me to do this, and worked wonders with the design.

To Octavia, who sadly is no longer with us – this should have had your name on it too. To Rossella Castello for the gifts of perfect timing, a photogenic face, steady hands and good humour. To the team at Thames & Hudson (Andrew, Amanda, Blanche, Nicola, Johanna) for making this work.

Of course, the biggest shout out has to go to my partner, friends and family who have put up with me throughout this process. I know I've been a borderline obsessive, confirmed recluse and an insufferable bore. My sincere apologies. The only way is up! The tolerance award has to go (with love) to Carli Pearson above all others – I couldn't have done it without you. Thanks also to Cari Campbell, Jo Cantlay, Laura Pannack and Anka Dabrowska – you distracted me when I needed it most!

As always, with love to my blood – Mum, Melinda, Josh, Dad and my not-so-little sister, Naia – as well as my 'adopted' family – Graham, Mette (and the Bak-Andersens) – and the Pearson/Nicoll clan: Odette, Alan, Rona, Lin and Les.

Photo Acknowledgments

Images, unless otherwise stated, are courtesy of the author. Images acknowledged by page number.

t = top, b = below, c = centre, l = left, r = right

4, 92 (fourth row, c), 164 Louis Little; 5, 10 (camera icons 1-4) Patricia Martinez; 10 (camera icons 5-6), 16, 67 (c), 73 (t), 83, 87, 90 courtesy The Impossible Project; 12 (b) (photo by Meroë Marston Morse) 13 (t), 20-21 (Edwin Land with instant photograph) Polaroid Corporation Records, Baker Library, Harvard Business School; 13 (t), photo by J. J. Scarpetti, courtesy of The Rowland Institute, Harvard; 24 (t) courtesy Baker Library, Harvard Business School; 18 'Pick a Number' courtesy of Adam & Eve DDB/Polaroid; 19 images courtesy Paul Giambarba; 23, 43 Courtesy The Impossible Project/Society for Imaging Science and Technology, reproduced from Edwin H. Land's Essays; 24 (c) Polaroid Corporate Archives/Arcadia Publishing; 25 (bl), 26, 44, 66 photos Rhiannon Adam, images reproduced courtesy of the MIT Museum; 25 (br) courtesy Option8/instantoptions.com; 27 (t) Boycott Polaroid badge by the Polaroid Revolutionary Workers Movement, reproduced with permission from The African Activist Archive/Michigan State University; 14-15, 27 (c, b), 28 (c, b), 32, 39, 46 (b), 47 (1-5 and 7-9), 56, 59, 61, 63, 67 (b), 68, 69 (b), 70-71, 76, 77 (b), 81 (cr) camera images courtesy Franz Edtberger; 28 (t) Tim Williams; 41 courtesy Elsa Dorfman; 45 (b, t) Polaroid; 45 (c) Co Rentmeester/Time & Life Pictures; 46 (t) 2016 Eames Office, LLC (www.eamesoffice.com); 46 (c) Wolf Von Dem Bussche, 1972, reproduced from Photography Year

1973/Time Life International; 47 (image 6), 81 (br, bl) courtesy of MiNT cameras; 57 (t) courtesy Paul Giambarba; 60 (l) Grant Hamilton; 67 (t) image by Enrique Valdivia; 69 (t) Maurizio Galimberti; 74-75, 98 (cr), 141 (tl) Ina Echternach; 77 (t) Steven Monteau; 78 , 79 (t, c, b) Fujifilm Holdings Corporation; 79 (bl), 80, 81 (tr) Lomographische AG; 80 (t) Leica Camera AG; 84 Ray Liu; 88-89 author's own, film packs courtesy The Impossible Project; 91 (tl, br), 92 (bottom row, l), 165, 169 (cl, bl) Daniel Meade; 91 (cr), 130-33, 185 (tl), 223 (cl) Thomas Zamolo; 92-93, 158 (t) Maija Karisma; 94 (top row, l; fifth row, cr), 95 (top row, cr; second row, r; fourth row, r; bottom row, r) 198 (tr, br) Annie France Noël; 94 (top row, r), 122 (tl, tr, cr), 145 (c, bl), 169 (br), 177 (tl), 204 (b), 218 (b), 220 (tr) Enrique Freaza; 94 (bottom row, r), 169 (tl), 172 (t), 173, 177 (tr, cr) Brian Henry; 94 (third row, cr, r), 93 (second row, c; fifth row, c), 145 (tl) Anne Locquen; 94 (bottom row, cr), 112 (t, bl), 168 (bl) Brandon C. Long; 94 (top row, c), 95 (third row, cl; fourth row, l; fourth row, cr; fifth row, l), 98 (cl) Amanda Mason; 94 (bottom row, c), 159 (tr, cr) David Salinas; 94 (fifth row, r), 93 (fourth row, cl), 123 (br), 161 (tl), 220 (bl, br), 222 (br), 223 (t, cr) Zora Strangefields; 94 (bottom row, cl), 105 David Teter; 94 (fourth row, r), 95 (third row, cr; bottom row, l, cr), 96, 97 (b), 152 (bl, br), 153, 154, 158 (b), 159 (cl), 212, 218 (t, c) Ritchard Ton; 94 (top row, cr), 95 (second row, cl; third row, l) Emilie Trouillet; 94 (second row, r), 95 (second row, l) Kat White; 95 (top row, r), 199 Hazel Davies; 95 (bottom row, cl), 102 (tl), 106 (tr, bl, br), 152 (cl, cr) Toby Hancock; 95 (fifth row, cl) Emilie Lefillec;

95 (bottom row, c) Guillaume Nalin; 95 (third row, c), 109 Rommel Pecson; 95 (top row, l), 101 (br), 102 (cl, bl) Dan Ryan; 95 (second row, cr), 106 (tl) S. F. Said; 95 (third row, r), 221 Edie Sunday; 98 (tl), 112 (br) Penny Felts; 98 (tr) Juli Werner; 98 (b), 99 (bc, br) Benjamin Innocent (with Celina Wyss); 99 (tl, tr, cl) Nick Carn; 99 (c), 176 (bl), 181 (b) Phillippe Bourgouin; 99 (cr) Sarah Seene; 102 (tc) Marion Lanciaux; 106 (cl) Jimmy Lam; 111 (tr) Ludwig West; 122 (br) Eduardo Martínez; 123 (tl, tr, bl) Carmen De Vos; 123 (cr) Dominik Werdo; 128 (bl, cr, br) Drew Baker; 129 (c) Mathieu Mellec; 129 (bl) Lucile Le Doze; 129 (br) Lou Noble; 139 John Nelson; 141 (tr) Jennifer Bouchard; 141 (b) Bob Worobec; 145 (tr) Martin Cartright; 145 (br) Anne Bowerman; 149 Lawrence Chiam; 152 (tl, tr), 222 (bl) Filippo Centenari; 155, 161 (cl, cr, bl, br) Chad Coombs; 159 (tl), 219 (bl, br) Maritza De La Vega; 168 (tl, tr) Oliver Blohm; 169 (tr) Amalia Sieber; 172 (b) Julian Humphries; 176 (t) Scott McClarin; 176 (br) Sean Rohde; 177 (b) Adela G. Capa; 181 (tl, tr) Andrew Kua; 181 (c) Susanne Klostermann; 182 Ron O'Connor; 185 (cl, bl) Bastian Kalous; 188 (t), 189 (t) Patrick Winfield; 188 (b) Simone Bærentzen; 189 (bl) Michael Mendez; 189 (br) Nick Marshall; 190 Toshihiro Oshima; 191 Britta Hershman; 195 Robert Solywoda; 198 (tl, cl, bl) Dominic Alves; 217 Arnaud Garcia; 218 (tc, tr, cl, c, cr), 222 (tc, tr, cl, c, cr), 223 (b) Jérôme Cimolai.

Selected Bibliography

Historical

Bonanos, Christopher, *Instant: The Story of Polaroid* (New York, 2010)

Buse, Peter, *The Camera Does the Rest: How Polaroid Changed Photography* (Chicago, 2016)

Earls, Alan R., Nasrin Rohani and Marie Cosindas, *Images of America: Polaroid* (Charleston, 2005)

Fierstein, Ronald K., *A Triumph of Genius: Edwin Land, Polaroid and the Kodak Patent War* (Chicago, 2015)

Giambarba, Paul, *The Branding of Polaroid* (self-published, 2012)

Kaps, Florian, *Polaroid: The Magic Material* (London, 2016)

McElheny, Victor, *Insisting on the Impossible: The Life of Edwin Land* (London, 1998)

Olshaker, Mark, *The Instant Image* (New York, 1978)

Wensberg, Peter C., *Land's Polaroid: A Company and the Man Who Invented It* (Boston, 1987)

Wurman, Richard Saul, *Polaroid Access: Fifty Years* (New York, 1989)

Instructional

Adams, Ansel, *Polaroid Land Photography Manual* (New York, 1963)

Altman, Jennifer, Susannah Conway and Amanda Gillingham, *Instant Love: How to Make Magic and Memories with Polaroids* (San Francisco, 2012)

Boursier, Helen T., *Watercolour Portrait Photography: The Art of Polaroid SX-70 Manipulation* (New York, 2000)

Carr, Kathleen Thormod, *Polaroid Transfers: A Complete Visual Guide to Creating Image and Emulsion Transfers* (New York, 1997)

—, *Polaroid Manipulations* (New York, 2002)

Dickson, John, *Instant Pictures: The Complete Polaroid Land Camera Guide* (London, 1964)

Farry, Eithne, *Polaroid: How to Take Instant Photos* (London, 2015)

Freeman, Michael, *Instant Film Photography: A Creative Handbook* (London, 1985)

Grey, Christopher, *Polaroid Transfer Step-By-Step* (New York, 2002)

Kaps, Florian, Marlene Kelnreiter and The Impossibe Project (eds), *101 Ways to do Something Impossible* (Vienna, 2012)

Wolbarst, John, *Pictures in a Minute* (Berkeley, 1960)

Artist Monographs

Aldridge, Miles, *Please Return Polaroid* (Göttingen, 2016)

Araki, Nobuyoshi, *Polaeroid* (Cologne, 1997)

Bergemann, Sibylle, *The Polaroids* (Osfildern, 2011)

Bitesnich, Andreas H., *Polanude* (New York, 2006)

Bianchi, Tom, *Fire Island Pines: Polaroids, 1975–1983* (Bologna, 2013)

Bourdin, Guy, *Polaroids* (Paris 2009)

Brodie, Mike, *Tones of Dirt and Bone* (Santa Fe, 2015)

diCorcia, Philip-Lorca, *Thousand* (Göttingen, 2007)

D'Orazio, Sante, *Polaroids* (San Francisco, 2016)

Ferrari, Fulvio, and Napoleone Ferarri, *Carlo Mollino: Polaroids* (Santa Fe, 2002)

Fischer, Arno, *Der Garten/The Garden* (Ostfildern, 2007)

Frank, Robert, *Seven Stories* (Göttingen, 2009)

Giger, H. R., *Polaroids* (Switzerland, 2014)

Hamilton, Richard, *Polaroid Portraits*, vol. I–IV (Stuggart, 1972–2001)

Heinecken, Robert, *Lessons in Posing Subjects* (Brussels, 2014)

Kerteész, André, *The Polaroids*, Robert Gurbo, ed. (New York, 2007)

Mapplethorpe, Robert, *Polaroids*, David Frankel, ed. (Munich, 2007)

Mark, Mary Ellen, *Twins* (New York, 2003)

Moriyama, Daido, *White and Vinegar* (Tokyo, 2012)

Müller, Robby, *Polaroid (Interior; Exterior)*, Marente Bloemheuvel, Annet Gelnick and Jaap Guldemond, eds (Cologne, 2016)

Newton, Helmut, *Pola Woman*, June Newton, ed. (Munich, 1996)

—, *Polaroids*, June Newton, ed. (Cologne, 2011)

Nicholson, Jon, *Seaside Polaroids* (Munich, 2013)

Rosenheim, Jeff L., *Walker Evans: Polaroids* (Zurich, 2002)

Saile, Lia, *Frail: The Impossible Project* (Vienna, 2011)

Samaras, Lucas, *Photo-Transformations* (New York, 1976)

Saramento, Julião, *95 Polaroids SX70* (Gent, 2012)

Schneider, Stefanie, *Instant Dreams*, Christoph Bamberg, Stefanie Harig and Marc A. Ullrich, eds (Berlin, 2014)

—, *Wastelands*, Thomas Schirmböck, ed. (Berlin, 2006)

Slack, Mike, *Ok Ok Ok*, The Ice Plant (Los Angeles, 2006)

—, *Scorpio*, The Ice Plant (Los Angeles, 2006)

—, *Pyramids*, The Ice Plant (Los Angeles, 2009)

Smith, Patti, *Camera Solo*, exh. cat., Wadsworth Atheneum Museum of Art (New Haven, 2011)

—, *Land 250* (London, 2008)

Strehle, Peter, *Lost Stories* (Stuggart, 2013)

Steadman, Ralph, *Paranoids* (London, 1986)

Uchitel, Diego, *Polaroids* (Bologna, 2012)

Van Sant, Gus, *One Step Big Shot* (Munich, 2010)

Warhol, Andy, *Red Books* (Göttingen, 2004)

Wegman, William, *Polaroids* (New York, 2002)

Woodward, Richard B., and Reuel Golden, *Andy Warhol Polaroids, 1958–1987* (Cologne, 2015)

List of Contributors

Dominic Alves — www.flickr.com/photos/dominicspics/albums/72157622910488534

Drew Baker — www.flickr.com/people/drewbaker/?rb=1

Oliver Blohm — www.oliverblohm.com

Jennifer Bouchard — www.jbbouchard.com

Philippe Bourgoin — www.flickr.com/people/philippebourgoin

Anne Bowerman — www.flickr.com/people/anniebee

Adela Capa — www.flickr.com/photos/adelagomez

Nicholas Carn — www.nicholascarn.tumblr.com

Martin Cartright — www.flickr.com/photos/skink74

Filippo Centenari — www.filippocentenari.it

Lawrence Chiam — www.lawchiam.com

Jerome Cimolai — www.flickr.com/people/cimolaijerome

Chad Coombs — www.chadcoombs.com

Hazel Davies — www.hazeldavies.co.uk

Maritza De La Vega — www.flickr.com/people/zazazed

Carmen De Vos — www.carmendevos.com

Ina Echternach — www.polaroid-fotografie.de

Penny Felts — www.pennyfelts.com

Annie France Noel — www.anniefrancenoel.com

Enrique Freaza — www.urizen.es/contact.html

Maurizio Galimberti — www.mauriziogalimberti.it

Arnaud Garcia — www.flickr.com/people/85728017@N00/?rb=1

Justin Goode — https://goodephotography.wordpress.com

Grant Hamilton — www.sxseventy.com

Toby Hancock — www.tobysx70.tumblr.com

Brian Henry — www.instantdecay.com

Britta Hershman — www.brittahershman.com

Julian Humphries — www.flickr.com/people/austintexas

Benjamin Innocent — www.instagram.com/mr_muse

Bastian Kalous — www.bastiankalous.com

Maija Karisma — www.kaiku-ja.blogspot.co.uk

Susanne Klostermann — www.susanneklostermann.jimdo.com

Andrew Kua — www.fuzzyeyeballs.com/blog

Jimmy Lam — www.jimmyjlphotography.com

Marion Lanciaux — www.flickr.com/people/mironabside

Lucile Le Doze — www.flickr.com/people/64952646@N04/?rb=1

Emilie Lefellic — www.flickr.com/emilie79

Louis Little — www.louislittle.co.uk

Ray Liu — www.rayliu.co.uk

Anne Locquen — www.instagram.com/annette1817

Brandon Long — www.theonlymagicleftisart.com

Nick Marshall — www.flickr.com/photos/nmarshall

Eduardo Martínez Nieto — www.pocketmemories.net

Amanda Mason — www.amandamason.com.au

Scott McClarin — www.flickr.com/photos/smcclarin

Daniel Meade — www.dan-meade.com

Mathieu Mellec — www.instagram.com/snapshots.and.bruises

Michael Mendez — www.flickr.com/people/michaelmendez

Steven Monteau — www.facebook.com/stevenmonteau

Guillome Nalin — www.flickr.com/people/nguillome

John Nelson — www.flickr.com/people/96421883@N04/?rb=1

Lou Noble — www.louobedlam.com

Ron O'Connor — www.flickr.com/people/ronphoto594

Toshihiro Oshima — www.flickr.com/people/tommyoshima

Rommel Pecson — www.cargocollective.com/pecson

Marian Rainer-Harbach — www.flickr.com/people/marianrh

Sean Rohde — www.moominsean.blogspot.co.uk

Dan Ryan — www.adreamofwhitehorses.blogspot.co.uk

S. F. Said — www.flickr.com/people/thegentlemanamateur

David Salinas — www.thelowestfidelity.blogspot.co.uk

Sarah Seene — www.flickr.com/people/welcometosarahland

Amalia Sieber — www.amaliachimera.com

Simone Bærentzen — www.eggzakly-photography.blogspot.co.uk

Robert Solywoda — http://robertsolywoda.wix.com/photography

Zora Strangefields — www.zorastrangefields.com

Edie Sunday — www.ediesunday.com

David Teter — www.flickr.com/people/davidteter

Emilie Trouillet — www.ahbahbravo.tumblr.com

Ritchard Ton — www.flickr.com/people/sx70manipulator

Dominik Werdo — www.loss-of-light.blogspot.co.uk

Juli Werner — www.madorangefools.com

Ludwig West — www.flickr.com/people/ludwigwest

Kat White — www.katwhite.com.au

Patrick Winfield — www.patrickwinfield.com

Bob Worobec — www.flickr.com/photos/boab

Thomas Zamolo — www.thomaszamolo.com

Stockists

Camera/Film Manufacturers

20"x24" Studio www.20x24studio.com

Fuji www.fujifilm.com/worldwide

Impossible Project www.impossible-project.com

Leica https://en.leica-camera.com/Photography

Lomography www.lomography.com

MiNT www.mint-camera.com

New55 www.new55.net

Retailers

Adorama www.adorama.com/l/Films-and-Darkroom/Film/Instant-Film

B&H Photo www.bhphotovideo.com

CatLABS www.catlabs.info

eBay www.ebay.com

Roger Garrell www.stores.ebay.co.uk/polaroidcamerasfromfastcat99

Jessops www.jessops.com

Erik Karstan Smith www.ebay.com/usr/dr.frankenroid

Mr Cad www.mrcad.co.uk

The Photographer's Gallery www.thephotographersgallery.org.uk

Polamad www.polamad.com

Shutter + Light https://shutterpluslight.com/shop

Supersense http://the.supersense.com

Urban Outfitters www.urbanoutfitters.com

West End Cameras www.westendcameras.co.uk

Repairs, Refurbs, Hacks and Mods

www.chriswardsecondshot.com
www.instantoptions.com
www.landcameras.com

Batteries

www.hellobatteries.co.uk
www.maplin.co.uk (for battery conversions)
www.smallbattery.company.org.uk

Filters

B+W www.schneideroptics.com
Hoya www.hoyafilter.com
Lee Filters www.leefilters.com
Rosco http://us.rosco.com/en/products

Chemical/Darkroom Suppliers

Silverprint www.silverprint.co.uk
Sunprint www.sunprints.org

Storage solutions

http://holgamods.com/holgamods/3D_Stuff.html
https://squareup.com/store/photole-photography
www.preservationequipment.com
www.secol.co.uk

Framing

www.ebay.co.uk/usr/midnight_gallery
www.instantframing.blogspot.co.uk
www.ikea.com
www.muji.com

Carry Cases

www.caselogic.com (folding sonar cameras)
http://en.unitportables.com (SX-70s I-1s)

Publishers

www.prymeeditions.com
www.redfoxpress.com

Guides

https://danfinnen.com/photography/
http://polaroids.theskeltons.org
https://support.impossible-project.com/hc/en-us
www.butkus.org/chinon/polaroid.htm
www.chemie.unibas.ch/~holder/SX70.html
www.filmphotographyproject.com
www.filmwasters.com
www.flickr.com/photos/aspectsoflight/sets/72157628059730518
www.giam.typepad.com/the_branding_of_polaroid_/

www.ifixit.com/Guide/Polaroid+Automatic+100+Bellows+Replacement/41629
www.instantoptions.com
www.instructables.com/id/Packtasticor-How-to-use-100-Series-Film-in-an-
www.landlist.ch/landlist/landhome.htm
www.lightsquared.tumblr.com
www.moominsean.blogspot.co.uk
www.photodreamfactory.blogspot.co.uk/2011/11/cokin-filters-for-polaroid-land-camera.html
www.polaroidland.net
www.rangefinderforum.com
www.silverbased.org

Sharing/viewing work online

https://magazine.the-impossible-project.com/submit
https://twitter.com/polaroidweek
www.instantfilmsociety.com
www.polaroid.net
www.polaroiders.ning.com
www.polaroid-passion.com
www.snapitseeit.com
wwwthe1212project.com

Safety Information

General Safety Tips

While many of the techniques in this book do not involve any contact with chemicals, some require the dismantling of the film sheet, exposing the inner chemistry. The liquid chemicals for the developing process contained in the more common instant photo sheets are highly alkaline and can cause mild chemical burns to sensitive skin. Avoid contact with skin where possible by wearing gloves, and remove any chemical with soapy water. You can carry wet wipes to help remove chemicals when on-the-go.

Some techniques call for heating. If you have used additional chemicals on your pictures before attempting to heat them, check the hazard warnings before continuing. Unwanted chemical reactions can occur.

Take care when using microwaves and instant pictures: there is a fire risk, so always keep your microwave on a very low setting and do not leave unattended.

Chemical substances

Sodium hypochlorite and/or hydrogen peroxide (Polaroid destruction)
These are common bleaching agents contained within many household cleaning products. Though everyday substances, they are both extremely corrosive in high concentration and can cause significant damage to skin and eyes. Do not swallow. Wear protective clothing including goggles and gloves.

Sodium sulfite (negative clearing technique)
Sodium sulfite is a soluble sodium salt of sulfurous acid and is a mild irritant that can be harmful if inhaled or when coming into contact with the skin. It can also cause serious eye irritation, and contact with acids can create toxic sulphur oxides. Avoid ingestion, and wear protective equipment for hands, eyes, nose and mouth. If you get it in your eyes, rinse with water for several minutes.

Potassium ferricyanide (cyanotype technique)
Sometimes also known as red prussiate. This bright-red powder is mixed with ferrous powder to produce a blue colour. It is not hazardous, though when mixed with acid it can react to create a toxic gas.

Ferric ammonium citrate (cyanotype technique)
Also known as ammonium ferric citrate, ammonium iron and ferric ammonium citrate. This is an irritant to eyes, skin and the respiratory system. Use a face mask and protective clothing (gloves, goggles, etc.).

Titanium dioxide
This white powdery substance is found in-between the layers of many integral films. It is a whitening agent used commonly in paints and many foodstuffs, and as such, poses little risk.

Index